T0251965

Flash XML Applications

Supplementary Resources Disclaimer

Additional resources were previously made available for this title on CD. However, as CD has become a less accessible format, all resources have been moved to a more convenient online download option.

You can find these resources available here: www.routledge.com/9780240809175

Please note: Where this title mentions the associated disc, please use the downloadable resources instead.

Flash XML Applications

Use AS2 and AS3 to Create Photo Galleries, Menus, and Databases

Joachim Schnier, Ph.D.

Focal Press
Taylor & Francis Group

NEW YORK AND LONDON

First published 2008 by Focal Press

This edition published 2015 by Focal Press

Published 2017 by Routledge
2 Park Square, Milton Park, Abingdon, Oxon OX14 4RN
711 Third Avenue, New York, NY 10017, USA

First issued in hardback 2017

Routledge is an imprint of the Taylor & Francis Group, an informa business

Notices
Practitioners and researchers must always rely on their own experience and knowledge in evaluating and using any information, methods, compounds, or experiments described herein. In using such information or methods they should be mindful of their own safety and the safety of others, including parties for whom they have a professional responsibility.

Product or corporate names may be trademarks or registered trademarks, and are used only for identification and explanation without intent to infringe.

Library of Congress Cataloging-in-Publication Data

Schnier, Joachim.
 Flash XML applications: use AS2 and AS3 to create photo galleries, menus, and databases / Joachim Schnier. p. cm.
Includes index.
ISBN 978-0-240-80917-5 (pbk. : alk. Paper) 1. Computer animation. 2. Flash (Computer file) 3. Web sites—
 Design. 4. Action Script (Computer program language) I. Title.
TR897.7.S3755 2007
006.7'86—dc22

 2007022353

British Library Cataloguing-in-Publication Data

A catalogue record for this book is available from the British Library.

 ISBN 13: 978-1-138-40329-1 (hbk)
 ISBN 13: 978-0-240-80917-5 (pbk)

Cover Design: Alan Studholme

Typeset by Charon Tec Ltd (A MacMillan Company), Chennai, India

Contents

Acknowledgements

First of all I want to thank my wife, Kayoko, for her patience during the many hours in which I disappeared to the computer to write this book and for her constant support. Special thanks go to Erik Pohovich, who was the technical editor of this book. Further, I want to thank Patrick Mineault for allowing the use of some code he wrote and www.webservicex.net for giving permission to use one of their Web services. I would also like to thank members of Focal Press, Dennis McGonagle, Mónica González de Mendoza, Robin Weston, Georgia Kennedy, and in particular Paul Temme for their support in producing this book.

Introduction

XML

XML, the other markup language, is used by many server-side applications to handle complex datasets. Recent additions include Web services and RSS feeds. While we can write our own XML files for certain applications and determine how we want to parse XML, RSS feeds and Web services have a given XML file structure, for which we need to write a parser. The XML object was first introduced in Flash 5, but at that time did not get as much attention. Parsing XML in Flash 5 was harder because white space had to be considered for the parser. With the introduction of dynamic loading of objects such as images and audio in Flash MX, and the introduction of the ignoreWhite Boolean, which eliminates the white space during parsing of XML, the use of XML as a data-holding tool became more fashionable. This allowed the development of XML-driven slideshows and MP3 players, to mention some applications. An advantage of XML is that, without opening and compiling the original Flash movie, we can update the application by adding or removing data. While this is also possible with simple text files, it is clear that complex data can be much more logically structured using XML. In Flash MX2004 many Flash components that use XML as a data source have been introduced.

As to which XML books can be recommended, I once read a comment that parsing XML depends on the individual application and is in many cases unique. This would make books that specifically focus on parsing XML in Flash unnecessary. I disagree, because there is a certain methodology that can be used and learned to access every piece of data in an XML file and create virtual XML files using Flash ActionScript. The existence of predetermined XML files from RSS feeds, Web services, and large data banks and the use of XML in components justifies specific literature that focuses on XML parsing.

ActionScript 2 and 3

XML parsing itself is only one part of an application. Once we have accessed the data we need to do something with it. The scripting language in Flash is ActionScript (AS). Early Flash versions such as Flash 4 had very primitive ActionScript and creating applications was limited. More complex applications were possible with Flash 5 and MX. However, ActionScript version 1 is not precise and is lacking data typing, for example, or allows compilation of scripts with undefined variables within equations. It makes applications error-prone. It changed with the introduction of

AS2, which allowed data typing and for the first time made it possible to write ActionScript in the form of external classes (Flash MX 2004). The compilation of ActionScript 2, however, was still similar to that of AS1, because it used the same virtual machine, which is referred to as AVM1 (ActionScript Virtual Machine 1). The introduction of AS2, however, made Flash more attractive to developers who were used to other programming languages such as Java or C++. Although this book has a short tutorial on some basics of AS2, the reader is referred to other books that deal with basic concepts of AS2 in more detail. AS2 has its limits and one of the limits is how ActionScript is compiled. This led to the development of the AVM2, which is now used to compile AS3, the newest version of ActionScript. The basics of AS3 are introduced in more depth in this book than those of AS2, because there is less basic literature available. AS3 adds many more features to create Flash movies that are lacking in previous ActionScript versions. It also brings changes to the way XML is parsed and introduces a new XML class.

How This Book Is Organized

The book is divided into four sections. The first section deals with the introduction of XML, XML parsing methods, and a short introduction to AS2. For all properties and methods of the AS2 XML class there are specific code examples. Therefore the book serves also as a resource. In our first relatively simple exercises we will apply what we have learned. The second section introduces version 2 components, which use XML as the data source. As an example we will deal with RSS feeds and also learn how to get data from a Web service. In the third section we will build a real estate Web site. Parts of the Web site are applications from the first two sections. The core of the Web site is a search engine to search for houses according to the number of bedrooms and price. We will also develop our own component-like tools, such as a menu bar (or ComboBox in Section 4). We will add a simple content management system. And all applications have a commonality; they use XML as the data source and all applications are written as class files. Once we have completed the whole Web site in AS2 we will redevelop parts of the site, for example, the search engine, in AS3. And this is Section 4, which deals exclusively with AS3. The new XML class will be introduced in this section and, as in the AS2 section, there will be specific code examples that demonstrate how to apply methods and use properties. A particular focus in this section is the difference between AS2 and AS3 and how to transition from one AS version to the other, since we create the same applications using AS3. In the AS3 section we will also deal with the improvement of applications. We will delete unnecessary code and objects. This will in some cases dramatically improve code compilation and rendering times.

Why Learn Both AS2 and AS3?

Why learn AS2, when already a new version of ActionScript is available? There are a number of reasons, and I will mention some. Many companies are now converting their code from AS1 to AS2. This has its origin in the availability of the Flash player distribution. The Flash player 9 is not yet widely distributed and businesses are afraid that users turn away from their sites when they have to download the player. However, as we discussed earlier, AS1 is error-prone and the next logical update is AS2. Therefore, AS2 will still be used widely for the next several years.

Now imagine you are not familiar with AS1 or AS2 and are asked to convert all the Flash applications that had been written in AS2 code to AS3. Sure, you can develop everything from scratch and reinvent the wheel. However, how much easier would it be if you know AS2 very well and you have access to all of the class files? Big applications do not consist of just one class file. As you will learn in this book, the code is distributed in a number of smaller class files and modules, with their own properties and methods, which can be used in other applications as well. Once you are familiar with AS2 you can reuse the class files and large chunks of code, which will save you time. Although the difference between AS2 and AS3 is significant, many methods and properties are still the same, and if you already know AS2, then learning AS3 will be much easier. The question of who should read this book has surely been answered. This book is written for Flash designers or developers who are, to some extent, familiar with basic Flash AS syntax (beginner to intermediate), but want to use XML in various Flash applications and move to AS2 and/or AS3.

Flash 8, Flash 9 Preview, Flash CS3, and Flex 2

The most recent Flash versions that were used to develop the applications in this book were Flash 8 for applications using AS2 and the Flash 9 preview for those using AS3. Although all AS3 exercises have been tested with the new Flash CS3 for accuracy, the Flash 9 preview, which was used to develop the tutorials, can be used. AS3 can be compiled by another application, Flex 2. The Flex 2 IDE is based on Eclipse, and the initial file used to start a Flex 2 application is an MXML file. The difference between Flash and Flex is that Flex is used to develop data exchange applications, while Flash is frame-based and used for animations. There are a large number of components in Flex 2. Comparing the AS3 language references for Flash and Flex you will notice that all the mx classes and components are missing in the Flash 9 preview. If you do not want to buy the Flex 2 builder but want to do some work with Flex 2 you can still use a free SDK after the trial version has timed out. In this book we are not dealing with Flex 2 applications nor any of its components. However, any AS3 knowledge obtained here can be applied, of course, to Flex 2 projects as well.

The Example Code

The example code is available on the accompanying CD. All exercises have been tested. If you find a bug, then let me know. On my Web site there will be a special section for this book, where also some updates will be published (http://www.flashscript.biz/flashapplications/index.html). All exercises are geared toward the final application, a real estate Web site. The core of this site is a search engine, but other applications such as RSS feed and contact forms will be available as well.

Typographical Conventions Used in This Book

Certain keywords/expressions when introduced are set within quotes.

Text within these elements is PCDATA, which stands for "Parsed Character Data".

Important code, for example, for variables or strings, when introduced for the first time is set within quotes as well.

Since Flash MX, objects are instantiated by the "new" word.

All class files start with a capital letter. ActionScript code, PHP, and XML are shown in Courier font, size 10.

```
class scripts.XML_regular
{
  private var myXML:XML;
  private var myText:TextField;
  private var myClip:MovieClip;
  public function XML_regular ()
  {
  }
  public function test (myFile:String)
  {
    myXML = new XML ();
    myXML.ignoreWhite = true;
    myXML.onLoad = loadXML;
    myXML.load (myFile);
  }
    private function loadXML ()
    {
    _level0.myClip.myText.text = String(this);
    trace ("This" + this);
  }
}
```

Traces to the output window are presented in the font Monaco, size 9.

```
Before: false
After: true
```

Node names when explained are written within angle brackets.

The <bath> node would be the next sibling of <bedroom> and the <price> node....

INTRODUCTION TO XML APPLICATIONS AND ACTIONSCRIPT 2

1 XML Introduction

What Is XML?

XML stands for "eXtensible Markup Language". In terms of a programming language the word "extensible" means that designers/developers can extend its capabilities. HTML is also a markup language, but it cannot be extended. This means that information is contained within tags. In HTML the tags are predefined and can be interpreted by a browser. The tags tell your browser to format objects such as text, images, and forms in a certain way. In contrast to HTML, however, XML does not have any structural information. This is a problem when it comes to displaying the information in a sensible way. Therefore, XML requires a parser to interpret the tags and display the data so that it makes sense. As an example, in HTML the tag tells the browser to do something with the text following this tag. In XML we could write <arial> to indicate that the following information may have something to do with a font, in particular the font Arial. However, a browser would not know. This makes XML a much more flexible language than HTML and this is what is meant by extensible.

The Structure of an XML Document

Before we go into further detail about the importance and application of XML we need to know what XML looks like. An XML document consists of

- an XML declaration
- a DTD (optional)
- a root node
- child nodes, and
- attributes (optional)

A typical XML document is show below.

```
<?xml version="1.0"?  encoding="utf-8"?>
<!DOCTYPE house [
< !ELEMENT house (bedroom, bath, price, built, city, image,
   details)>
<!ATTLIST house id ID #REQUIRED>
< !ELEMENT  bedroom (#PCDATA)>
< !ELEMENT bath (#PCDATA)>
< !ELEMENT price (#PCDATA)>
```

```
<!ELEMENT built (#PCDATA)>
<!ELEMENT city (#PCDATA)>
<!ELEMENT image (#PCDATA)>
]>
<house id="1">
    <bedroom>3</bedroom>
    <bath>2</bath>
    <price>239,999</price>
    <built>1990</built>
    <city>North Sacramento</city>
    <image>images/house1.jpg</image>
</house>
```

In a browser window the document would be shown as in Figure 1.1.

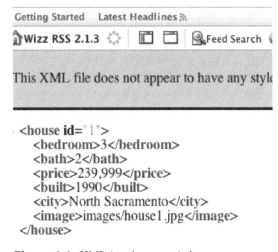

Figure 1.1 *XML in a browser window*

The DTD

DTD stands for "document type definition". The DTD is an analysis of the XML structure and contents. It can be written within the XML file as shown in our example or it can be placed outside and referenced in the XML file. An external DTD is referenced as follows:

```
<!DOCTYPE root-element SYSTEM "filename">
```

In our example that would be

```
<!DOCTYPE house SYSTEM "house.dtd">
```

The DOCTYPE is the root element. All other tags are elements. Text within these elements is PCDATA, which stands for "parsed character data", unless there are more subelements. Attributes are named ATTLIST. A different way of presenting the XML document is shown in Figure 1.2.

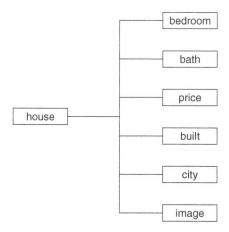

Figure 1.2 *XML as a tree*

This represents the XML document as a tree, in which <house> is the first element, which has tree branches, also called child elements/nodes. As you have already noticed, the tree is more of a family tree, since we speak of children, parents, and siblings, as you will see later when we discuss Flash and XML. Although Flash can parse XML files without any XML declaration, this is usually added to XML documents and is part of a well-formed XML document. DTDs are added to XML documents, which ought to be accessible to other developers, to allow parsers other than the Flash player to parse the documents.

XML Nodes

All XML files have to have a root node followed by child nodes. The root node in our example is <house>. If we eliminated the <house> tags, <bedroom> would become the root element. However, we would get an error message, "junk after document" (see also Figure 1.6), pointing to <bath> and the rest of the document as junk. In addition to the element or node name, nodes can have attributes, which are used to provide additional information: <house id="1">. "id" is an attribute and the value of an attribute has to be within quotation marks. As mentioned above, all nodes are elements or child nodes, including the root node. If there is more than one child node, as in our XML example, their relation to each other would be "siblings". I am already slowly introducing the naming used in Flash. The content within a child node, if not other child nodes, is called the "node value". In the DTD node values are indicated as PCDATA.

XML with Namespaces

Recently there has arisen a new type of XML document, which looks like XML but has some modifications compared to a regular XML document. An example is shown below.

```
<?xml version="1.0" encoding="UTF-8"?>
<cb:menu xmlns:cb="http://www.getyourownhouse.com">
  <cb:partofCity id="1">
    <cb:North>xml_files/North.xml</cb:North>
<cb:South>xml_files/South.xml</cb:South>
<cb:East>xml_files/East.xml</cb:East>
<cb:West>xml_files/West.xml</cb:West>
  </cb:partofCity>
```

A namespace is a set of names. Namespaces are identified via a URI (universal resource identifier, for example, a URL). The URI in the above example is http://www.getyourownhouse.com and is, therefore, a unique identifier. A namespace consists of a "prefix", in our example "cb", and a "local part" such as South or West. Namespaces are mechanisms to resolve naming conflicts. Namespaces in XML documents allow similar documents with the same node or element name but different meanings to be distinguished. In our case <North> or <West> refers to the particular XML document paths. However, another XML document could refer to something else, like a street located in a region of the city:

```
<partofCity id="1">
    <North>Washington Avenue</North>
```

There would be no way to distinguish between those XML documents, which could be identical except for the node values. However, the introduction of namespaces, which require a unique identifier, allows these files to be distinguished. We will use XML documents with namespaces in some of the future tutorials.

The Need for XML

XML, compared to HTML, is a relatively young language. Until Internet Explorer 5 XML could not be interpreted by a browser but had to be translated to HTML. So, why was there a need for XML in the first place? The answer to this is that XML is a perfect tool to store data. Go to the URL http://www.ncbi.nlm.nih.gov/entrez/query.fcgi.

This is the URL for the National Library of Medicine of the National Institutes of Health. Click on "Limits ==> Tag terms" and select "Title". In the search field type "XML" and then click on the Go button. You will see a large number of titles of journal articles, mostly bioinformatics— because of the search word XML—and many of the headlines use the term "database", or from the title it is obvious that the article content deals with data storage. Now click on the button next to the word "Summary". There is a drop-down menu and one of the terms is XML. Select "XML"

and all the data you have seen before is displayed in an XML document as shown in Figure 1.3. Click the Back button and press on one of the links for any journal article. The title, authors, and an abstract will be shown. Again select the drop-down menu next to the word "Abstract" and select "XML". Not surprisingly, all the information you saw before as formatted text is now present in XML format. I don't have to explain further why XML was created. XML allows storing of any kind of data, whether these are medical journal lists or individual articles of medical journals or cookbook recipes.

Figure 1.3 *Data from the NCBI database*

RSS Feeds and Web Services

Later in this book you will learn about RSS feeds and Web services. The information for RSS feeds and Web services is also stored in XML documents, because it is all database-type information. We could create an XML parser for a RSS feed for real estate information for provider A. Now we need to create a parser for a RSS feed for real estate information for provider B. If we are lucky, we could use exactly the same application/parser to display the data, since the structure of RSS feed XML documents is often similar. Unfortunately, the reality is not so and most often each provider of similar information creates its own format. However, the formats are usually so closely related that it is easy to adjust the parser. Individuality still dominates but it has its limits. So to summarize, we now know that XML is a perfect base to store any kind of data in a format that can easily be accessed using parsers.

XML Has Strict Rules

XML has very strict rules regarding structure and tags. While browsers neglect mistakes in an HTML script, such as a missing tag for example, this is forbidden in XML, and browsers would spit out error messages. In the following we discuss some of the errors that can be made. Browsers are the perfect debugging tools for XML documents. Before using an XML file in an application, open it in a browser window. If you see the document displayed as in Figure 1.1, you are safe. A typical common error is misspelling of a corresponding tag. For example, if in the XML document we write the closing tag </House> instead of </house>, we would get an error as shown in Figure 1.4. An opening tag requires the exact corresponding closing tag except for a slash in front of it. Another error, which can occur during the formatting of an XML document, is extra white space as shown in Figure 1.5. This is not considered a well-formed XML document. The main reason is that white space is not empty but regarded as a node. If we place a child node outside of the root element, we will get an error that there is junk, as shown in Figure 1.6. Some errors may not affect the parsing of an XML document by Flash, but it is safer and a good habit to correct any errors before proceeding further. So as a rule, always check an XML document in a browser before working with it in Flash.

XML Parsing Error: mismatched tag. Expected: </house>.
Location: file:///Users/jschnier/Desktop/book-proposal/Bo
Line Number 18, Column 3:

```
</House>
--^
```

Figure 1.4 *Misspelling of an element name*

XML Parsing Error: not well-formed
Location: file:///Users/jschnier/Desktop/book-proposal/Bo
Line Number 12, Column 6:

```
   < bedroom>3</bedroom>
-----^
```

Figure 1.5 *XML document not well formed*

XML Parsing Error: junk after document element
Location: file:///Users/jschnier/Desktop/book-proposal/Bo
Line Number 3, Column 5:

```
   <bath>2</bath>
----^
```

Figure 1.6 *Nodes outside the root element*

XML Parsers

XML can be parsed in various ways, such as XSL and XPath. XSL stands for "eXtensible Style sheet Language". XSL is a style sheet for XML documents and XSLT is an XML-transforming tool. XSLT transforms XML into HTML, which can then be read by a browser. You can find out more about XSLT on the pages of the World Wide Web Consortium (W3C.org): http://www.w3schools.com/xsl/default.asp.

If you are interested in XSLT you need to know also about XPath, which is a language used to find nodes in an XML document. XPath has more than 100 built-in functions allowing navigation within XML documents. Basically XPath is similar to what we are going to do in the following chapters of this book using Flash. You can find out more about XPath at http://www.w3schools.com/xpath/xpath_intro.asp.

Jen deHaan has developed a class with the name Xpath (which is not XPath), which can parse XML in Flash. More information can be found at http://weblogs.macromedia.com/dehaan/archives/2005/01/using_xpath_wit.cfm.

I am not going into further detail about these tools, but feel free to explore them more on your own.

XHTML, a Dream of the W3C School

For many years the World Wide Web Consortium wanted to introduce a standard for HTML pages. As you probably know, HTML is a language with very loose rules, while XML has strict rules. To convert HTML into some kind of XML standard version XHTML has been developed. Basically an XHTML page is an XML document containing HTML. The general header of an XHTML page looks like this:

```
<?xml version="1.0">
<!DOCTYPE html PUBLIC "-//W3C//DTD XHTML 1.0
  Transitional//EN"
  "http://www.w3.org/TR/xhtml1/DTD/xhtml1-transitional.dtd">
<html xmlns="http://www.w3.org/1999/xhtml" xml:lang="en"
lang="en">
```

Everything below the HTML tag is similar to regular HTML pages. There is only one problem; XHTML pages have the .html or .htm extension. If you alter tags so that the opening tag is not identical to the closing tag, for example, browsers will show the page as if there were no mistakes. Now change the extension to .xml and open the same file in a browser. There will be an error message. This means that browsers will interpret XHTML documents depending on the extension. Text editors such as BBEdit for the Mac have built-in capabilities to convert an HTML document into a well-formed XHTML, and mistakes will be corrected. In this book you will learn more about XHTML and we will actually build an XHTML parser. You can learn more about XHTML if you go to http://www.w3schools.com/xhtml/.

2 ActionScript 2 Revisited

Why Learn ActionScript 2?

Before we continue to work with XML we need to cover some Flash ActionScript. The ActionScript in this book is strictly ActionScript 2 (AS2) using object-oriented programming (OOP). If you are familiar with AS2 and OOP syntax you can skip this crash course and go directly to the next chapter. Otherwise, unless you intend to learn AS2 from a different source, it is essential to read this chapter. Initially, coming from ActionScript 1, you may not feel comfortable using AS2, but not to worry; once you get used to AS2 and using class files you will not miss AS1 any more, because you will be in control of the ActionScript and the movie and not the other way round.

Why is this so? AS2 has strict rules regarding variable definitions and declarations. Every variable needs to have a data type and will maintain this data type. A data type is a String, a Number, a MovieClip, etc., which is the type of data of a variable. This allows faster performance, since the player no longer has to guess which data type a variable has. There is a strict rule that capital letters are not the same as the corresponding small letters. A variable named "mypic" is not the same as "myPic". If a variable, for example, b in a numeric equation ($aa = b + c$), does not have a value, then the whole equation is undefined and the variable aa will be undefined. This was not the case in earlier versions of ActionScript, in which you could still get a value for aa. Remember, using AS1, you frequently associated scripts with Buttons and MovieClips: on (press) or on (clipEvent) as examples. If you face a problem because of a mistake in a script of a MovieClip of a MovieClip of a MovieClip, you have a hard time finding the problem. When you present your problem in a forum and show your .fla file, many members look at your .fla file, but you wonder why nobody answers. It is simple, since debugging of hidden scripts within the context of the movie is very difficult and time-consuming. By using AS2 class files you have all the scripting present in separate files and you can easily find a mistake by checking only one single file. That is control. There are many other advantages regarding the use of AS2 files. However, I would like to mention one more advantage. Adobe/Macromedia has now developed AS3, which is different from AS2, but strongly related. Once you have learned AS2 and OOP, it will be much easier to transition to AS3, which will be the main scripting language for Flash in the long term. However, even if you are familiar with creating classes, it does not mean you are not allowed to use scripts in .fla files, but you will write these scripts in AS2 syntax. You will, for example, feel more comfortable adding data types to variables or return types to functions. The usage of some words such as "public" or "private", however, is not allowed in .fla file scripts.

Now we will get started and have a crash course in AS2. If you want to learn more about AS2 there are some excellent books available, particularly I recommend *Understanding Macromedia Flash 8 ActionScript 2* by Andrew Rapo and Alex Michael (Focal Press, 2006), which teaches you the latest version of AS2 using game development as examples.

ActionScript 2 Syntax

Which tools do we need to write our own classes? Flash MX2006 and 8 offer a new file type called an "ActionScript File", which when saved will end with the extension ".as". Check your Flash application menu and open a new ActionScript File. What you see is a blank page (see also Figure 2.1).

Figure 2.1 *ActionScript 2 file*

Clicking on the "+" on the far left side of the upper menu opens a drop-down menu, which allows you to get code and place it in the script. However, that is very tedious. I recommend writing all code by yourself. The most important aid for you now is the Flash Help files. If you do not know the correct code syntax, search the Help files. Make as much use of the Help files as possible. Since Flash MX2004, they have been very much improved and provide lots of code examples. It may be difficult in the beginning to write your own code; however, after some time you will copy and paste code from the Help files or from your own scripts or tutorial scripts. I strongly recommend that you experiment wherever you can, change code, and test your movies. This is, in my experience, the best way to learn. To get you started I will provide simple starter files, which will teach you AS2 syntax and OOP basics. However, unlike all other files, these simple starter files are not on the CD. They are written in this book chapter and you must type the code by yourself. Sorry, but that is part of the exercise to get you used to typing your own code. Now let's get started. Get your favorite drink and make yourself comfortable.

The First Class File

Create a folder on your desktop or where you want to keep these exercise files and name it AS2. Open an empty ActionScript File and type the following lines:

```
class Hello
{
  public function Hello ()
  {
  }
  public function traceHello ():Void
  {
    trace ("Hello, my first script.");
  }
}
```

It should look like in Figure 2.1, nicely formatted for better readability.

What do those lines mean? We will go through them step by step. First we have the class declaration. A class is an object with methods and properties. Flash has built-in classes. As you will see you create your own classes and you can make use of the built-in classes by extending them. We have named our class "Hello". If we had the class in a folder called "Scripts", and the movie from which we call the class would be above this folder, we would need to redefine the class path and write "class scripts.Hello." Class names conventionally always start with a capital letter.

Constructor

Following the class declaration we have a function with the same name as the class name, which is empty in this example. We call this function the "constructor". The constructor is immediately called when the class is instantiated in the movie. Therefore, right from the beginning get used to looking at the constructor as a function that is different from other functions. Either leave the constructor empty or use it to initiate certain variables. Some programmers eliminate the constructor completely when it is empty. This is up to you. I always have the constructor present as a habit, since I like to have complete information. Regarding the naming of your functions, as a rule keep in mind not to give any function the same name as the class name, since, other than the constructor, this is not allowed. Also do not give the same name using small letters for a function. There will be a warning, although the script will be executed:

```
**Warning** /Users/username/Desktop/AS2_basics/scripts/
  Hello.as: Line 4: The member function 'hello' has a
  different case from the name of the class being defined,
  'scripts.Hello', and will not be treated as the class
  constructor at runtime.
  public function hello ()
Total ActionScript Errors: 1 Reported Errors: 1
Hello, my first script.
```

The constructor also does not have any return value (Void, String, Number, etc.), like other functions. If you add a return type to the function you will get an error message. The word "public" means that the function is accessible from the movie or from another class. In AS2 classes all variables and functions are by default public and actually you do not need to add the word public. Again I recommend doing it for two reasons: (1) give as much information as possible to the compiler; (2) in AS3 it is required to add public or private to some functions. So get used to it from the beginning. I just mentioned the word "private". If we want a variable or function not to be public, we call it private. However, if we try to access a private variable or function from outside the class, we will get an error message and the script will not be executed. Finally, all the code within a class is flanked by {}. Now you have learned a lot already, but what is missing is how to execute the class.

Execution of the Hello Class

To execute the class we create a movie. Open a new .fla file and in the first frame add these lines:

```
var hWorld:Hello = new Hello ();
hWorld.traceHello ();
```

In the first line two things are accomplished. The class Hello is imported and an instance of the Hello class using the new word is created. This is something to keep in mind. Whenever a class is called and a new instance of the class is created we use the following general syntax:

```
var var_name:Classname = new Classname ();
```

It is important how we import the class. The above case assumes that the class file is located in the same folder as the movie. This is, however, rarely the case. For example, if the class is located in a folder with the name "scripts", we either instantiate writing,

```
var hWorld:scripts.Hello = new scripts.Hello ();
```

or, since depending on the number of folders names can become quite long, use the word "import":

```
import scripts.Hello;
var hWorld:Hello = new Hello ();
```

Alternatively, we could use a wildcard:

```
import scripts.*;
```

However, this is not a good technique and usually used if we either are not sure about the complete class path or want to import other classes from the same folder. It is always recommended to call the individual classes, since we might import classes that we do not need.

Now coming back to our original script, if we had any method in the constructor it would have been executed right after creating an instance of the class. In the second line we call the function "traceHello()" using the instance variable "hWorld". The output window will show the line:

```
"Hello, my first script.".
```

Play around with this script and make changes. For example, change the data type of the variable or do not write any data type. See which error messages you get and then come back to continue. It is important that you get familiar with AS2. You will not regret it.

Variables

Now we turn to variables. We will pack the sentence "Hello, my first script." into a variable. There are several ways to do this. From AS1 you are probably familiar with creating a local variable. A local variable is defined within only one function and will be undefined outside of that function. However, creating any variable in AS2 is different from AS1. In AS1 you could just write

```
myHello = "Hello, my first script.";
```

or

```
var myHello = "Hello, my first script.";
```

This is no longer allowed in an AS2 class script. Open the Hello class and change the "traceHello" function in the following way:

```
public function traceHello ():Void
{
  var myHello:String = "Hello, my first script.";
  trace (myHello);
}
```

All we have done here is associate the string with a variable we name "myHello". However, we have to use the word "var" and we have to give "myHello" a data type. Since the data is of the type String we add ":String" to myHello. If we write a number instead of the text,

```
var myHello:String = 3;
```

we would get an error message, because 3 is a number and not a string. To convert it to a string we set it in quotations, "3". If we do not want a local variable but want the variable to be available to every function in the script, we define it at the beginning before the constructor:

```
class Hello
{
  private var myHello:String;
  public function Hello ()
  {
  }
  public function traceHello ():Void
  {
    myHello = "Hello, my first script.";
    trace (myHello);
  }
}
```

Now the variable "myHello" is not local any more. When this function is executed there will be the same trace as before. Further, the variable is now private. This means that the variable cannot be accessed directly from the movie but can be accessed anywhere within the class file. By default variables are public in AS2. If you declare

```
var myHello:String = "Hello, my first script.";
```

newly within the function the original variable would be overridden and "myHello" would be a new local variable, and its content would not be available anywhere else other than in this function.

Casting

In AS2 a variable is not allowed to change the data type. However, sometimes there is the situation in which the value of a variable needs to have a different data type. If we have a string, "3", and want it to be a number, we "cast" the variable holding the string. The following example demonstrates this:

```
class Casting
{
  private var myHello:String;
  public function Casting ()
  {
  }
  public function castVar ():Void
  {
    myHello = "3";
    var num1:Number = 5;
    var num2:Number = Number (myHello);
    var theSum:Number = num1 + num2;
    trace ("theSum: " + theSum);
    var addNum:String = String (num1) + myHello;
    trace ("addNum: " + addNum);
  }
}
```

In this example we want the sum of the value from "myHello" and "num1". "myHello" is a string variable. If we just set

```
var theSum:Number = num1 + myHello;
```

we would get this error message:

```
Line 12: Type mismatch in assignment statement: found
  String where Number is required.
    var theSum:Number = num1 + myHello;
```

Therefore, we need to convert "myHello" to the data type Number. We do that by just placing the new data type in front of the variable and having the variable in parentheses. The above example also shows what would happen if both numbers were strings.

Static

Another useful feature of AS2 is that functions or variables can be "static". This means they are part of the class and are called by the class name. In AS1 you are probably familiar with the Math methods. All methods and variables are called by directly using the class name, because they are static members of the class, for example, "Math.ceil (number)". Furthermore, static variables will be recognized anywhere within a class file as long as they have a value. Static variables can have only one value, unlike variables, which are not static and which can be instantiated more than one time in a movie holding different values. If a static variable is accessed from different instances of the movie, it will always have only one value, the one that was last given to it. This can be useful in counters, for example. Static variables are called using the class name. Alter the script in Hello.as to the following:

```
class Hello
{
  public static var myHello:String;
  public function Hello ()
  {
  }
  public function traceHello ():Void
  {
    myHello = "Hello, my first script.";
  }
}
```

In your movie you can access the variable using the class name, but you need to create an instance of the class first to execute the "traceHello" function:

```
var hWorld:Hello = new Hello ();
hWorld.traceHello ();
trace(Hello.myHello);
```

Extending a Class

Very often in this book you will find that a class extends another class, for example, we could extend the MovieClip class by the Hello class. The MovieClip class would then be the "superclass" of the Hello class, although the usefulness of this is doubtful. But nevertheless let's do it once for demonstration purposes. Create a new movie and save it in your folder. Add a symbol in your movie, for example, add a circle and name it "circle". Then give it linkage id and add the class name

Figure 2.2 *Extending the MovieClip class*

HelloCircle as shown in the screenshot in Figure 2.2. Place a circle instance on stage and name it "myCircle". In frame 1 of the movie write the lines:

```
import HelloCircle;
var myCircle:MovieClip;
myCircle.traceHello ();
```

What we are doing here is first importing the class HelloCircle. We do not need to create an instance of the class, because the class and the function "traceHello" will be called over the MovieClip myCircle. Now, open a new ActionScript file and type the following lines:

```
class HelloCircle extends MovieClip
{
  private var myHello:String;
  public function HelloCircle ()
  {
  }
  public function traceHello ():Void
  {
    myHello = "Hello, my first script.";
    trace(myHello);
    trace(this);
  }
}
```

As you can see we use the word "extends" and a class name in the class declaration that we want to extend. When you test the movie you should see these two trace actions in the output window:

```
Hello, my first script.
_level0.myCircle
```

The word "this" now refers to the MovieClip instance myCircle on the stage. This is very useful, as you will see in the upcoming tutorials. If we had other MovieClips inside the circle MovieClip we could access those by using the word "this" as well.

Getter and Setter

There are special methods for getting the value of a variable and changing it to a new value. These are called the "Getter" and "Setter" methods. A "Getter" function always has a return statement and the "Setter" function always has a parameter but no return statement. Here is a simple example:

```
class GetSet
{
  private var myHello:String = "Greetings from the new
   world."
  public function GetSet ()
  {
  }
  function get hello ():String
  {
    return myHello;
  }
  function set hello (nHello:String):Void
  {
    myHello = nHello;
  }
}
```

The "Getter" function contains the reserved word "get" followed by a function name, and the "Setter" the reserved word "set" followed by a function name. Both function names can be identical. To get the value of "myHello" we first instantiate the class and then, using the instance variable name followed by the function name for the "Getter", we can trace the value of "myHello":

```
var greetings:GetSet = new GetSet ();
trace (greetings.hello);
```

If we want to set a new value for "myHello" at any time we use the instance name followed by the function name for the "Setter" and set it equal to the new value:

```
greetings.hello = "This is the new string.";
trace (greetings.hello);
```

If we do a trace before and after setting the value for "myHello" we obtain both values:

```
Greetings from the new world.
This is the new string.
```

These methods allow getting and setting variable values at any time in a movie. We are now ready to write our AS2 class script. There are some more features we could have mentioned, but this is more the task of a specialized book on AS2. A number of additional features will be mentioned when the individual scripts are presented.

3 XML and XMLNode Classes

Overview

Flash 8 or earlier versions have two classes to create and/or work with XML documents, the XML class and the XMLNode class. In this chapter we will list the properties, events, and methods of both classes. All classes are updated for Flash 8. For most of the properties, events, and methods, there are examples in the tutorials. However, separate examples will be shown as well.

The XML Class: Properties

All properties of the XML class can be read and set. In the following examples only one of the two possibilities is shown. You can find .fla files for every script presented here on the accompanying CD.

contentType (XML.contentType property)

public contentType : String

This property is used when data is sent to the server via XML.send() or XML.sendAndLoad(). Value is the MIME (Multipurpose Internet Mail Extensions) type.

Example:

```
var myXML:XML = new XML
  ("<house><price>120000</price></house>");
trace ("1: " + myXML.contentType);
myXML.contentType = "text/xml";
trace ("2: " + myXML.contentType);
```

will trace

```
1: application/x-www-form-urlencoded
2: text/xml
```

docTypeDecl (XML.docTypeDecl property)

public docTypeDecl : String

Using this declaration an XML document's DOCTYPE can be defined.

Example:

```
var myXML:XML = new XML ();
myXML.docTypeDecl = "<!DOCTYPE house SYSTEM \"house.dtd\">";
trace (myXML.docTypeDecl);
```

will trace

```
<!DOCTYPE house SYSTEM "house.dtd">
```

idMap (XML.idMap property)

public idMap : Object

idMap is an array of child nodes identified by an id attribute assigned to each node. Flash 8 has a bug and idMap cannot be run in AS2 class scripts except with the XML-load script described here. idMap requires the XML document to be parsed using XML.parseXML().

Example:

See Chapter 5 for examples. Part of the example for how to use it is shown below.

```
private function loadXML ()
{
  for (var count01 in iniXml.defaultXML.idMap)
  {
    var findChild:XMLNode = iniXml.defaultXML.
     idMap[count01];
    trace (findChild);
    trace(iniXml.defaultXML.idMap["house"]);
  }
}
```

ignoreWhite (XML.ignoreWhite property)

public ignoreWhite : Boolean

This property will eliminate white space in an XML document to be recognized as nodes. The default setting is "false".

Example:

```
var myXML:XML = new XML ();
// myXML.ignoreWhite = true;
myXML.onLoad = function ()
{
  trace (this);
};
myXML.load ("xml_files/whitespace.xml");
```

The trace would be

```
<?xml version="1.0"?  encoding="utf-8"?>
  <house>
    <bedroom> 3 to 5 </bedroom>
    <price> </price>
  </house>
```

If we now uncomment the second line and set ignoreWhite to "true", this would be the trace:

```
<?xml version="1.0"?  encoding="utf-8"?><house><bedroom>
 3 to 5 </bedroom><price /></house>
```

loaded (XML.loaded property)

public loaded : Boolean

This property indicates whether the XML document has been successfully loaded.

Example:
```
var myXML:XML = new XML ();
myXML.onLoad = function ()
{
  trace (this.loaded);
};
myXML.load ("xml_files/sample.xml");
```

would trace

```
true.
```

status (XML.status property)

public status : Number

This property automatically sets and returns a numeric value that indicates whether an XML document was successfully parsed into an XML object or whether an error occurred because of a malformed XML document.

Example:
```
var myXML:XML = new XML ();
myXML.onLoad = function ()
{
  trace (this.status);
};
myXML.load ("xml_files/malformed.xml");
```

The trace would give -6, because of a malformed node ($<$ bath$>$).

- -0: No error; parse was completed successfully
- -2: A CDATA section was not properly terminated
- -3: The XML declaration was not properly terminated
- -4: The DOCTYPE declaration was not properly terminated
- -5: A comment was not properly terminated
- -6: An XML element was malformed
- -7: Out of memory
- -8: An attribute value was not properly terminated
- -9: A start-tag was not matched with an end-tag
- -10: An end-tag was encountered without a matching start-tag

xmlDecl (XML.xmlDecl property)

public xmlDecl : String

This is a string that specifies information about an XML document. To parse an XML document in Flash a declaration is not required.

Example:

```
var myXML:XML = new XML ();
myXML.xmlDecl = "<?xml version=\"1.0\"?  encoding=\"utf-
  8\"?>";
trace (myXML);
```

will trace

```
<?xml version="1.0"?  encoding="utf-8"?>
```

The XML Class: Events

onData (XML.onData handler)

onData = function(src:String) {}

This is invoked when XML text has been completely downloaded from the server or when an error occurs in downloading XML text from a server. The difference compared to onLoad is that the XML document has not been parsed and white space, for example, has not been removed. In the example below "this.status" will give "0" despite the malformed XML document. The parameter "src" is a string holding the XML text.

Example:

```
var myXML:XML = new XML ();
myXML.onData = function (src:String)
{
  trace (src);
```

```
    trace("Status: "+this.status);
  };
  myXML.load ("xml_files/malformed.xml");
```

will trace

```
  <?xml version="1.0"?  encoding="utf-8"?>
  <house id="1">
    <bedroom>3</bedroom>
    <bath>2</bath>
  </house>
  Status: 0
```

onHTTPStatus (XML.onHTTPStatus handler)
onHTTPStatus = function(httpStatus:Number) {}

This is invoked when Flash Player receives an HTTP status code from the server. It can be executed also within the onData event handler, but then only when there is an onLoad event. It will be undefined when the XML document is loaded from the computer hard drive.

Example:
```
  var myXML:XML = new XML ();
  myXML.onHTTPStatus = function (httpStatus:Number)
  {
    this.httpStatus = httpStatus;
  };
  myXML.onLoad = function ()
  {
    trace ("httpStatus: " + this.httpStatus);
  };
  myXML.load
  ("http://www.flashscript.biz/MX2004/xml2004_tutorial/xml_
   tutorial_1.xml");
```

will trace

```
  httpStatus: 200
```

A list of numbers is shown below.

- httpStatus < 100: flashError
- httpStatus < 200: informational
- httpStatus < 300: successful
- httpStatus < 400: redirection

- httpStatus < 500: clientError
- httpStatus < 600: serverError

onLoad (XML.onLoad handler)

onLoad = function(success:Boolean) {}

The onLoad event handler is invoked when an XML document is received from the server. The parameter "success" is then true. Unlike the onData event handler the XML document has been parsed into an XML object and the status can be monitored.

Example:

```
var myXML:XML = new XML ();
myXML.onLoad = function (success:Boolean)
{
  trace (success);
  if (success)
  {
    trace (this.status);
  }
};
myXML.load ("xml_files/malformed.xml");
```

will trace

```
true
-6
```

XML constructor

public XML(text:String)

This creates a new XML object. The parameter is a string. To load an XML document from the server the XML object is left empty (var my_xml:XML = new XML();).

Example:

```
var my_xml:XML = new
  XML("<house><price>120000</price></house>");
```

The XML Class: Methods

addRequestHeader (XML.addRequestHeader method)

public addRequestHeader(header:Object, headerValue:String) : Void

This adds or changes HTTP request headers (such as Content-Type or SOAPAction) sent with POST actions. A nice example of its use is shown in the tutorial at

http://www.martijndevisser.com/blog/article/using-http-authorization-headers, where the Header is changed to call a file protected by a username and password. This is used in connection with XML.sendAndLoad().

Example:
```
my_xml.addRequestHeader ("Action", "'the_action'");
```

createElement (XML.createElement method)
public createElement(name:String) : XMLNode

This will create a new XML node and is used with appendChild(). The parameter name will set the node name.

Example:
```
var myXML:XML = new XML ();
var element1:XMLNode = myXML.createElement ("house");
var element2:XMLNode = myXML.createElement ("bedroom");
myXML.appendChild (element1);
element1.appendChild (element2);
trace (myXML);
```

will trace

```
<house><bedroom /></house>
```

createTextNode (XML.createTextNode method)
public createTextNode(value:String) : XMLNode

This method will create a new text node and is used with appendChild(). The parameter will set the node value.

Example:
```
var myXML:XML = new XML ();
var element1:XMLNode = myXML.createElement ("house");
var element2:XMLNode = myXML.createElement ("bedroom");
myXML.appendChild (element1);
element1.appendChild (element2);
var myText:XMLNode = myXML.createTextNode ("2 to 5");
element2.appendChild (myText);
trace (myXML);
```

will trace

```
<house><bedroom>2 to 5</bedroom></house>
```

getBytesLoaded (XML.getBytesLoaded method)

public getBytesLoaded() : Number

The number of bytes loaded will be returned.

Example:

```
var myXML:XML = new XML ();
_root.onEnterFrame = function ()
{
  var bytes:Number = myXML.getBytesLoaded ();
  trace (bytes);
};
myXML.load ("xml_files/sample.xml");
```

will trace

```
0
419
```

getBytesTotal (XML.getBytesTotal method)

public getBytesTotal() : Number

This method returns the number of bytes of the XML document.

Example:

```
var myXML:XML = new XML ();
_root.onEnterFrame = function ()
{
  var bytes:Number = myXML.getBytesTotal ();
  trace (bytes);
};
myXML.load ("xml_files/sample.xml");
```

will trace

```
undefined
419
```

load (XML.load method)

public load(url:String) : Boolean

This is a method to load an XML document. The parameter is a string that is the URL for an XML document. When loading is initiated the XML property loaded is set to false, and when

the XML document is completely downloaded from the server, the property loaded is set to true.

Example:
```
var myXML:XML = new XML ();
myXML.onLoad = function ()
{
  trace ("After: " + this.loaded);
};
myXML.load ("xml_files/sample.xml");
trace ("Before: " + myXML.loaded);
```
will trace

```
Before: false
After: true
```

parseXML (XML.parseXML method)

public parseXML(value:String) : Void

This method parses the XML text specified in the parameter. In the example below, without parseXML(xml_str), the trace would give "undefined".

Example:
```
var xml_str:String = "<house><price>120000</price>
 </house>";
var my_xml:XML = new XML ();
my_xml.parseXML (xml_str);
trace (my_xml.firstChild.firstChild.firstChild.nodeValue);
```
will trace

```
120000
```

send (XML.send method)

public send(url:String, [target:String], [method:String]) : Boolean

This encodes the specified XML object into an XML document and sends it to the specified URL, such as a php file.

Example:
```
var my_xml:XML = new XML ();
my_xml.contentType = "text/xml";
```

```
var newNode:XMLNode = my_xml.createElement ("login");
newNode.attributes["phone"] = "555-922-4567";
newNode.attributes["email"] = "foe@foemail.com";
my_xml.appendChild (newNode);
my_xml.send ("xml_parser.php", "_blank");
```

sendAndLoad (XML.sendAndLoad method)

public sendAndLoad(url:String, resultXML:XML) : Void

This method encodes the specific XML object into an XML document, sends it to the URL, and downloads the response from the server as specified in resultsXml.

Example:

```
var resultsXml:XML = new XML ();
resultsXml.ignoreWhite = true;
resultsXml.onLoad = function (success:Boolean)
{
  success = Boolean (this.firstChild.attributes.success);
  var msg:String = this.firstChild.attributes.msg;
  if (success)
  {
    trace (msg);
  }
  else
  {
    var msg:String = this.firstChild.attributes.error;
    trace (msg);
  }
};
var my_xml:XML = new XML ("<login email=\"foe@foemail.com\"
 phone=\[E22]"555-922-4567\" />");
my_xml.contentType = "text/xml";
my_xml.sendAndLoad ("xml_parser.php", resultsXml);
```

The Object Class

The XML class has properties and methods inherited from other classes such as the Object class.

- addProperty (Object.addProperty method)
- hasOwnProperty (Object.hasOwnProperty method)
- isPropertyEnumerable (Object.isPropertyEnumerable method)
- isPrototypeOf (Object.isPrototypeOf method)

- registerClass (Object.registerClass method)
- toString (Object.toString method)
- unwatch (Object.unwatch method)
- valueOf (Object.valueOf method)
- watch (Object.watch method)

The XMLNode Class: Properties

Some of the properties are read-only, as indicated.

attributes (XMLNode.attributes property)

public attributes : Object

This is an object used to access attributes in an XML file.

Example:
```
var my_xml:XML = new XML ();
var newNode:XMLNode = my_xml.createElement ("login");
newNode.attributes["phone"] = "555-922-4567";
newNode.attributes["email"] = "foe@foemail.com";
my_xml.appendChild (newNode);
trace(my_xml.firstChild.attributes.phone);
```

will trace

```
555-922-4567
```

childNodes (XMLNode.childNodes property)

public childNodes : Array [read-only]

This is a read-only array, which will list all child nodes.

Example:
```
var my_xml:XML = new XML
("<bedroom>3</bedroom><price>100,000</price>");
trace (my_xml.childNodes[1]);
```

will trace

```
<price>100,000</price>
```

firstChild (XMLNode.firstChild property)

public firstChild : XMLNode [read-only]

This is a reference to the first child of an XML document or parent node.

Example:
```
var my_xml:XML = new XML
  ("<bedroom>3</bedroom><price>100,000</price>");
trace(my_xml.firstChild);
```

will trace

```
<bedroom>3</bedroom>
```

lastChild (XMLNode.lastChild property)

public lastChild : XMLNode [read-only]

This is a reference to the last child of an XML document or parent node.

Example:
```
var my_xml:XML = new XML
  ("<bedroom>3</bedroom><price>100,000</price>");
trace(my_xml.lastChild);
```

will trace

```
<price>100,000</price>
```

localName (XMLNode.localName property)

public localName : String [read-only]

This is a reference to the XML node name in an XML document with namespaces.

Example (the following namespace XML file will be used for all properties and methods related to namespaces):

```
<?xml version="1.0" encoding="UTF-8"?>
<ag:Agency xmlns:ag="http://www.getyourownhouse.com">
  <hs:Body
xmlns:hs="http://www.getyourownhouse.com/houses">
    <hs:Description>
      <hs:Built text="Built in ">1990</hs:Built>
      <hs:Location text="Located in ">Sacramento</hs:Location>
      <hs:Price text="Price: ">$239,000</hs:Price>
    </hs:Description>
  </hs:Body>
</ag:Agency>
```

Code in Flash movie:

```
var my_xml:XML = new XML ();
my_xml.ignoreWhite = true;
my_xml.onLoad = function ()
{
  trace (this.firstChild.localName);
};
my_xml.load ("xml_files/namespace.xml");
```

will trace

```
Agency
```

namespaceURI (XMLNode.namespaceURI property)

public namespaceURI : String [read-only]

This is a reference to the URL identifier in a namespace XML document.

See above example, except:

```
trace (this.firstChild.namespaceURI);
```

will trace

```
http://www.getyourownhouse.com/houses
```

nextSibling (XMLNode.nextSibling property)

public nextSibling : XMLNode [read-only]

This is a reference to the next sibling of the first child in an array of child nodes.

Example:

```
var my_xml:XML = new XML
  ("<bedroom>3</bedroom><price>100,000</price>");
trace (my_xml.firstChild.nextSibling);
```

will trace

```
<price>100,000</price>
```

nodeName (XMLNode.nodeName property)

public nodeName : String

This is a reference to the name of an XML node.

Example:
```
var my_xml:XML = new XML
  ("<bedroom>3</bedroom><price>100,000</price>");
trace (my_xml.firstChild.nodeName);
```

will trace

```
bedroom
```

nodeValue (XMLNode.nodeValue property)

public nodeValue : String

This is a reference to the value of an XML node.

Example:
```
var my_xml:XML = new XML
  ("<bedroom>3</bedroom><price>100,000</price>");
trace (my_xml.firstChild.firstChild.nodeValue);
```

will trace

```
3
```

parentNode (XMLNode.parentNode property)

public parentNode : XMLNode [read-only]

This is a reference to the parent node of a child node.

Example:
```
var my_xml:XML = new XML
  ("<bedroom>3</bedroom><price>100,000</price>");
trace (my_xml.firstChild.firstChild.parentNode);
```

will trace

```
<bedroom>3</bedroom>
```

prefix (XMLNode.prefix property)

public prefix : String [read-only]

This is a reference to the prefix of a namespace XML document.

See namespace example and change the trace line:
```
trace (this.firstChild.prefix);
```

will trace

ag

previousSibling (XMLNode.previousSibling property)

public previousSibling : XMLNode [read-only]

This is a reference to the previous sibling of a child node.

Example:
```
var my_xml:XML = new XML
  ("<bedroom>3</bedroom><price>100,000</price>");
trace (my_xml.lastChild.previousSibling);
```

will trace

```
<bedroom>3</bedroom>
```

XMLNode constructor

public XMLNode(type:Number, value:String)

Using the constructor and the new word, a new instance of an XML node can be created. There are two parameters, the node type and its value. Although there are 12 possibilities for node types the Flash player supports only two of them, type 1, ELEMENT_NODE, and type 3, TEXT_NODE.

Example:
```
var my_node_1:XMLNode = new XMLNode (1, "<bedroom>");
trace ("1: "+my_node_1);
var my_node_2:XMLNode = new XMLNode (3, "<bedroom>");
trace ("3: "+my_node_2); // this will now become text node
```

will trace

```
1: <<bedroom> />
3: <bedroom>
```

The XMLNode Class: Methods

appendChild (XMLNode.appendChild method)

public appendChild(newChild:XMLNode) : Void

This method will append a new child node to an XML document root or child.

Example:
```
var myXML:XML = new XML ();
var element1:XMLNode = myXML.createElement ("house");
var element2:XMLNode = myXML.createElement ("bedroom");
myXML.appendChild (element1);// appends element 1 to root
 element1.appendChild (element2);// appends element 2 to
 element 1 trace (myXML);
```

will trace

```
<house><bedroom /></house>
```

cloneNode (XMLNode.cloneNode method)

public cloneNode(deep:Boolean) : XMLNode

This method allows you to copy nodes. The parameter is either "true" or "false".

Example:
```
var myXML:XML = new XML ();
var element1:XMLNode = myXML.createElement ("house");
var element2:XMLNode = myXML.createElement ("bedroom");
myXML.appendChild (element1);
element1.appendChild (element2);
var copy_node:XMLNode = myXML.firstChild.firstChild.
 cloneNode(true);
trace(copy_node);
```
will trace

```
<bedroom />
```

getNamespaceForPrefix (XMLNode.getNamespaceForPrefix method)

public getNamespaceForPrefix(prefix:String) : String

This returns the namespace URI.

See namespace example and change the trace line:
```
trace (this.firstChild.getNamespaceForPrefix ("ag"));
```
will trace

```
http://www.getyourownhouse.com
```

getPrefixForNamespace (XMLNode.getPrefixForNamespace method)

public getPrefixForNamespace(nsURI:String) : String

This returns the prefix for a give namespace URI.

See namespace example and change the trace line:

```
trace (this.firstChild.getPrefixForNamespace
  ("http://www.getyourownhouse.com"));
```

will trace

```
ag
```

hasChildNodes (XMLNode.hasChildNodes method)

public hasChildNodes() : Boolean

This method returns true when an XML node has child nodes.

Example:

```
var my_xml:XML = new XML ("<house><bedroom>3</
  bedroom><price>100,000</price></house>");
trace(my_xml.firstChild.hasChildNodes());
```

will trace

```
true
```

insertBefore (XMLNode.insertBefore method)

public insertBefore(newChild:XMLNode, insertPoint:XMLNode) : Void

This will insert a new child node at a given insert point.

Example:

```
var my_xml:XML = new XML ("<price>100,000</price>");
var new_node:XML = new XML ("<bedroom>3</bedroom>");
var insert_point:XMLNode = my_xml.firstChild;
my_xml.insertBefore (new_node, insert_point);
trace (my_xml);
```

will trace

```
<bedroom>3</bedroom><price>100,000</price>
```

removeNode (XMLNode.removeNode method)

public removeNode() : Void

This will remove a node specified as part of an XML document.

Example:

```
var my_xml:XML = new XML
  ("<bedroom>3</bedroom><price>100,000</price>");
var nodeRemove:XMLNode =  my_xml.firstChild;
nodeRemove.removeNode()
trace(my_xml);
```

will trace

```
<price>100,000</price>
```

toString (XMLNode.toString method)

public toString() : String

This method converts an XML document or node to a string and allows string manipulations. This can be important for XML manipulations.

Example:

```
var my_xml:XML = new XML
  ("<bedroom>3</bedroom><price>100,000</price>");
var node_string:String = my_xml.toString ();
var splitted:Array = node_string.split ("3");
node_string = splitted.join ("6");
var alt_node:XML = new XML (node_string);
trace (alt_node.firstChild);
```

will trace

```
<bedroom>6</bedroom>
```

4 Tutorial: Creating a Universal XML Load/onload Class

Introduction

In this chapter we will create our first class file. What you will learn is how to load an XML file. We will first discuss the standard way to load an XML file. However, because of problems that can occur, we will design our own XML loading class file, which we will use throughout the book.

A Regular XML Load/onLoad Script

To load an XML file we will use the load method combined with an onLoad event handler. A regular class script to load and display an XML file would be something like this:

```
class scripts.XML_regular
{
  private var myXML:XML;
  private var myText:TextField;
  private var myClip:MovieClip;
  public function XML_regular ()
  {
  }
  public function test (myFile:String)
  {
    myXML = new XML ();
    myXML.ignoreWhite = true;
    myXML.onLoad = loadXML;
    myXML.load (myFile);
  }
  private function loadXML ()
  {
    _level0.myClip.myText.text = String(this);
    trace ("This" + this);
  }
}
```

We first define a number of variables right before the constructor, because we want these variables to be recognized in every function. These are the XML object, a text field to display the XML, and a

MovieClip, which contains the text field. Now look at the function test, which has the parameter myFile of data type String. This is just another way of initiating a local variable, in this case only for this function. But do not forget to add the data type. Then we write the XML-onLoad/load script. First we need to create a new instance of the XML object. Since Flash MX, objects are instantiated by the "new" word. Then we make sure by setting "myXML.ignoreWhite = true;" that all the white space in the XML file is ignored, since white space is also regarded as node. Do not forget this line, because you may get strange results. Next we have an onLoad event. This event is executed only when the XML file is fully loaded. We create a new function, "loadXML", to display and, if we intend, to parse the XML once the data is loaded. The last line simply initiates the loading of the XML file from the server. The XML file is held in the String variable "myFile". The function "loadXML" contains a line that will show the whole XML file in the text field. Note here that we use the word "this" to display the XML, which refers to the XML object myXML. This could be a problem, if we need to refer to objects outside this function. You can see what I mean if instead of "String(this)" we write "String(myXML)", which would give undefined. You will learn how to solve this problem later.

We want to display the XML data and, therefore, we convert the XML object to a string, because text fields display strings. Now we examine the .fla file (XML_regular.fla) and the script, which is needed to actually execute the class:

```
import scripts.XML_regular;
var xmlTtest:XML_regular = new XML_regular ();
var myFile:String = "xml_files/combo.xml";
xmlTtest.test (myFile);
```

We import the class XML_regular and create an instance, xmlTest. Then we create another variable for the path to the XML file, which is the string variable myFile. Finally we call the function test using the class instance.

Introducing the Delegate Class

As mentioned earlier, functions within an onLoad event have a narrow scope, meaning that objects outside this function cannot be accessed. The word "this" refers to the object triggering the function but not anything outside of the function. This can cause a number of problems, since we often need access to objects outside of this function. Using the Delegate class can change the scope of the function. In the example the Delegate class is introduced. If you have Flash MX2004 you will need to update to Flash 7.2.

First you need to import this class.

```
import mx.utils.Delegate;
```

Then the Delegate class is incorporated in the following way using our example above:

```
    myXML.onLoad = Delegate.create (this, loadXML);
    myXML.load (myFile);
}
```

```
private function loadXML ():Void
{
  _level0.myClip.myText.text = String(myXML);
  trace ("This" + this);
}
```

The Delegate class has a static function named "create" with two parameters, of data type Object and of data type Function. We can actually guess that by just looking at this one line, because the function "create" is called over the class name. "this" is an object, because it can refer to different data types including the Object data type. "loadXML" is a function. If you now test the movie (XML_regular_delegate.fla), "myXML" is correctly recognized as the XML object and "this" refers to the class object.

Creating a Reference Variable

Using the Delegate class is one way to extend the scope of a function. Another way is to declare a variable, which refers to the class. Reference variables are useful when we cannot use the Delegate class. You will see various applications throughout this book. I have prepared a simple example. Open the XML_regular_reference.as file. We have a variable "classClip" with a data type Object. We make this variable static, so it can be accessed everywhere in the script, but we leave it private to prevent accessibility from outside the class.

```
private static var classClip:Object;
```

This is an occasion to make use of the constructor function to initiate the variable, which will hold the class object by using the "this" word.

```
public function XML_regular_reference ()
{
  classClip = this;
}
```

When we want to call any object outside the loadXML function we add "classClip" in front of it as shown in the example below. While "this" will still refer to the function, "classClip" will refer to the class, but both will display the XML data.

```
private function loadXML ()
{
  _level0.myClip.myText.text = String(this);
  trace(classClip.myXML);
}
```

proxy.php: calling XML from a different server

There are times when you need to call an XML file from a different server. Doing so would directly conflict with security issues of the Flash player. To bypass this we create a php file, which

we call proxy.php, for example, containing one variable that holds the URL for the file we want to call. Then we use the php method readfile.

```php
<?php
$dataURL ="http://www.foreignurl/file.xml";
readfile ($dataURL);
?>
```

In the Flash movie we create a new instance of the LoadVars object and the XML object. However, instead of loading an XML file we load the php file using the LoadVars sendAndLoad method, since we are sending data and are waiting to receive data from the server. As the receiving object we use the XML object myXML. Once the file is loaded the XML can be parsed. I have not prepared any special example but later you will have other examples in which the proxy method will be applied.

```
var sendFile:LoadVars = new LoadVars();
var myXML:XML = new XML();
myXML.ignoreWhite = true;
myXML.onLoad = function()
{
  trace(this);
};
sendFile.sendAndLoad("proxy.php", myXML, "POST");
```

InitiateXml.as: from HTTPstatus over onData to onLoad

At this point we are warmed up with AS2 syntax. We know how to write classes and we also know how to load XML files and what kind of problems could occur. However, it would be cumbersome if every time we need to create an XML object we have to write all the lines all over again and need to think about proxy or using the Delegate class. Therefore, we will create our own XML load class, in which we combine all the methods and the Delegate class is by default called. We will name this class InitiateXml and we will add some features in addition to Delegate and proxy. To see the whole script, open the file InitiateXml.as in the Chapter 4—Scripts—Helper folder. Right at the beginning before the class is declared we import the Delegate class. The class path is scripts.helper.InitiateXml because the class will always be located in a folder named Scripts containing a folder named Helper.

```
import mx.utils.Delegate;
class scripts.helper.InitiateXml extends XML
{
  public var defaultXML:XML;
  private static var httpStatus:Number;
```

If you want to have the class in a different folder do not forget to change the class path. We extend the XML class with our new class. You will see how this can be useful. In the sample script there are some variables for text areas; however, these are optional and only for demonstration purposes.

Later we will take them out. The XML object defaultXML is a regular variable and not static, because this would not allow calling several XML files from one movie. The XML object is public, since we need to access it from outside of this class.

The function that we call is "init" and has several parameters, xmlFile for the XML filename; loadFunction, which is the name of the function when we parse the XML file; myClip, which refers to the class from which we call the XML; and proxy, if we need to call a URL from another domain. The variable "myClip" is of data type Object and at this point I should mention that whenever we expect a possible variety of data types we use the data type Object. It covers for several data types such as Function, MovieClip, and others. However, the Object data type should not be used to just bypass correct data typing.

```
public function init (xmlFile:String,
  loadFunction:Function, myClip:Object, proxy:Boolean):Void
{
```

We now create an instance, defaultXML, of the XML object. Since we extended the XML class, we can use "this" to refer to it instead of "new XML()".

```
defaultXML = this;
```

Next we create a function, which allows us to monitor the http status, given as a number, of the XML file, such as 200, if the file was properly loaded, or 404 if an error occurred.

```
defaultXML.onHTTPStatus = function (httpStatus:Number)
{
  this.httpStatus = httpStatus;
};
```

We now pass on all parameters to the next function. We could have continued here without creating a new function, but the script is easier to overlook if we divide it into several units.

```
this.parsXML (xmlFile, loadFunction, myClip, proxy);
}
```

Loading the XML File

We have carried over all the parameters to the function, where we actually load the XML file.

```
private function parsXML (xFile:String, lFunction:Function,
mClip:Object,proxy:Boolean):Void
{
  defaultXML.onData = function (xFile:String):Boolean {
```

The onData event handler is executed when all data is received from the server or when an error has occurred. At this point we can inquire about the http status and we will create some "if" statements to find out.

```
if (this.httpStatus == undefined)
{
  this.httpStatus = null;
  this.httpStatusType = "Error";
}
```

Here we are particularly interested in if the URL we have called was correct. Otherwise we could provide an HTML page, for example, or a trace action, which will be called to report the error.

```
if (this.httpStatus == "404")
{
  //getURL ("Error404.htm");
  this.httpStatusType = "Error";
  trace ("httpStatusType = 404")
}
```

The next line will give us the actual http status. From now on you will always see a trace action when you test a movie and an XML file is called. If there is no trace action, the function was not executed.

```
trace ("httpStatusType: "+this.httpStatus);
```

The variable "xFile", which originally was only the path to the XML file, now holds the XML document data. Try a trace and find out by yourself. If there is XML data, then we can proceed to the onLoad event handler. As you can see we strip off white space here and set onLoad to true. We also use the method parseXML, which will build an XML tree and later facilitate coding. The onLoad event is similar to the onData event and is executed only when the file loading is finished. If anything went wrong and "xFile" is undefined, the script will be terminated at that point.

```
if (xFile != undefined)
{
  this.ignoreWhite = true;
  this.contentType = "text/xml";
  this.parseXML (xFile);
  this.loaded = true;
  this.onLoad ();
}
else
{
  this.loaded = false;
}
};
```

For the onLoad event handler we use the Delegate class to broaden the scope of the function, which is held by the variable "lFunction". This is the function that will parse the XML data. In the

examples later you will see that in fact the "this" word will refer to the class in which it is used and not to the function, since we broadened the scope here using the Delegate class.

```
defaultXML.onLoad = Delegate.create (mClip, lFunction);
```

Finally, we need to load the XML file. Here we distinguish whether we have to load the XML file from the same server (proxy = false) or from another domain (proxy = true). The variable "proxy" is of the data type Boolean.

```
if (proxy)
{
  var sendFile:LoadVars = new LoadVars ();
  sendFile.sendAndLoad ("proxy.php", defaultXML, "POST");
}
else
{
  defaultXML.load (xFile);
}
```

We can now test the class and see if it works properly.

Testing the InitiateXml Class

I have prepared several test files, but I will discuss only one file, which demonstrates how to use the InitiateXml class, since we will use the class throughout this book. The test script, Test_xml.as, is located in the Scripts folder. In the first line we import the InitiateXml class.

```
import scripts.helper.InitiateXml;
```

Then we declare the class Test_xml.

```
class scripts.Test_xml
{
```

We define several variables that we need, such as "iniXml", which is of data type InitiateXml. "myClip" is a MovieClip with the text field myText. I noticed that when I want to format the script using the format button, it will give an error when I use a data type belonging to a class we have created by ourselves, such as the InitiateXml data type. However, testing the script for errors will give the trace, so we know that the script contains no errors. If we eliminate the data type, formatting proceeds. I do not know the reason for that. Therefore, you will find in the .as files that variables with data types for newly created classes have no data type. However, do not get used to this habit, but do it for convenience.

```
public var iniXml:InitiateXml;
private var myText:TextField;
private var myClip:MovieClip;
public function Test_xml ()
{
}
```

We create a function, which we can call from the movie, that has two parameters, the path to the XML file and proxy. We create an instance of the InitiateXml class and trigger the "init" function, which, as you recall, has four parameters. We know myFile and proxy. "loadXML" is the function, which we use to parse the XML data. The "this" word refers to the class object and since we had included the Delegate class, we are now able to refer to any object outside of the "loadXML" function using the "this" word.

```
public function test (myFile:String, proxy:Boolean)
{
  iniXml = new InitiateXml ();
  iniXml.init (myFile, loadXML, this, proxy);
}
```

The "loadXML" function just contains a line of script to display the XML data. The data is held by the variable "defaultXML", which we can access using the variable "iniXml" for the InitiateXml class.

```
private function loadXML ()
{
  _level0.myClip.myText.text = String (iniXml.defaultXML);
  trace ("This"+this);
}
}
```

Now we add a script in the movie (decode_1a.fla) to see if the class works properly. We import the class Test_xml and create an instance of the class. Then we give the two parameters myFile and proxy values and execute the function test from the Test_xml class. When you test the movie you will see the XML data from sample.xml displayed in the text field.

```
import scripts.Test_xml;
var xmlTtest:Test_xml = new Test_xml ();
var myFile:String = "xml_files/sample.xml";
var proxy:Boolean = false;
xmlTtest.test (myFile, proxy);
```

From now on we will use this scheme to load and parse the XML files. I created some other examples, which demonstrate the loading of a file from another domain using proxy. However, if you want to use the proxy method you need to upload all files to your server and select a URL from a different server. There is one example in which several XML files are called, since in our main movie, we will call several XML files simultaneously. And this brings us to the conclusion of this chapter.

5 Parsing XML with AS2

Accessing XML Nodes: The Script

In this chapter we deal with parsing XML data. We use one script for all examples, which will always have the same structure. We import the class InitiateXml to load the XML file. Then we declare the class and the variable "iniXml", which is the instance variable holding the XML data. The data is parsed in the function "loadXML". Only the code within the "loadXML" function will be shown, since apart from the class name everything else will stay the same.

```
import scripts.helper.InitiateXml;
class scripts.Attributes
{
  public var iniXml:InitiateXml;
  public function Attributes ()
  {
  }
  public function test (myFile:String, proxy:Boolean)
  {
    iniXml = new InitiateXml ();
    iniXml.init (myFile, loadXML, this, proxy);
  }
  private function loadXML ()
  {
    //XML parsing code here
  }
}
```

The script in the .fla file should be familiar to you by now, as shown here for Siblings.fla.

```
import scripts.Siblings;
var xmlTtest:Siblings = new Siblings ();
var myFile:String = "xml_files/ sample.xml";
var proxy:Boolean = false;
xmlTtest.test (myFile, proxy);
```

Accessing Nodes

As we discussed earlier, XML data is organized like a family tree with parents and children. This is also reflected in the syntax used to access nodes. As an example we use the XML file shown below.

```
<?xml version="1.0"?>
<text>
  <house id="1">
    <bedroom description="Bedroom: ">3</bedroom>
    <bath description="Bath: ">2</bath>
    <price description="Price: ">239,999</price>
    <built description="Built in: ">1990</built>
    <city description="City: ">North Sacramento</city>
    <image>images/house1.jpg</image>
    <details description="Details: ">null</details>
  </house>
</text>
```

In the following exercise we want to get to the value of the node <built>, which is >1990<. Open the .fla Siblings (Section 1—Chapter 5) and the .as file Siblings.as in the Scripts folder. The XML file has one child node, <text>, which is the first child of the XML object "iniXml.defaultXML". This node is the parent node for the child node <house>. To access these nodes we simply write

```
iniXml.defaultXML.firstChild.firstChild
```

To shorten the script we create a variable:

```
var shortNode:XMLNode = iniXml.defaultXML.firstChild.
 firstChild;
```

To get to the <built> node we need to go first to the first child

```
shortNode.firstChild
```

or the last child

```
shortNode.lastChild
```

of the child node of <house>, which is <bedroom> or <details>. All child nodes of the node <house> are related like brothers and sisters and are called siblings. The <bath> node would be the next sibling of <bedroom> and the <price> node the next sibling of <bath> and so on. The <image> node would be the previous sibling of <details> and the <city> node the previous sibling of <image> and so on. And there we are, we just need to add

```
nextSibling.nextSibling.nextSibling
```

to the end of the previous XML node and we will reach the node <built>, but not yet its node value. The node value is a child node as well. We add

```
firstChild.nodeValue
```

and we have finally reached our goal. We use the same strategy when we approach from the last child. You may have noticed that it can be quite cumbersome to write the exact path to a node that we want to access. We can use a shortcut. All nodes of the child node <house>, to stay with our example, can be summarized by using the term "childNodes", which is of data type Array. As you probably know, members of an array are numbered starting with 0 and can be accessed using square brackets []. The <built> node is the fourth node and therefore all we do is write

```
shortNode.childNodes[3]
```

and then we add

```
firstChild.nodeValue
```

Test the movie Siblings.fla to see the result.

Accessing Attributes

Attributes in XML are used to provide additional information. They belong to nodes and are strings and, therefore, need to be flanked by quotation marks. Because attributes are easier to access than nodes some developers like to create XML files with few nodes and many attributes. I had this habit when I started using XML, but it is not a good habit. One can run into problems quite often, when there is a given XML data structure and we have to adjust the parsing script to this structure. I have avoided using XML files filled with attributes in this book. One particular attribute, id, however, can be very useful as you will see, since using the idMap array we can access any node and its child nodes with an id attribute value. The reason attributes are so easy to access is that we can use the attribute value. As an example file to access a particular attribute, we use again the XML file sample.xml. We want to access the attribute description belonging to the <built> node.

```
<built description="Built in: ">1990</built>
```

First we need to have access to the <built> node. We have already learned how to do that. Then all we do is add the word "attributes" followed by a dot and the name of the attribute.

```
shortNode.childNodes[3].attributes.description
```

We can have multiple attributes in one node, all of which we access the same way. Now you understand why attributes are favored; however, as the definition says, their purpose is not to replace XML nodes.

For Loop

So far we have been looking for only a single node and we have made a number of assumptions; for example, we know the exact position of a node within many child nodes. But what if we need to list all the child nodes, as in a house description for a real estate ad? Of course we can write them out one by one, but that is tedious and requires a large script. We always want to keep a script

small. To cover all child nodes we make use of a "for" loop. In a for loop a condition is repeatedly checked a number of defined times. The for loop works like a counter and usually counting starts from 0 to a certain length, like the length of an array for example. The basic for loop syntax is shown below:

```
var fChild:Array = iniXml.defaultXML.firstChild.firstChild.
 childNodes;
for (var count01 = 0; count01 < fChild.length; count01++)
{
  var detectChild:XMLNode = fChild[count01];
  trace (count01 + ": " +detectChild);
  if (detectChild.nodeName == "built")
  {
    trace ("built: " + detectChild.firstChild.nodeValue);
  }
}
```

First we create a variable for an array, "fChild", which holds all the child nodes of the <house> node. Then we use the for loop and iterate through from 0 up to the length of the array, which is determined by the number of child nodes. It is important here not to count to exactly the length of the array, which is 6 in this case, but to stop just one number before, at 5. The reason is that 0 is also included and from 0 to 5 includes six numbers. Therefore we use the < operator instead of the <= operators. Every iteration increases the value of count01 and a new child node will be listed. If we are interested only in the <built> node we create an "if" statement and ask for the node names. If a node name is identical to the name "built" we ask for the node value of the first child of the child node, which should be >1990< in this case. Using the same strategy we can filter any node in which we are interested.

For In Loop

While the for loop is a counter, the "for in" loop iterates through properties or, as shown in our example, through the elements of an array.

```
var fChild:XMLNode = iniXml.defaultXML.firstChild.
 firstChild.childNodes;
for (var count01 in fChild)
{
  var findChild:XMLNode = fChild[count01];
  trace (count01);
  if (findChild.nodeName == "built")
  {
    trace (findChild.firstChild.nodeValue);
  }
}
```

While count01 in the for loop was of data type Number it is of data type String in the for in loop, but the result will be the same, since the string number is recognized as number in the [] of the array. The trace action for count01, in this example, is 6,5,4,3,2,1,0. Note that members of the array are listed starting from the last member. Open the files For_in.as and For_in.fla, test the movie, and change the script. The for in loop comes in particularly handy when we use the idMap array.

idMap Array

idMap has been introduced with Flash 8 and therefore does not exist in Flash MX2004. idMap will give an error message during compilation of AS2 classes when we use it with regular XML loading scripts. I do not know the reason. However, idMap works properly and without error messages when used in combination with the InitiateXml class. Now you have another reason it was worthwhile to develop this class. What is idMap? idMap is an array that lists all nodes with the attribute id. For a long time developers have been using id as an attribute to identify individual nodes, which can then be detected with a for in loop. By using idMap we can pick up any node, if we know the id number. This is actually a string, since it is in quotation marks, but that, as we know, is fine when we deal with arrays. Check the XML file sample_idMap_2.xml. By using the syntax

```
XMLobject.idMap[number]
```

as shown below,

```
var findChild:XMLNode = iniXml.defaultXML.idMap[2];
trace (findChild);
```

we can get hold of any node in the XML file as long as an XML tree exists and as long as the id value is unique. Test it out by changing the values. In the present example the node with the node name <house> and the id="2" is selected.

Using a for in loop and by iterating through the idMap array we can detect and list any node with an id attribute. In this case the id attribute does not necessarily have to be a number, but can be any string. Open the XML file sample_idMap.xml. There are three child nodes with the node name <house> and two of them have an id attribute, house and 2. Furthermore, one child node with the node name <built> has an id attribute with the value "Built in". Only those nodes that have the attribute id are listed. Its value is not important.

```
for (var count01 in iniXml.defaultXML.idMap)
{
  var findChild:XMLNode = iniXml.defaultXML.idMap[count01];
  trace (findChild);
}
```

count01 as in our previous example iterates through members of the idMap array. Although in this case the nodes with the id="house" and the id="Built in" are also listed, we cannot get hold of them when we use them as identifiers, since we would have to write idMap[house]. This will give an error, since it is not a number. But wait; we can change the syntax and write

```
trace(iniXml.defaultXML.idMap["house"]);
```

and that will give us the correct node. We could also do this with number values, since these are actually strings (idMap["2"]). So we can use any unique string as long as we write the correct syntax. Now you understand how powerful the use of idMap is and how much it facilitates identifying XML nodes.

Parsing XML with Namespaces

XML files with namespaces play a more important role than ever, because they contain unique identifiers. The question is if they are different with regard to parsing from regular XML files. The answer is that basically they are the same but there are a few instances in which we need to be careful and use syntax different from parsing regular XML files. I have prepared an example. Below is the XML file namespace.xml.

```
<?xml version="1.0" encoding="UTF-8"?>
<ag:Agency xmlns:ag="http://www.getyourownhouse.com">
  <hs:Body xmlns:hs="http://www.getyourownhouse.com/
   houses">
    <hs:Description>
      <hs:Built text="Built in ">1990</hs:Built>
      <hs:Location text="Located in ">Sacramento</hs:
       Location>
      <hs:Price text="Price: ">$239,000</hs:Price>
    </hs:Description>
  </hs:Body>
</ag:Agency>
```

Because we are using two different prefixes, ag and hs, we also need two unique URIs. In the example I have tried to cover the whole syntax used for namespace XMLs. Also in this script we try to access the <built> node. All trace results are shown in italics.

```
var shortNode:XMLNode = iniXml.defaultXML.childNodes[0].
 childNodes[0].childNodes[0];
var second_node:XMLNode = shortNode.childNodes[1];
var node_value:String = shortNode.childNodes[1].firstChild.
 nodeValue;
trace ("Node: " + second_node); // Node: <hs:Location
 text="Located in ">Sacramento</hs:Location>
trace ("Node Value: " + node_value); // Node Value:
 Sacramento
trace ("Prefix: " + second_node.prefix); // Prefix: hs
trace ("Prefix: " + shortNode.getPrefixForNamespace
 ("http://www.getyourownhouse.com/houses")); // Prefix: hs
trace ("Namespace: " + shortNode.getNamespaceForPrefix
 ("hs")); // Namespace:
http://www.getyourownhouse.com/houses
```

```
var node_array:Array = shortNode.childNodes;
for (var count01 = 0; count01 < node_array.length;
 count01++)
{
  if (node_array[count01].localName == "Built")
  {
    trace ("Single Node: " + node_array[count01].
     attributes.text + node_array[count01].firstChild.
     nodeValue); // Single Node: Built in 1990
  }
}
```

As you can see we do not search for the node name here, because the node name is <hs:Built>.
We search for the local name, which comes after the prefix hs and is Built. In the chapter on the
combo box component we parse a namespace XML and apply what we have learned here. In the
following chapters we will create individual applications, all of which we put together for the final
real estate Web site. In the next chapter we will learn how to parse a special type of HTML file, the
XHTML.

6 Tutorial: Creating a Universal XHTML Parser

A Simple XML–Text Parser

Our final goal of this chapter is to create a parser for XHTML pages. The parser will recognize the title tag and the style sheet link tag and apply the style sheet and the body tag to set a background color. Of course, the parser will be able to display the text and images from the content within the body tag. However, since this is the first tutorial in which we apply XML methods, we will start with a simpler parser, which will recognize the title tag and set the background color with a defined style sheet. The final parser script will be a few lines longer and will be able to recognize the style sheet link and apply the style sheet to the text. This will allow the application of any style sheet given in an XHTML page. Then all you need is to write the XHTML page using your favorite editor, such as BBedit, Dreamweaver, or just Notepad.

Structure of the XHTML File

Before we actually write the script for the parser we need to look at the file to be parsed, the XHTML file, from the point of view of the Flash player.

```
<?xml version="1.0" encoding="utf-8"?>     XML DECLARATION
<!DOCTYPE ....>                            DOCTYPE
<html>                                     firstChild
<head>                                     firstChild.firstChild

HEAD PART
  <meta />
<title>Title here</title>
  <link rel="stylesheet" href="Stylesheetname.css"
  type="text/css"/>
</head>
<body>                                     firstChild.firstChild.nextSibling
BODY PART
</body>
</html>
```

As we discussed earlier, XHTML is an XML document with HTML content. Therefore, we can apply the same rules as parsing a regular XML document. For the current parser all we need is to

access the body portion of the file, which is "firstChild.firstChild.nextSibling". All other tags within the body tag are child nodes of the <body> node.

The .fla File

In order to see the contents of the XHTML file in a manner similar to a browser window, we need to set up a text field or text area component in the .fla file. Some people don't like to use components because of their higher file size. A text area component will use 40 kb, while a text field will hardly use any bytes. But then we need to add a scrollbar to the text field, which is a component, unless we create our own scrollbar, and the file size will increase again. For this movie we place a text area component on the stage and size it. We click on the text area and from the menu we choose "Modify—convert to symbol", which will place the text area automatically into the newly created MovieClip. We name the MovieClip htmParser. We highlight htmParser in the library and we check the properties in the library menu. We check the "Export for ActionScript" box, and in the AS2 class line we write "scripts.Decodehtm_simple". We do this because we want to extend the MovieClip class with the Decodehtm_simple class. Once we have written the class file and want to test it, we will come back to the .fla file and add the necessary lines in the actions frame in the .fla file to call one or more functions from the class.

The Decodehtm_simple Class

Before we create the .as file we place a folder on stage and name it Scripts. We do this to have all the class files in a separate folder. This makes the movie arrangement easier. Then we open a new ActionScript file, name it Decodehtm_simple.as, and save it within the Scripts folder. Before we start scripting we need to think about the objects that we will need in the movie. At this stage, of course, we do not know every class variable, so we will add those later, but obviously we need variables for:

- The text area component
- The XML file
- The style sheet (CSS)
- Variables to call the InitiateXml class for loading the XML file
- The instance variable "iniXml"
- The instance variable "newXml" for the XML file path/name
- The Boolean variable "proxy"
- The XML class variable "defaultXML"

However, don't worry. If you forgot to declare a variable, the compiler will definitely remind you and you can add it later. Also, some variables are local variables, which we add just when we need them in the function. Looking back we realize that we have to import classes associated with some variables, the TextArea (text area component) and the InitiateXml class (to load the XML file). We also import the Delegate class, since we anticipate that at a later stage there will most probably be a function whose scope needs to be extended. Make it a rule to incorporate the Delegate class, since

we need it most of the time. We do not need the Delegate class within the parsing function, since it was included already in the XML loading class. Now we can write the first code starting with the import statements. We also add the constructor to have everything complete, even if the constructor will stay empty.

```
import mx.controls.TextArea;
import mx.utils.Delegate;
import scripts.helper.InitiateXml;
class scripts.Decodehtm_simple extends MovieClip
{
  private var myText:TextArea;
  public var cssUrl:String;
  public var proxy:Boolean;
  public var newXml:String;
  private var iniXml;
  private var defaultXML:XML;
  public function Decodehtm_simple ()
  {
  }
}
```

Except for variables, which will be called from the movie, we make all variables private to prevent them from being accessed from the movie or from other classes.

The Main Function "xmlLoad"

Now after finishing what I would call the head part of a class script we will write some functions. The first function is the one that we call from the movie. We name it "xmlLoad" and it will have three parameters, cssUrl, to load the style sheet; newXml, to load the XML file; and proxy, in case we want to load external files from a different server. Before we do anything further we set HTML true for the TextArea component instant:

```
this.myText.html = true;
```

Then we load the style sheet, since we have to apply the style sheet onto the text field or text area before the text is loaded and displayed. We have already learned a lot about loading XML files in a previous chapter, so loading a style sheet is similar. We create an instance of the StyleSheet class by creating a local variable, "xmlCss":

```
var xmlCss:TextField.StyleSheet = newTextField.
  StyleSheet ();
```

Now the Delegate class becomes handy, since we can extend the scope of the onLoad event function and access objects outside of the function using the "this" word:

```
xmlCss.onLoad = Delegate.create (this, loadCss);
```

The onLoad event is executed only when the file is downloaded from the server. If a file was downloaded then we apply the style sheet to the text area:

```
function loadCss (success_1:Boolean)
{
  if (success_1)
  {
    this.myText.styleSheet = xmlCss;
  }
  else
  {
    this.myText.text = "Stylesheet not loaded!";
  }
}
xmlCss.load (cssUrl);
```

The next two lines to call the class, which loads and parses the XML file, are familiar to us:

```
iniXml = new InitiateXml ();
iniXml.init (newXml, textLoad, this, proxy);
}
```

"newXml" is the name for the XML file, and "textLoad" is the parsing function; this refers to the MovieClip htmParser and proxy.

Parsing the XML File

We have done all the preparations and now we are ready to parse the XML file. We have already called the function "textLoad" and here we will write it out:

```
private function textLoad ():Void
{
```

We access all the tags we are interested in. These are the <title> and the <body> tags. The title tag is a child of the <head> node. However, in our particular example we have a Meta tag preceding. Therefore, the title tag is the next sibling of the Meta tag. You can foresee one problem here. If there are more tags than only one Meta tag we need to change the way we access the desired tag, but then our parser is no longer universal and cannot parse all XHTML documents. We do not care about that for now, but in the advanced version of the parser we will take care of this issue by using loops.

```
var myTitle:String = iniXml.defaultXML.firstChild.
 firstChild.firstChild.nextSibling.firstChild;
```

If we have a large number of variables that have a portion in common, for example:

```
iniXml.defaultXML.firstChild.firstChild;
```

we would create a shortcut variable, which we reuse for other variables to avoid long text. However, here we have only a small number of variables.

We now access the body tag and the attribute "bgcolor" of the body tag, which will give us the value for the background color:

```
var htmBody:XMLNode = iniXml.defaultXML.firstChild.
 firstChild.nextSibling;
```

There is only one problem. The color attribute value in HTML style is written in this way: #FFFFFF for the color white, for example. The Flash player would not recognize this style but instead recognizes 0xFFFFFF. We, therefore, have to convert the string to match our needs, which we do with some string methods as shown below. We split the string after "#" and leave the six letters as one string. Then we join, which eliminates "#":

```
var bgColor:String = htmBody.attributes.bgcolor;
bgColor = "0x"+(bgColor.split ("#", 6).join (""));
```

We are now ready to set the background color of the text area using the setStyle method:

```
this.myText.setStyle ("backgroundColor", bgColor);
```

To ensure that we are correctly calling the body tag, we add an "if" statement, in which we set the htmBody.nodeName string to lowercase. The tags are not always in small or in capital letters.

```
if (htmBody.nodeName.toLowerCase () == "body")
{
```

Then we display the contents of the body tag in the text area. Since the data type of the variable "htmBody" is XMLNode, we need to convert the data type to a string to match it to the requirements for the text area. We do that by type casting:

```
this.myText.text = String (htmBody);
```

We close the statement by adding a reminder in case the body tag was not found:

```
else
{
    this.myText.text = "Body tag was not found.";
}
```

To test the movie, we need to add a few lines in the .fla file. You can open the file Decodehtm_simple.fla and you will see the following lines, which are familiar to you from the previous chapter:

```
var newXml:String = "test_xhtml.htm"; // XHTML url
var cssUrl:String = "flashbody.css";   // Stylesheet url
```

```
var proxy:Boolean = false;                    // local file
htmParser.xmlLoad (cssUrl, newXml, proxy); // calling the parser
```

Now, test the movie, and do not forget to add a style sheet. If you get too many error messages that do not make any sense, I recommend deleting the ASO cache first and then testing the movie again.

Looping through the XHTML File: The Head Part of the Class

As I mentioned above, the final parser will be able to pull the URL for a style sheet from the XHTML page itself and apply it on the text field/area. This parser will also correctly access all the nodes even if the number of Meta tags varies. Our final movie will look like that in Figure 6.1.

Figure 6.1 *XHTML parser*

We start where we finished, modifying the Decodehtm_simple class. Create a copy of the .as file and name it Decodeallhtm_parser. You need to change the class name and the constructor name accordingly.

The head part is shown below:

```
import mx.controls.TextArea;
import scripts.helper.InitiateXml;
class scripts.Decodeallhtm_parser extends MovieClip
{
  private var myText:TextArea;
```

```
private var titleText:TextArea;              // new
private static var thisText:XMLNode;         // new
public var newXml:String;
public var proxy:Boolean;
private var iniXml:InitiateXml;
private var defaultXML:XML;
private var bgColor:String;                  // new
private static var myClip:MovieClip;         // new
public function Decodeallhtm_parser ()
{
}
```

You may notice that the script is not exactly the same. I have already entered new variables (// new), and I have eliminated those that we do not need any more, such as "cssUrl" as parameter to load the style sheet file. The variable "titleText" is the name of a new TextArea instance for the title, "bgColor" will hold the value for the background color, and "myClip" is just a reference variable. In this script we do not use the Delegate class.

The head part is followed by the constructor, in which we give the reference variable "myClip" a value and the main function to load the XML file. We have only two parameters left: newXml and proxy.

```
public function Decodeallhtm_parser()
{
   myClip = this;
}
public function xmlLoad (newXml, proxy):Void
{
  iniXml = new InitiateXml ();
  iniXml.init (newXml, textLoad, this, proxy);
}
```

We use "myClip" later as a reference variable instead of using the Delegate class. The reason is that we cannot use the Delegate class within a function that is already using the Delegate class. That is the XML parsing function "textLoad".

Next we parse the XHTML file, which is done within the "textLoad" function.

```
private function textLoad ():Void
{
```

The First Loop: Catching the <Body> Node

In the previous class we have called the <title> and <body> nodes by an absolute URL. While this is fine for the <body> node—since the body portion always follows the head—it will cause

problems for the <title> and also the style sheet <link> node, which are children of the <head> node. We can expect other nodes such as <meta> tag nodes and Java scripts, which would interfere by altering the XML tree structure. To bypass this we loop through the XHTML file using "for" loops. It is, however, important to get the <body> node first, since the text needs to be loaded into the text area/field within the "onLoad" function for the style sheet. If the style sheet is loaded after the text from the body of the XHTML file is displayed in the text area, the text will not be formatted.

```
for (var count1 = 0; count1 <
 iniXml.defaultXML.firstChild.childNodes.length;
 count1++)
{
  var foundNode:XMLNode = iniXml.defaultXML.
   firstChild.childNodes[count1];
  if (foundNode.nodeName.toLowerCase ()
   == "body")
  {
    var bgColor:String = "0x" + (foundNode.
     attributes.bgcolor.split ("#", 6).join
     (""));
    thisText = foundNode;
    if (bgColor != undefined)
    {
      this.myText.setStyle ("backgroundColor", Number
       (bgColor));
    }
    else
    {
      this.myText.setStyle ("backgroundColor",
       0xFFFFFF);
    }
  }
}
```

We loop through the child nodes of the first child of the XML object iniXml.defaultXML, to identify the <head> and <body> nodes. We ask for the <body> node name. Then we ask for the bgcolor attribute and we can set the background color as described in the first part of this chapter. We also make sure there will be a background color in case the bgColor attribute for whatever reason is not defined. Next we define the variable "thisText" and give it the value "foundNode", which contains the whole body part and will be the main contents for the text area/field.

The Second Loop: Catching the <Head> Node

Next we focus on the <head> node and, using a second for loop, we loop through the child nodes of the <head> node to find the title of the XHTML file first:

```
if (foundNode.nodeName.toLowerCase () == "head")
{
  for (var count2 = 0; count2 < foundNode.
   childNodes.length; count2++)
  {
    var foundSubnode:XMLNode = foundNode.
     childNodes[count2];
    if (foundSubnode.nodeName.toLowerCase ()
     == "title")
    {
      this.titleText.text = foundSubnode.
       firstChild.nodeValue;
    }
```

We can do it this way because the node name <title> is a defined HTML tag, which will never be different unless there is a spelling mistake. Once we get hold of the <title> node, we can assign the text for the title, which is a child node to the text field titleText.

The other node within the <head> node that we want to target is the <link> node with the href attribute containing the URL for the style sheet:

```
if (foundSubnode.nodeName.toLowerCase () == "link")
{
  var a_href:String = foundSubnode.attributes.href;
```

We create a variable, "a_href", which will hold the URL. Then we can load the style sheet as learned in the previous example. We create a new StyleSheet instance:

```
var xmlCss:TextField.StyleSheet = new TextField.
  StyleSheet ();
```

Using an onLoad event, we assign the style sheet to the text area. Now you see where we need the reference variable "myClip", which refers to the class object, since we need to extend the scope to the outside of the onLoad event function. We cannot use the Delegate class here to achieve the same result, because we used the Delegate class when the XML file was loaded and parsed. You can test this by yourself.

```
xmlCss.onLoad = function (success:Boolean)
{
  if (success)
```

```
    {
      myClip.myText.styleSheet = xmlCss;
      myClip.stsheetStatus.text = a_href;
      myClip.myText.text = thisText;
    }
    else
    {
      myClip.myText.text = thisText;
      myClip.stsheetStatus.text = "not loaded!";
    }
  };
  xmlCss.load (a_href);
```

Since upon completion of the onLoad event the style sheet is downloaded from the server, we can now load the body portion, which is held by the variable "thisText". We need to add the "myClip" variable here as well, since the variable "thisText" cannot be found within the scope of the onLoad event function. In case the style sheet is not loaded, we nevertheless want to see the contents of the XHTML page. This will become important when files are loaded from an external server. The rest of the script is in parentheses to close the function and the class. We should not forget to add some lines in the .fla file, otherwise the script would not be executed. We are using several buttons to call different files, and a typical script is shown below for a component button:

```
  var myButListener_1:Object = new Object ();
  myButListener_1.click = function ()
  {
    var htmFile:String = "test_xhtml.htm";
    var proxy:Boolean = false;
    decoder.xmlLoad (htmFile, proxy);
  };
  but1.addEventListener ("click", myButListener_1);
```

"decoder" is the MovieClip, containing the text field and text area, to which the class is associated. Finally you can test the movie and should see the body of the XHTML page formatted with the style sheet. The .fla file is called decodeallhtm_final.fla. The .fla file Decodehtm_parser.fla is also using the same class. This will be the .fla file, which we use for the final application.

7 XML Server-Side

Introduction

The XML class has methods to send XML data to a server. There are a number of applications, which, however, we are not dealing with in this book. One of the applications is how to create an XML socket connection, which is useful for chat rooms. We will discuss two applications for how to send XML data to a PHP script on the server, where the data is analyzed and XML is sent back to the Flash movie. The first application is a mortgage ad, in which the user can send a request to ask for a quote. The second application is a contact form. We will discuss mainly the mortgage ad in more detail, since the contact form is very similar. The main method that we use is the xmlsendAndLoad method. It would be advantageous for you to know a bit about PHP, although it is not absolutely required. Both applications are part of the real estate Web site (Figure 7.1).

Figure 7.1 *mortgage_ad.fla stage*

Tutorial: Creating a Mortgage Ad

In this tutorial we create a form to request a rate for a mortgage. This form is meant to be an ad. What do we need? We want to know the mortgage amount that a potential client would like to borrow. Then we want to get hold of some of the client's contact information. We ask for phone and e-mail. When you open mortgage_ad.fla you will find some text and one MovieClip, "adClip", which contains three radiobuttons, two input-text areas, one text field, and a Submit button.

The Mortgagequote Class: Declaring Variables

The class script is located in the file Mortgagequote.as. The first lines, including the constructor, are shown below. We first import all the classes that we need. You will notice that we import the RadioButtonGroup class in addition to the RadioButton class. The reason is that we define the Radiobutton group by ActionScript, so that only one radiobutton can be clicked at one time. We also import the Alert class, since we want to alert users if they forget to enter certain information that is required.

```
import mx.controls.TextInput;
import mx.controls.Button;
import mx.controls.RadioButton;
import mx.controls.RadioButtonGroup;
import mx.controls.Alert;
```

The class extends the MovieClip class. The MovieClip to which this class is associated is adClip.

```
class scripts.Mortgagequote extends MovieClip
{
```

We declare a number of variables. Those are mainly for all the objects in the MovieClip. We also declare some other variables, such as "mortValue", which will hold the value obtained from the radiobuttons; "defValues", which is a Boolean; and the reference variable "myClip", which we declare in the constructor. In this class the Delegate class is not very convenient. Instead we use a reference variable, which has a similar function.

```
private var submitBut:Button;
private var phone:TextInput;
private var email:TextInput;
private var mortGroup:RadioButtonGroup;
private var radio_1:RadioButton;
private var radio_2:RadioButton;
private var radio_3:RadioButton;
private var message:TextField;
private var mortValue:String;
private static var defValues:Boolean;
private static var myClip:MovieClip;
//
```

```
public function Mortgagequote ()
{
  myClip = this;
}
```

RadioButton Listener

The first function is to hold the value for the mortgage amount.

```
public function radioInformation ():Void
{
```

We group the radiobuttons by giving each button the same group name. We do that using a "for" loop:

```
for (var count01 = 1; count01 <= 3; count01++)
{
  this["radio_" + count01].groupName = "mortGroup";
}
```

Then we give each button a label:

```
this.radio_1.label = " 0 - $100,000";
this.radio_2.label = " $100,000 - $250,000";
this.radio_3.label = " over $250,000";
```

To retrieve the label we create a listener for the radiobuttons:

```
var radioListener:Object = new Object ();
radioListener.click = function ():String
{
```

We access the individual radiobuttons by referring to their group name:

```
myClip.mortValue = myClip.mortGroup.selection.label;
  return myClip.mortValue;
}
this.mortGroup.addEventListener ("click", radioListener);
}
```

Function to Check Users' Entry

The second function will check if the user has entered all the information that is required in this form, the mortgage amount, the phone number, and an e-mail address. If one of the values is omitted we call the Alert box to remind the user to do so. Of course we cannot check if the user has given the correct information. This function has a return value, "defValues", which is a Boolean. If any of the information has not been entered "defValues" will be false and the execution of the

script will be terminated at that point. The Alert component is triggered by the Alert.show method.

```
private function confirmValues ():Boolean
{
  if (this.mortValue == null)
  {
    Alert.show ("Please select mortgage.", "ERROR:",
     Alert.OK);
    defValues = false;
    return defValues;
  }
  else if (this.phone.text == "")
  {
    Alert.show ("Please enter a phone number.", "ERROR:",
     Alert.OK);
    defValues = false;
    return defValues;
  }
  else if (this.email.text == "")
  {
    Alert.show ("Please enter an Email address.",
     "ERROR:", Alert.OK);
    defValues = false;
    return defValues;
  }
  else
  {
    defValues = true;
    return defValues;
  }
}
```

Submit Function

Next we define the function to send the data to the server:

```
function sendData ():Void
{
```

We restrict the characters for the phone input field to numbers and hyphens.

```
this.phone.restrict = "0-9\\-";
```

We create a listener for the Submit button.

```
var butListener:Object = new Object ();
butListener.click = function ():Void
{
```

From now on we have to use the reference variable "myClip" to access some of the variable values that lie outside of the listener.

```
myClip.confirmValues ();
```

We declare a new XML object for the response from the server, since the response document is an XML document.

```
var resultsXml:XML = new XML ();
resultsXml.ignoreWhite = true;
resultsXml.onLoad = function (success:Boolean)
{
```

We define the Boolean success as an attribute from the incoming XML document. If true, there was no error in parsing the PHP script. We also define "msg", which will hold any incoming message.

```
success = Boolean (this.firstChild.attributes.
 success);
var msg:String = this.firstChild.attributes.msg;
if (success)
{
  myClip.message.text = msg;
}
```

In case there was a failure, the "fail" function in the PHP script will be executed and a different XML document with success set to false will be sent.

```
else
{
  var msg:String = this.firstChild.attributes.error;
  myClip.message.text = "Error: " + msg;
}
};
```

We are ready to send the data to the server. The variable "defValues", a Boolean, is true when all the fields are properly filled out.

```
if (defValues)
{
```

We create an XML document from scratch, which will be sent to the server:

```
var my_xml:XML = new XML ();
my_xml.contentType = "text/xml";
```

The XML document has one node with several attributes, which hold the values that the user has entered. The node is created with the createElement method and added to the XML object using the appendChild method. Before that we add several attributes to the node <newNode>:

```
var newNode:XMLNode = my_xml.createElement
 ("quote");
newNode.attributes["phone"] = myClip.phone.text;
newNode.attributes["email"] = myClip.email.text;
newNode.attributes["mortgage"] = myClip.
 mortValue;
newNode.attributes["message"] = "Thank you for
 contacting Mortgage.com.";
my_xml.appendChild (newNode);
message.text = "Please wait...";
```

We are ready to send the XML document using the sendAndLoad method with the two parameters for the target to send to and the target object for the response, which by itself is an XML object:

```
my_xml.sendAndLoad ("mortgage.php", resultsXml);
      }
   };
   this.submitBut.addEventListener ("click", butListener);
}
```

We need to call functions from the movie. In the .fla file we add the following two lines in frame 1. addClip is the name of the MovieClip that contains all the objects.

```
adClip.radioInformation ();
adClip.sendData ();
```

We are ready to prepare the PHP script.

The PHP Script: mortgage.php

The data that has been sent to the server needs to be parsed. An e-mail message with the data has to be sent to the administrator, and an e-mail message to confirm sending the data and a thank you message have to be sent to the client. One way to do this is to use PHP. It would be an advantage for you to know a very basic syntax of PHP, although we will go through the script step by step. First of all it is important that the order of events does not change. If you change the order, the script will no longer function properly. A PHP script is flanked by an opening (<?) and a closing tag (?>). All variables in PHP start with a $ sign.

```
<?
```

The script, which is located on the server, is of course spatially separated from the Flash movie. Therefore, data will travel from the Flash movie to the script. In the first line we define a new variable,

"$my_xml", which will hold the data encoded in $HTTP_RAW_POST_DATA, which is the data from the Flash movie:

```
$my_xml = $HTTP_RAW_POST_DATA;
```

We start with the function "xml_start", which holds three arguments. $parser is a reference to the XML parser handler, which is automatically called. $name is the root node name of the XML document, in our case "quote". $attribs are the attributes in our XML document.

```
function xml_start($parser, $name, $attribs)
{
```

In this if statement we confirm that the root node name of the incoming XML document is correct. We set it to lowercase (strtolower) to make sure that the letters have all the same case. Then we create variables for all the attributes followed by functions. The last function is "success", which, when executed, will signal that no errors have occurred. The parameter for the "success" function is a message, which is one of the attributes from the XML document.

```
if (strtolower($name)=="quote")
{
  $myPhone = $attribs["PHONE"];
  $myEmail = $attribs["EMAIL"];
  $myMortgage = $attribs["MORTGAGE"];
  $myMessage = $attribs["MESSAGE"];
  sendEmail($myEmail);
  mailAdmin($myEmail, $myPhone, $myMortgage);
  success ($myMessage);
}
}
```

We now define two functions, which send e-mail to the client and the administrator. Both functions use different attributes from the XML document as function arguments. The main executing function is the PHP-defined "mail" function with four parameters. It is important here to add "From:" in front of the sender name, because otherwise no name would be detected and we would see "nobody" as the e-mail sender.

```
function sendEmail($myEmail)
{
  $mailTo = "<$myEmail>";
  $mailFrom = "From: yoursite.com";
  $mailSubject = "Your request for mortgage information...";
  $mailBody = "Dear Customer \n  Thank you for your
    interest. We will get back to you shortly. \n\n
    Regards!\n\n Flashscript.biz";
  mail($mailTo, $mailSubject, $mailBody, $mailFrom);
}
```

```
function mailAdmin($myEmail, $myPhone, $myMortgage)
{
  $mailTo = "John Doe <foo@yoursite.com>";
  $mailFrom = "Mortgage candidate";
  $mailSubject = "Mortgage";
  $mailBody = "Email : $myEmail \nPhone : $myPhone
   \nMortgage : $myMortgage";
  mail($mailTo, $mailSubject, $mailBody, $mailFrom);
}
```

The next function indicates the end of the XML document.

```
function xml_end($parser, $name)
{
}
```

This function creates a new XML parser.

```
$xmlparser = xml_parser_create();
if (!($xmlparser = xml_parser_create()))
{
  fail ("Cannot create parser");
}
```

The next method sets the element handler functions for the XML parser. It is necessary that the functions (see above, xml_start and xml_end) already exist when they are called here. That is why the order in which the functions are placed is important.

```
xml_set_element_handler($xmlparser, " xml_start",
  " xml_end");
```

The method xml_parse () parses an XML document.

```
xml_parse($xmlparser, $my_xml);
```

If the XML document is not parsed, an error is thrown. Otherwise the XML parser is freed.

```
if (!xml_parse($xmlparser, $my_xml))
{
  $reason = xml_error_string(xml_get_error_code($xmlparser));
  $reason .= xml_get_current_line_number($xmlparser);
  fail($reason);
}
else
{
  xml_parser_free($xmlparser);
}
```

The last two functions contain messages in case an error has occurred and the process was terminated (function "fail") or everything was correctly executed (function "success"). The echo statement is caught by the Flash movie and the XML message parsed after the onLoad event has been executed:

```
function fail($erMsg)
{
  echo "<result success=\"false\" error=\"$erMsg\" />";
  exit;
}
function success ($myMessage)
{
  echo "<result success=\"true\" msg=\"$myMessage\" />";
  exit;
}
?>
```

This brings us to the end of this tutorial.

Contact Form

The contact form is very similar to the Mortgage_ad regarding the PHP script and the way data is sent (Figure 7.2). The main difference is the text fields, which we use instead of radiobuttons. The

Figure 7.2 *The contact form stage*

form contains four text-input fields and two buttons for submitting the data and for clearing. Check the Flash files Contactform.fla and ContactForm.as, which are well commented.

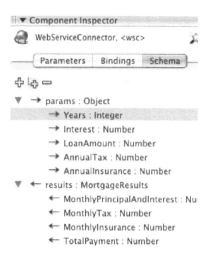

COMPONENTS

02

8 The Menu, MenuBar, and Tree Components

Overview

Section 2 is a special section dealing only with components. I would like to make some comments about components, in particular about some false statements that I often read in forums. Components are, in my opinion, a great tool to facilitate the work of a designer or developer. The main reason is that, with a minimum of ActionScript, they return a maximum of functionality that would otherwise require extensive advanced coding. Some developers do not like components, because the functionality they are aiming at is not perfect or because they prefer a different appearance. The first argument can be true. We also create our own menu bar, because the functionality of the MenuBar component is not satisfactory for our purpose. Regarding appearance/skinning, component skins can easily be changed, as an article from the Adobe Web site shows (http://www.adobe.com/devnet/flash/articles/skinning_fl8_02.html). I often hear another argument against the use of components, that they increase the movie size. This is true if one considers 40 kB a considerable increase in file size. However, if we plan to use more than one component the file size would not increase further. Since Flash MX2004, the components share a common architecture, the V2 structure. Skins, for example, are shared among components as well as a number of methods and properties. Components are also becoming important for when you decide to work with the Flex 2 builder.

The Menu and MenuBar Components

In this first chapter about components we deal with the Menu component; the MenuBar component, which is used in combination with the Menu component; and the Tree component. The Tree component is only related to the Menu components; however, it can be used to create menus with subfolders and individual links. That is the reason it is explained in this chapter. I will not and cannot go into all the details about the components. That is not the task of this book. I have created applications for a number of components, which can be manipulated with XML. Once you are familiar with a component and would like to get further information, you can learn more from the Flash Help files or other tutorials in the Web.

The Menu component is similar to a drop-down menu. The component requires a MovieClip or button to be opened. If you are interested in drop-down menus, then Menu and MenuBar are the components to look at. The MenuBar component alone is not functional. It just provides buttons

to trigger drop-down menus created with the Menu component. The buttons on the MenuBar component can open only menus created with the Menu component. But don't worry, in the main section in which we create the final real estate Web site there is a chapter that shows you how you can create your own menu bar that has more functionality. These are unfortunately limitations of the two menu-related components. But nevertheless they can be useful, in particular to create nice drop-down menus quickly. Both components have one property in common. They can use XML data, which is the reason they are discussed here.

The Tree Component

The Tree component will use an XML file, which can be assigned to a data provider, and a tree-like menu is created. This component can form several levels of submenus, and the component manipulation requires only a minimum of ActionScript. Icons can be added and folders can be set to open at runtime or stay closed until they are opened. The limitation of this component is that it can be used only to create vertical menus.

The Menu Component: Creating a Menu (XML Document)

The Menu component uses the MenuDataProvider class, which has a few methods to add and remove or identify menu items. As I mentioned before, the Menu component works best with a button that triggers the display of the menu. The menu is present when it is created, but hidden. For this tutorial open the folder —Chapter 8—menu and you will find all the required files. We are planning to use the menu to move to different frames in a movie. The XML file keywords.xml, which is used as the data, is shown below.

```
<?xml version="1.0"? encoding="utf-8"?>
<keywords>
  <main>SITE DIRECTORY
    <kword>Home</kword>
    <kword>News</kword>
    <kword>Search</kword>
    <kword>Contact</kword>
  </main>
</keywords>
```

There is a headline and several keywords, which will be the names for the frames.

The Menu_tut Class

We first set up the movie as shown in menu_xml.fla. All we need is a button and a text field to see if the menu works. We do not need extensive ActionScript except to call the class containing all the methods. We import the class Menu_tut, which we are going to write, which will create the

menu. We call a public function of the class with two parameters for the XML file path and the Boolean proxy:

```
import scripts.Menu_tut;
var nMenu = new Menu_tut ();
var newXml:String = "xml_files/keywords.xml";
var proxy:Boolean = false;
nMenu.createmenu (newXml, proxy);
```

Now go to the Scripts folder and open Menu_tut.as, which contains the script. The first part of the script should, by now, be quite familiar to you. We import several classes, including the Menu class, and then declare variables. One of the variables, "myClip", is a reference variable. We need the Button, Menu, and InitiateXml class to load and parse the XML file.

```
import mx.controls.Button;
import mx.controls.Menu;
import scripts.helper.InitiateXml;
class scripts.Menu_tut
{
  private var iniXml;
  private var my_menu:Menu;
  private var menu_button:Button;
  private static var myClip:Object;
  public function Menu_tut ()
  {
    myClip = this;
  }
}
```

We load the XML file and create the menu my_menu using the Menu.createMenu method:

```
public function createmenu (newXml:String,
 proxy:Boolean):Void
{
  my_menu = Menu.createMenu ();
  iniXml = new InitiateXml ();
  iniXml.init (newXml, menuLoad, this, proxy);
```

In the function menuLoad we fill the menu with links, which are the frame names. However, in our menu we have a headline, SITE DIRECTORY, and we do not want this to be a link. We also want an empty space between the headline and the links. Therefore, we need to disable the first two lines in the menu. We create a variable, "menukw", to hold the main part of the XML data, the first child node.

```
function menuLoad ():Void
{
```

We add the node value of the first child of "menukw", which holds the headline, using the menu.addMenuItem method:

```
var menukw:XMLNode = iniXml.defaultXML.firstChild;
my_menu.addMenuItem (menukw.firstChild.firstChild.
 nodeValue);
```

Then we add an empty space (" "). We need to use quotation marks, because the value within the parentheses is of data type String.

```
my_menu.addMenuItem ("");
```

Using the menu.getMenuItemAt (menu position) method we now disable the first two lines:

```
my_menu.getMenuItemAt (0).attributes.enabled = false;
my_menu.getMenuItemAt (1).attributes.enabled = false;
```

Why do we have to use attributes here? We did not define these as attributes originally. The answer is given to you if you do a trace such as "trace(my_menu.getMenuItemAt (0));" after disabling the first line. The trace output will be

```
<menuitem enabled="false" label="SITE DIRECTORY" />
```

When we add the node value using menu.addMenuItem, a new XML node is created when the script is compiled with the attributes enabled and label. The Flash player reads these attributes as ActionScript commands for virtual button components.

Next we add the node names from the XML file that we want to use as links. We do that by using a "for" loop and looping through all the child nodes. We sort the menu to make sure that all nodes are added in the order they are written in the XML file. However, by using an "if" statement we make sure that no undefined items are added:

```
for (var i = 0; i < menukw.firstChild.childNodes.length;
 i++)
{
  var mItem:String = menukw.firstChild.childNodes[i].
   firstChild.nodeValue;
  if (mItem != undefined)
  {
    my_menu.addMenuItem (mItem);
    my_menu.sortItemsBy ("label", "ASC");
  }
}
```

We need to give functionality to the menu by adding a listener:

```
var menuListener:Object = new Object ();
menuListener.change = function (evt_obj:Object)
```

```
  {
    var item_obj:Object = evt_obj.menuItem;
    var selKeyword:String = item_obj.attributes.label;
    _root.myText.text = "_root.gotoAndPlay (" + selKeyword
      + ")";
  };
  my_menu.addEventListener ("change", menuListener);
```

evt_obj.target is the menu and evt_obj.menuItem is an individual node of the newly created XML for the menu. It has to be "menuItem" and not "menuitem", which is the node name of the XML nodes that has been created by the Flash player. As we have seen before, all the newly created nodes have attributes and the label attribute holds the name of the link, such as "contact".

The movie is not yet functional, since we need to make the menu visible with the button. We add a listener for the button component:

```
  var buttonListener:Object = new Object ();
  buttonListener.click = function (evt_obj:Object)
  {
```

The target of the listener is the button:

```
    var my_button:Button = evt_obj.target;
    myClip.my_menu.show (my_button.x, my_button.y +
      my_button.height);
  };
  _root.menu_button.addEventListener ("click",
    buttonListener);
```

We use the menu.show method to make the menu visible. We also need to place it somewhere, and one good place is directly underneath the button. We need to use the reference variable "myClip" here, because "my_menu" is not recognized within the listener. Now the menu movie is ready to be tested.

MenuBar Component: Creating a Menu (XML Document)

Often we need to open several drop-down menus. We could use buttons, as we have learned in the previous tutorial. However, Flash has a much nicer substitute for that, which is the MenuBar component. To start we need to write the XML file for the component. I have deliberately used different node names to demonstrate that the XML node names do not necessarily need to have the same names. We design three drop-down menus, but this time we want to give different functionality to the links of the menus. Some we will code to go to different frames and others to open HTML pages. We add an attribute, type, to the nodes with a value of "frame". This indicates that these links when pressed will be used to move the timeline to another frame.

```xml
<?xml version="1.0"? encoding="utf-8"?>
<menu>
  <mItem label="Site Directory (gotoAndPlay())">
    <mItem label="Home" data="home" type="frame" />
    <mItem label="News" data="news" type="frame" />
    <mItem label="Search Home" data="database"
     type="frame" />
    <mItem label="Contact us" data="mail"
     type="frame" />
  </mItem>
  <menuitem label="Links (getURL())">
    <link label="FlashMX(6)" data="flashmx.html" />
    <link label="FlashMX2004(7)" data="mx2004.html" />
    <link label="Flash 8" data="flash8.html" />
  </menuitem>
  <menuitem label="More links (getURL())">
    <link label="Components" data="components.html" />
    <link label="Snippets" data="snippets.html" />
    <link label="Flash-PHP" data="php.html" />
  </menuitem>
</menu>
```

The Menubar_tut Class

In the following I am not showing the whole script, only the important part of the script, since the first part of this script is similar to the previous script for the Menu component. You can find the whole script in the Chapter 8—Menubar—Scripts folder. We start with the function menuLoad, which follows after the onLoad event of the XML document. We associate the XML node object to the dataProvider of the menu bar. Child nodes in the XML will be used automatically to create menus. The node names are not restricted to a certain name, as I have demonstrated in the above XML.

```
function menuLoad ():Void
{
  _root.gen_menu.dataProvider = iniXml.defaultXML.
  firstChild;
```

One problem that could occur is that the events do not properly execute. I have observed this with other menus. We, therefore, add the AsBroadcaster method here, because we want to make sure that when the menu is opened the data will be present and the menus will not be undefined. The AsBroadcaster is similar to the eventDispatcher method. The variable datProvider, which holds the new XML data created by the menu bar, is the event broadcaster, and the listener add_MenuListener will receive notification when the event is broadcast. This is very useful when events have to proceed

in an ordered manner and one wants to prevent an event from occurring before another event is finished.

```
var datProvider:Object = _root.gen_menu.dataProvider;
var add_MenuListener:Object = new Object ();
add_MenuListener.add_Menu = function ()
{
```

Now we create the listener for the menu bar when a mouse event is triggered:

```
var menuListener:Object = new Object ();
menuListener.change = function (evt_obj:Object)
{
```

We need to distinguish the attributes to have the correct method, gotoAndPlay or getURL, executed. We do this with an "if" statement asking for the attribute value. The variable "myData" will hold the frame name to go to or the URL. The data attributes in the XML file hold the frame names and the URLs.

```
var myData:String = evt_obj.menuItem.attributes.data;
```

We ask whether there is an attribute, type, with a value of "frame". This will include only nodes that have the type attribute. Those are the frame names.

```
if (evt_obj.menuItem.attributes.type == "frame")
{
  _root.message.text = "_root.gotoAndPlay
  (" + myData + ")";
}
else
```

The others are the URLs.

```
{
  _root.message.text = "getURL (" + myData + ")";
}
};
_root.gen_menu.addEventListener ("change", menuListener);
};
```

The variable "datProvider" is the trigger for the AsBroadcaster, while the variable "add_MenuListener" listens to "datProvider" and then executes the function "add_Menu". This makes sure that the function is executed only when "datProvider" is defined.

```
AsBroadcaster.initialize (datProvider);
datProvider.addListener (add_MenuListener);
datProvider.broadcastMessage ("add_Menu");
```

As you can see the MenuBar component is easy to manipulate and does not require any XML parsing.

Tree Component: Creating a Real Estate Display

The next component, which creates menus by directly parsing an XML document, is the Tree component. As we did for the MenuBar component, we assign the XML to a dataProvider. Then the XML data is used by the Flash player to create a new XML document. For this movie, which will be used later for the real estate Web site, we need several text fields or text areas, in which data is displayed, and we use the Loader component to display images. The Loader component is very convenient, because images are automatically resized to the width and height that we set, maintaining the aspect ratio. We also place an instance of the Tree component on stage, but do not size it. Open the treeMenu.fla file in the Treemenu folder to see the movie setup.

XML File

Next we need to write the XML file. Shown below is not the actual XML file but the XML tree structure. To see the actual XML file open the file new.xml in the xml_files folder. The label of the main child node, node, is the label for the main folder, followed by folders created thereafter. The component itself will create folders when there are more child nodes. However, we need to be careful, because we do not want the folders to function as one of the links in the tree menu listener.

```
<?xml version="1.0"? encoding="utf-8"?>
<node>                    // main child node to be used as opening folder
  <sacnode>               // node for subfolders, also used in the script as
                             parent node
    <node1 />             // individual data node
    <node4 />
    <node8 />
  </sacnode>
  <rosenode>
    <node2 />
    <node6 />
  </rosenode>
</node>
```

ActionScript

It is now time to look at the script. Again, as before, I show only the script within the main function in which the XML data is parsed. If you want to see the script as a whole, please check Tree_tut.as in the Scripts folder.

```
function treeLoad ():Void
{
```

We associate the XML data with the tree dataProvider.

```
_root.myTree.dataProvider = iniXml.defaultXML;
```

We set an icon from the movie library in front of the Root folder using the setIcon method. To do this we need to have icons in the library, which are set to "Export for ActionScript".

```
_root.myTree.setIcon (_root.myTree.getTreeNodeAt (0),
  "t_icon");
```

We want the Root folder and the First child folder to be open when the movie is loaded. Therefore, we use the setIsOpen method:

```
_root.myTree.setIsOpen (_root.myTree.getTreeNodeAt (0),
  true);
_root.myTree.setIsOpen (_root.myTree.getTreeNodeAt
  (0).firstChild, true);
}
```

We create a listener for the tree component, which is triggered when any of the links are pressed:

```
var treeListener:Object = new Object ();
treeListener.change = function (evt:Object)
{
```

We need a variable to hold the label of the parent nodes, to get the name of the city later, since there is no separate child node for the name of the city. For that purpose we use the parent node, whose label is the name of the city. This is part of the XML file.

```
<node label="Just on the Market">
<sacnode label="Sacramento">
   <node1 id="1" label="under 300k" data="images/
   house1.jpg" bedroom="3" price="$239,999" built="1990"
   street="3314 Oak" isBranch="true" />
   <node4 id="4" label="apartment" data="images/
   house4.jpg" bedroom="1" price="$56,000" built="1985"
   street="1212 Riverroad" isBranch="true" />
   <node8 id="8" label="luxury" data="images/house8.jpg"
   bedroom="5" price="$693,499" built="1998" street="204
   Westvillage Rd" isBranch="true" />
</sacnode>
```

The node <sacnode> is the parent node and label is the attribute holding the city name.

```
var parentNode:XMLNode = evt.target.selectedItem.
  parentNode.attributes.label;
```

We create a second variable for the same nodes that we use in the "if" statement, because we do not want any of the text fields to be filled when the user presses any of these nodes. This would give undefined, and in all text fields the word "undefined" would appear. This variable is different from "parentNode", since "parentNode" will be used within the "if" statement and will refer to the parent of the node to be pressed. Then "parentNode" refers to the parent of the links.

```
var mainNodelabel:String = evt.target.selectedItem.
 attributes.label;
if (mainNodelabel != "Just on the Market" &&
 mainNodelabel != "Sacramento" && mainNodelabel
 != "Roseville" && mainNodelabel != "Davis")
{
```

All text fields receive data in this case. defText is a text field, which has text when the user presses any of the parent nodes.

```
_root.defText.text = "";
```

"loImag" is the name of the loader component. All others are text fields for the individual child nodes.

```
_root.loImag.contentPath = evt.target.selectedNode.
 attributes.data;
_root.bRoom.text = evt.target.selectedNode.
 attributes.bedroom;
_root.prText.text = evt.target.selectedNode.
 attributes.price;
_root.yBuilt.text = evt.target.selectedNode.
 attributes.built;
_root.wCity.text = parentNode;
_root.wStreet.text = evt.target.selectedNode.
 attributes.street;
}
else
```

When the parent nodes are pressed we want to show a message in the separate text field defText.

```
{
 _root.defText.text = "Open the menu and select a
 city!";
}
};
_root.myTree.addEventListener ("change", treeListener);
```

This now brings us to the end of this chapter. We will deal with these files later when we create the final application.

9 The ComboBox Component

Overview

The ComboBox component is frequently used. It is a pop-up list from which items can be selected. The ComboBox component shares many methods with other components, such as the List component. In the following tutorial we will load an XML file, parse the file, and directly feed to the ComboBox component. When we open the movie for the first time, we will see a label in the combo box upper text field. However, if we now try to get this value without pushing the List button of the ComboBox component, there can be a problem. Data is broadcast only when a label is selected. This label will then move to the top of the list. Theoretically, we could select the top-level label as well, but no user is going to do that. I will show how the label value and the data associated with this initial label can be further used without touching the component.

For the real estate search engine we will need four different menus, one menu each to select

- the city
- the minimum price
- the maximum price, and
- the number of bedrooms

You may ask, now, since the ComboBox component shows data similar to that of a menu component, why not use the MenuBar component. The main reason is that we always want our choice to be seen when we search, which is the case with the ComboBox component, with which the selected items move to the top and are displayed. I have also prepared files using the List component instead of the ComboBox component, which you will find in the Chapter 9 folder. All I have done is use the same script as for the combo box, but replace ComboBox with List and changed the name of the class. That demonstrates that components have very similar structures and functions. Once you have created a class script for one component it will be very easy to modify the script to adjust it to another similar component. We will, however, not discuss the List component further here.

Tutorial: The Multiple-Choice Selection XML File

For this tutorial I have selected an XML file with namespaces, because you need to get familiar with this type of XML display. Except for some specifics, parsing is the same as for regular XML data.

So let's have a look at the XML file. Open the XML file combo.xml in the Chapter 9—xml_files folder. We introduce the prefix "cb" to the first node, the root node. Then we need to add a unique URL. The URL does not actually have to exist but it must be unique. Normally that is the case for the URL of your Web site, where your files are located. Here we assume that getyourownhouse.com is the domain name. Note that we also add id attributes to every parent node. I often do that automatically, because it is really an easy way to identify the corresponding nodes using idMap, as we learned earlier.

```xml
<?xml version="1.0" encoding="UTF-8"?>
<cb:menu xmlns:cb="http://www.getyourownhouse.com">
  <cb:partofCity id="1">
    <cb:North>xml_files/North.xml</cb:North>
    <cb:South>xml_files/South.xml</cb:South>
    <cb:East>xml_files/East.xml</cb:East>
    <cb:West>xml_files/West.xml</cb:West>
  </cb:partofCity>
  <cb:noBedrooms id="2">
    <cb:row1>show all</cb:row1>
    <cb:row2>1</cb:row2>
    <cb:row3>2</cb:row3>
    <cb:row4>3</cb:row4>
    <cb:row5>4</cb:row5>
    <cb:row6>more than 4</cb:row6>
    </cb:noBedrooms>
  <cb:minPrice id="3">
    <cb:row1>0</cb:row1>
    <cb:row2>100000</cb:row2>
    <cb:row3>250000</cb:row3>
    <cb:row4>500000</cb:row4>
  </cb:minPrice>
  <cb:maxPrice id="4">
    <cb:row1>100000</cb:row1>
    <cb:row2>250000</cb:row2>
    <cb:row3>500000</cb:row3>
    <cb:row4>750000</cb:row4>
    <cb:row5>2000000</cb:row5>
  </cb:maxPrice>
</cb:menu>
```

We have four nodes with child nodes for the different combo boxes. We do not use separate XML files for each combo box, because that would require much more scripting and we always try to keep the file number as small as possible. We also use only one class to add data to all combo boxes.

The Movie

Open the movie ComboPack.fla. There are four combo box instances on stage and three text fields and one button. The text fields and the button are only for demonstration purposes and will later be removed in the final application. However, we need some easy way to test if the combo boxes are functional. When you test the movie, press the button before doing anything else and you will see the default value for the XML file. **This is important:** Do not touch the combo box and change its initial value. Now, when you change the city and then press the Default button you will see that the XML name will also change accordingly.

All combo boxes are part of the MovieClip comboPack. Since we have four combo boxes, later it will be easy to just copy and paste the MovieClip comboPack into our final application. Just do not forget to copy and paste the two lines of script, as well, that contain the path to the XML file and activate the ComboBox instances.

```
var menuXml:String = "xml_files/combo.xml";
comboPack.selectSearch (menuXml);
```

We do not need to copy the button script, because it is only for testing purposes. In the first listener function, we make sure that the default XML file name is defined. We call the variable "myCityXml", using the class name SelectCombo, because myCityXml is a static variable (see class SelectCombo). Later when we prepare our final application we will do the same, when we need the name for the XML file.

```
import scripts.SelectCombo;
import mx.controls.Button;
var defaultBut:Button;
var defListener:Object = new Object ();
defListener.click = function ()
{
   defaultText.text = SelectCombo.myCityXml;
};
defaultBut.addEventListener ("click", defListener);
```

When we test the movie we will get a value for the default settings.

Class SelectCombo

We now prepare the script for the class SelectCombo, which adds functionality to the combo boxes. This script contains a number of repetitive lines, because we need to repeat all steps for four combo boxes. Therefore, in the following I will explain only the script for one combo box, in which the city is shown, and when a city is selected an XML file will be associated. Shown below are the variables, which we need to make the ComboBox instance partofCity functional. **Note:** Two variables are static, because we want them available through the whole script. We want only

one value associated with them and we need to be able to call them from another class. The variable "myCity" holds the name of the city and "myCityXml" holds the URL for the XML file.

```
private var partofCity:ComboBox;
public static var myCity:String;
public static var myCityXml:String;
private var cityDefault:String;
```

The next part is to add data to the combo box. We create a local variable, "selCity", which will hold the child node with id=1, which contains child nodes with local names for the city and node values for the XML files (<cb:North>xml_files/North.xml</cb:North>). You can now see how handy the idMap array is, since we can access the whole node in one piece:

```
var selCity:XMLNode = com.defaultXML.idMap[1];
```

Using a "for" loop we loop through the child nodes of this node:

```
for (var count01 = 0; count01 < selCity.childNodes.length;
count01++)
{
```

We set the default value, which is the node value of the first node:

```
cityDefault = selCity.childNodes[0].
  firstChild.nodeValue;
```

Then we create local variables, which hold values for the label and data. We can use the same name as for the static variables, because these local variables will exist only within this function. **Note:** To get the name of the city we need to ask for the local name and not the node name, which would be cb:Davis, for example, since the XML file contains namespaces.

```
var cityXML:String = selCity.childNodes[count01].
  firstChild.nodeValue;
var myCity:String = selCity.childNodes[count01].
  localName;
```

We use the addItem method, which is common among many list-type components. As we are used to adding values to an array, we now add the label and data values to the combo box:

```
this.partofCity.addItem ({label:myCity, data:cityXML});
}
```

We need to use the "this" word, since originally our class extends the MovieClip class and "this" refers to the MovieClip comboPack, where all the combo boxes are located.

We then write two functions to add functionality to the combo box, (1) when the user selects an item (selectCity) and (2) to set the default value (defaultCity).

```
this.selectCity ();
this.defaultCity (cityDefault);
```

We first focus on the function "selectCity" to select an item from the menu, in this case a city name:

```
private function selectCity ():Void
{
```

We create a listener for the combo box. We need to change two values, the name of the city, which will be displayed in the text field of the combo box, and the name and path for the XML file. We use cityObj.target.selectedItem.label, which is the item selected by the user. Associated with it is the data value. Since both variables are public and static, their values will now be available everywhere in the script and can also be accessed from another class.

```
var cityListener:Object = new Object ();
cityListener.change = function (cityObj:Object):String
{
  myCity = cityObj.target.selectedItem.label;
  myCityXml = cityObj.target.selectedItem.data;
};
this.partofCity.addEventListener ("change",
  cityListener);
}
```

The second function will set the default value in case the user did not change the initial value when the movie was loaded. As a return value we now add String instead of Void, because the function contains a return statement, and the return value is of data type String.

```
private function defaultCity (cityDefault):String
{
  if (myCityXml == undefined)
  {
    myCityXml = cityDefault;
    return myCityXml;
  }
}
```

We create similar functions for all other combo boxes. There is only one difference. For the other values, such as the bedroom and minimum and maximum price, we need only the labels in the final application for the search engine, since there are no specific data values associated.

10 Connector Components

Overview: XMLConnector

We will discuss two connector components, the XMLConnector and the WebServiceConnector. Both components have a common duty, to receive or send data in the form of XML, which can then be further manipulated by connecting to other components. Both components are not visible on stage, since their only task is to process XML and connect to other components. When XML data is received you can see the display of the XML structure as shown in Figure 10.1 for the XMLConnector. Your task is then to decide to which components you will connect. Open Chapter 10—XMLConnector—xml_files—justsold.xml. It is an XML file with namespaces. I have selected a file with namespaces to show you that it does not matter whether the XML file has namespaces or is a regular XML file.

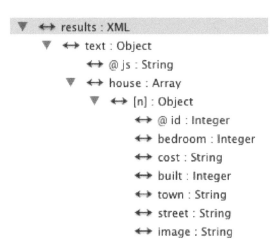

Figure 10.1 *XML schema*

If you look at Figure 10.1 you will see the analysis of the XML file. The analysis shows the data types, such as Array, String, and Integer or just Object. The @ sign indicates attributes. To create an application with the XMLConnector you do not need much ActionScript knowledge. The same is also true for the WebServiceConnector, which functions in a similar way. However, you can also create an

application with the XMLConnector using the XMLConnector class. If you look at the ActionScript it reminds you of what you see in the property inspector when you click on an XMLConnector instance, such as XMLConnector.ignoreWhite, direction, suppressInvalidCalls, or URL.

Tutorial: Creating a Real Estate Display with the XMLConnector

In this tutorial we create an application with the XMLConnector component in a way that you will often encounter when you need to manipulate data. Part of the XML file for this tutorial is shown below.

```
<?xml version="1.0" encoding="UTF-8"?>
<js:text xmlns:js="http://www.getyourownhouse.com/
 justsold.xml">
  <js:house id="1">
    <js:bedroom>3</js:bedroom>
    <js:cost>$239,999</js:cost>
    <js:built>1990</js:built>
    <js:town>Sacramento</js:town>
    <js:street>3314 Oak</js:street>
    <js:image>images/house1.jpg</js:image>
  </js:house>
  <js:house id="2">
    <js:bedroom>2</js:bedroom>
    <js:cost>$139,999</js:cost>
    <js:built>1982</js:built>
    <js:town>Roseville</js:town>
    <js:street>118 Citystreet</js:street>
    <js:image>images/house2.jpg</js:image>
  </js:house>
  <js:house id="3">
```

The file has eight child nodes with the local name house. Each child node has six child nodes with different local names. The prefix here is the same for all nodes and is "js". If you go back to Figure 10.1 you will see that house is of data type Array, because there are eight nodes with the same local name house. What would happen if we change each local name to house1, house2, etc.? The result is shown in Figure 10.2. house1, house2, etc., are now objects and we do not have any array any more. Does that give us an advantage? Most probably not, because the fact that we have an array of nodes allows us to select a list-type component such as a ComboBox or List component, which would list each <house> node as a link. Therefore, it is very important that you plan beforehand how you design your XML file, which components you choose, etc., unless you have no choice because the XML file is predetermined.

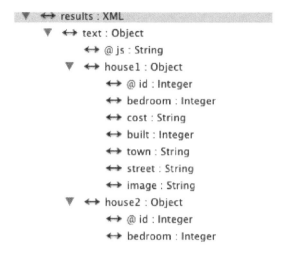

Figure 10.2 *Changing local names for house*

Connecting the XML to Components

In the following we will walk through step by step to create the application. Open the starter.fla file, which has all the components that we need. Open the components panel and drag an instance of the XMLConnector on stage and place it somewhere outside of the movie stage. Open the Windows—Component inspector and click on the XMLConnector on stage. Under Parameters enter the path to the XML file, which is xml_files/justsold.xml. Click on Direction and select Receive, since we are only receiving and not sending any data. Now click on Schema and you will see something like in Figure 10.3. Click on the little window to which the arrow points and a drop-down menu will appear as in Figure 10.4. Highlight Import XML Schema. This will open a window in which you can select a file.

Select the XML file justsold.xml. You will then see the structure of the XML tree and the node analysis as shown in Figure 10.5. Note that the read only property has automatically changed from

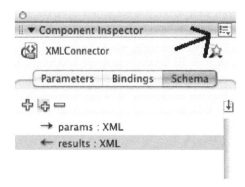

Figure 10.3 *Schema display*

Figure 10.4 *Import XML schema*

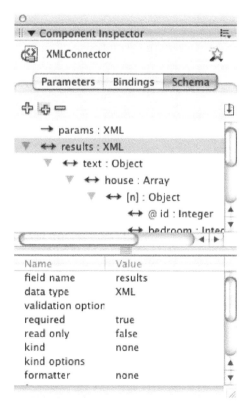

Figure 10.5 *Schema of justsold XML data*

true to false when you click on results. Now that we have the structure analysis of the XML tree and data we understand much better why we select certain components. We have eight parent nodes with the name house. We want to click on a link and then see an image of the house and its description. We, therefore, need a ComboBox or List component listing the nodes. I have selected a List component for this example. Then we have images that we want to display. I have selected a Loader component, because no matter how large the images are they will be automatically resized. For the child nodes, which contain all the data that we want to show, we use TextArea component instances. Before we forget, we need to give the XMLConnector a name in the property inspector. Otherwise we will be reminded later to do that. We name the connector xmlCon. We can now add one line of ActionScript on the main timeline, which is required for the connector to function. Create a new frame and add "this.xmlConn.trigger ();". We are ready to bind the XML data to the individual components.

Binding of List Component to the XMLConnector

It is important that we bind data to the components in the correct order. The first items are the nodes and child nodes of <house>. Click on the XMLConnector and Binding and then press the "+" operator. A separate window will open, which shows the schema as in Figure 10.1 or 10.5. Click on house : Array, which triggers the addition of the line "results.text.house" under Bindings (Figure 10.6). Next click on direction and select out. To bind to a component click on bound to and a new window will open as shown in Figure 10.7. Select List and for schema select

Figure 10.6 *Binding to components*

Figure 10.7 *Binding the List component to the XML data*

dataProvider. We will now examine what we have done and how the XML data is shown in the List component on stage when we test the movie. We see all the child nodes of each <house> node. However, we would consider this raw data and, of course, this is not what we want, since users cannot do anything with this information. To display actual links that make sense to users, we select one node that has the node value we want to show. For example, in our case we want to show the town where the house is located listed in the List component.

We click on formatter (Figure 10.6) and select Rearrange Fields. Then we click on formatter option and an empty text box pops up. We write "label=town". The word "label" is used by the component as the node label. When you check the XML file, the node name containing the name of the city is "town". The prefix "js" is neglected. We could have selected "bedroom" as the label. Then the number of bedrooms for each house would be shown. However, it does not make much sense. It is essential that you do not leave any spaces. "label=town" is correct, but not "label = town".

Binding of TextArea Instances to the List Component

We now have to bind the data from the List component to the text areas. We will start with "bedroom". Under Bindings click on the "+" operator and when the window with the schema appears, select bedroom. You will see something like

```
results.text.house.[n].bedroom
```

In the window, select direction out and click on bound to, then select TextArea <bRoom>. We now need to connect the text area instance to the List component. Click on Index for "house" and select the List component in the window. Then select "selectedIndex: number". When you test the movie now and press on one of the city links in the List component window the number of bedrooms will be shown. Now you can add all the other components in the same way. There is only one component that is slightly different and that is the Loader component. When we click on the component we select the line "contentPath: String". Now you can test the movie and it is the final version that we aimed at.

Overview: WebServiceConnector

Web services in Flash follow SOAP (Simple Object Access Protocol). All Web service URLs have the ending wsdl. There are two ways to load and see the schema of a Web service, by using the WebServiceConnector component or by opening a window under Window—Other Panels—Web Services. Just press the Add (+) button and add the Web service URL. After a short break, during which a connection to the Web service is created, you will see a menu (Figure 10.8). By clicking on the folders a drop-down list of parameters is displayed. An arrow to the right indicates the data to be sent and an arrow to the left indicates the data to be received. You will see a similar display when you call the URL from the WebServiceConnector component. As with the XMLConnector the most difficult part is to decide which components you will use to connect to the service. Web services can also be created using the WebService class and related classes such as the PendingCall or the SOAPCall class.

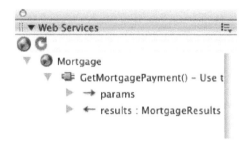

Figure 10.8 *Web Services window*

Creating a Mortgage Calculator with the WebServiceConnector: Connecting to the Web Service

Before we jump into the tutorial I would like to mention and thank WebserviceX.NET, since we are using their service for the Mortgage calculator. Using the WebServiceConnector component is similar to using the XMLConnector component. XML data is received by the component and evaluated. To add a Web service, open the Web service window as shown in Figure 10.8. Click on the blue circle, which opens a new window, and enter the URL for the Web service in this window by pressing the "+" operator. A menu as shown in Figure 10.9 will appear. Open the drop-down menus by clicking on the arrowheads. Click on GetMortgagePayment() and in the very right corner of the window open the menu and select Add Method Call. This signals that an instance of the WebServiceConnector component is placed on stage and the empty lines in the property inspector will be automatically filled with the URL and method. We need to give a name to the component, such as "wsc". In the property inspector click on Schema and you will see the analysis of the incoming XML data (Figure 10.9). There are five data parameters whose direction is toward the connector (in) and four results items whose direction is from the connector to the components (out), which will display the results. Since we need to

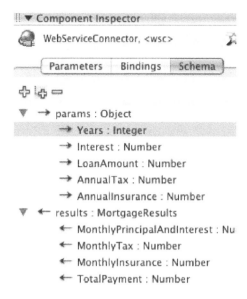

Figure 10.9 *XML analysis*

type something into a text field, we select the TextInput component for the in direction and the TextArea component for the out direction. And once we have decided this, the rest is very simple. Click on the connector component instance wsc and in the property inspector select Bindings. Then press the "+" operator. Select years, which will be added in the property inspector as "params.Years". Automatically the direction will be set to "in". Now press bound to and a new window will open with all the component instances. Select TextInput <Years> and it is done. Repeat this procedure with all other parameters and results. Since we have given similar names to the component instances it is easy to recognize which instances we select.

Adding Function to the WebServiceConnector

We now have to give functionality by triggering the WebServiceConnector. Doing that is simple, as shown by the script below, in which we use a button to trigger the event.

```
var listener:Object = new Object ();
listener.click = function ()
{
  wsc.trigger ();
}
triggerBut.addEventListener ("click", listener);
```

When you test the movie you will notice that the numbers displayed in the Results section are not rounded. This does not look nice and, therefore, we need to write a script to round up the numbers.

This is a little bit more complex. In the following script we also format the components. First we import the classes:

```
import mx.data.components.WebServiceConnector;
import mx.controls.TextArea;
import mx.controls.TextInput;
import mx.controls.Button;
import mx.controls.Alert;
import mx.utils.Delegate;
```

Then we create variables for all the objects on stage, first the connector:

```
var wsc:WebServiceConnector;
```

These are the variables for the TextInput fields. We restrict the input to numbers only:

```
var Years:TextInput;
Years.restrict = "0-9";
var Interest:TextInput;
Interest.restrict = "0-9";
var LoanAmount:TextInput;
LoanAmount.restrict = "0-9";
var AnnualTax:TextInput;
AnnualTax.restrict = "0-9";
var AnnualInsurance:TextInput;
AnnualInsurance.restrict = "0-9";
```

Variables for the TextArea component instances and a button follow:

```
var princAndinterest:TextArea;
var monthlyTax:TextArea;
var monthlyInsurance:TextArea;
var totalPayment:TextArea;
var myMessage:TextArea;
var triggerBut:Button;
```

We now create the script for the Submit button. We use a listener, since we use a button component. The event trigger for the button is "click". We also use the Delegate class to facilitate referring to all objects outside the scope of the function using "this".

```
var listener:Object = new Object ();
listener.click = Delegate.create (this, submitFunction);
function submitFunction ()
{
```

To prevent a TextInput field not being filled out we create a safeguard. If an input field is empty when the Submit button is pressed, an alert window will appear. We use the "switch" function for that, since we have several TextInput fields. We also have an alert icon in the library, which we show with the Alert window.

```
switch ("")
{
case this.Years.text :
  Alert.show ("Enter number of years!", "ERROR:", flags,
    parent, clickHandler, "alertIcon", defaultButton);
  return Years.text;
  break;
case Interest.text :
  Alert.show ("Enter Interest!", "ERROR:", flags, parent,
    clickHandler, "alertIcon", defaultButton);
  return Interest.text;
  break;
case LoanAmount.text :
  Alert.show ("Enter LoanAmount!", "ERROR:", flags,
    parent, clickHandler, "alertIcon", defaultButton);
  return LoanAmount.text;
  break;
case AnnualTax.text :
  Alert.show ("Enter AnnualTax!", "ERROR:", flags, parent,
    clickHandler, "alertIcon", defaultButton);
  return AnnualTax.text;
  break;
case AnnualInsurance.text :
  Alert.show ("Enter AnnualInsurance!", "ERROR:", flags,
    parent, clickHandler, "alertIcon", defaultButton);
  return AnnualInsurance.text;
  break;
```

When all fields have been filled out, the "default" action will be executed, which allows further processing of the script.

```
default :
  myMessage.text = "Proceeding...";
  break;
}
```

We now trigger the WebServiceConnector:

```
wsc.trigger ();
```

However, we set the text color of each TextArea instance that will display results to white to prevent the user from seeing the original numbers, which have to be further processed. Although this is only the case for a short moment, it would look ugly.

```
princAndinterest.setStyle ("color", 0xFFFFFF);
monthlyTax.setStyle ("color", 0xFFFFFF);
monthlyInsurance.setStyle ("color", 0xFFFFFF);
totalPayment.setStyle ("color", 0xFFFFFF);
```

We use the event broadcaster and together with setInterval we achieve a short delay to convert the numbers. This ensures that the display of the final numbers does not occur before the numbers have come back from the Web service.

We create a new object, myLoadedVar, which is the event broadcaster:

```
var myLoadedVar:Object = new Object ();
```

Then we need to create a listener:

```
var myListener:Object = new Object ();
```

Using the listener object we create a variable, "traceVar", for the "setInterval" function.

We allow about 1 second for the interval, which is more than sufficient for the event to occur. We initiate the broadcaster with a variable ("myLoadedVar"). The variable, "myListener", will listen to an event. The event is triggered by the variable "traceVar", which holds the "setInterval" function. Within the function we place an "if" statement, which monitors the event. In our case this is the return of a value for one of the text areas (totalPayment). This is optional and depends on what we want.

```
myListener.traceVar = setInterval (Delegate.create (this,
  resultListener), 1000);
function resultListener ()
{
  if (totalPayment.text != "")
  {
```

Once the event has occurred we round the numbers, which we originally intended. We use a static function, the "round" function. Since you are now familiar with AS2 you realize that "round" must be a static function because it is called over the Math class. We need to cast the value of all the text areas, because the values are strings, but we need to convert them to numbers as shown below. We do that for all text areas:

```
var pai:Number = Number (princAndinterest.text);
pai = Math.round (pai);
var mt:Number = Number (monthlyTax.text);
mt = Math.round (mt);
var mi:Number = Number (monthlyInsurance.text);
```

```
mi = Math.round (mi);
var tp:Number = Number (totalPayment.text);
tp = Math.round (tp);
```

Then we display the new values in the text areas and since we are dealing with dollar amounts we add "$":

```
princAndinterest.text = "$" + String (pai);
monthlyTax.text = "$" + String (mt);
monthlyInsurance.text = "$" + String (mi);
totalPayment.text = "$" + String (tp);
```

Now we can change the color of the text back to black and we can see the values:

```
princAndinterest.setStyle ("color", 0x000000);
monthlyTax.setStyle ("color", 0x000000);
monthlyInsurance.setStyle ("color", 0x000000);
totalPayment.setStyle ("color", 0x000000);
```

Then we clear the interval and indicate in a message that it is done:

```
clearInterval (myListener.traceVar);
myMessage.text = "Done";
}
else
{
myMessage.text = "Proceeding...";
}
}
```

The following lines call the AsBroadcaster class:

```
AsBroadcaster.initialize (myLoadedVar);
myLoadedVar.addListener (myListener); // Registers
 myListener as listener
myLoadedVar.broadcastMessage ("traceVar"); // Broadcasts
  "traceVar".
}
this.triggerBut.addEventListener ("click", listener);
```

Now you can test the movie and see if you have done everything correctly.

11 Creating an RSS Feed Reader

Analyzing a Commercial XML

RSS feeds have become very popular as tools for organizations that have continuously updatable information, such as newspapers or databases. An RSS feed is an XML document that provides short descriptions of news content together with a link to the full version of the content. RSS stands for Really Simple Syndication. While the structures of RSS feeds are very similar, there are slight differences, which have to be adjusted when a reader is developed. For this tutorial I have picked up a typical RSS feed, and our task now is to decipher all the information contained in it.

Let's first have a look at the basic structure of this feed. There is the XML declaration, because RSS is an XML document. Then follows the RSS version declaration. The currently most updated version is 2.0. The version determines the node names. However, some nodes are optional and that makes the difference between RSS feeds with the same version number. The child nodes flank the <channel> node. The <title>, <link>, and <description> nodes are all mandatory child nodes. All other child nodes are optional. Only some of the child nodes are shown here. A channel may contain any number of <item> nodes. The <item> node contains a <title>, a <description>, and a <link> and some additional optional nodes. The <author> node is an e-mail address to the author of the article. I would like to mention the <guid> node, which may have an attribute, "isPermalink", which when true is a URL that can be opened in a browser. Usually, the <guid> node just contains a unique identifier URL. The <guid> node can be used as a forwarding URL to some advertisement, for example:

```
<?xml version="1.0" encoding="ISO-8859-1"?>
<rss version="2.0">
  <channel>
    <title>XML for Designers</title>
    <link>http://www.flashscript.biz/</link>
    <description />
    <copyright>Copyright GetYourOwnHouse.com</copyright>
    <language>en-us</language>
    <lastBuildDate>Jan 11 2007 08:10:05 PCT</lastBuildDate>
    <image>
      <url>http://flashscript.biz/book/images/booklogo.
      gif</url>
```

```
      <title>XML for Designers</title>
      <link>http://flashscript.biz/book/RSSfeed/rssfeed.
       xml</link>
    </image>
    <item>
      <title> Chapter 1 XML Introduction</title>
      <link>http://www.flashscript.biz/book/chapter1.
       html</link>
      <description>Introduction to XML with examples.
       </description>
      <author>email here (or name)</author>
        <guid isPermaLink="true">http://www.focalpress.
         com</guid>
      <pubDate>Sun, 11 Jan 2007 00:00:00 PCT</pubDate>
    </item>
  </channel>
</rss>
```

There is an excellent article about RSS feeds at http://blogs.law.harvard.edu/tech/rss.

Movie Organization

When we create an RSS feed reader the question is how to organize the movie. We need some kind of header to show a logo and indicate what the RSS is about. This information is contained in the RSS itself (Figure 11.1) in the first <title> tag and within the <image> node. The logo is usually the <url> text node. Other useful information that we want to show is the copyright and the date when the information was last updated.

XML for Designers

Date	Author	Title	Description	
Sun, 11 Jun 2006 00:00:00 EDT	email (or name)	Chapter 1 XML Introduction	Introduction to XML with examples	
Sun, 11 Jun 2006 00:00:00 EDT	email (or name)	Chapter 2 ActionScript 2 revisited	Crash course in ActionScript 2, building classes.	
Sun, 11 Jun 2006 00:00:00 EDT	email (or name)	Chapter 3 XML and XMLNode Classes	Listing of all properties and methods.	

Last updated: Jan 11 2007 08:10:05 PCT Copyright GetYourOwnHouse.com

Figure 11.1 *The RSS feed movie*

We create a MovieClip, "rssFeed", in which we place all other objects. Inside this MovieClip, we place another MovieClip, which we name "header" and which contains the TextField for the headline and some background shape. Further, we place a DataGrid component instance, because the DataGrid component is most suitable to display all the data in form of a table. At the bottom there are two TextFields for the update date and the copyright. Check the .fla file in the folder Chapter 11. We place an instance of rssFeed on the stage and name it "myFeed". We need to create three more MovieClips, which will stay in the library. We name them "MultiLineCell" and "MultiLineCell_2" and "MultiLineHeader". All MovieClips will have a class path to the corresponding cell-renderer classes located in the Scripts.helper folder. MultiLineHeader is a class that we create for the header.

Introducing the DataGrid Component

Before going into the script I want to describe the DataGrid component a bit more, since this the core of the RSS feed. This component acts like a table with rows and cells and headers. The source for feeding the component, the DataProvider, is an array. So when we parse the XML document we create variables for all text nodes, which will be stored in an array. We can store several items in one member of the array and they will all have their own column and header. A feature of the DataGrid is that we can size the columns and row heights and use a row or cell as buttons for links, for example. In our example we will have one cell for sending an e-mail and another cell for opening a JavaScript window with an HTML file. The DataGrid component requires a second script to render the cells, which is called by a MovieClip in the library and is the cellRenderer property of the DataGrid. We use a simple script provided in the Flash 8 Help files; however, in our example we add a second script, because we want to have different text properties in some of the cells.

The RSS Feed Script: Variables and Classes

We start the script by importing several classes. Some classes are unfamiliar. One of them (ExternalInterface) is needed to open the JavaScript window, and three other unfamiliar classes (MultiLineCell, MultiLineCell_2, MultiLineHeader) are needed to render the cells from the DataGrid.

```
import mx.utils.Delegate;
import flash.external.ExternalInterface;
import scripts.helper.MultiLineCell;
import scripts.helper.MultiLineCell _2;
import scripts.helper.MultiLineHeader;
import scripts.helper.InitiateXml;
```

We are declaring the class and extending the MovieClip class. So don't forget to add the class path in the library to the rssFeed MovieClip symbol.

```
class scripts.RSSFeed extends MovieClip
{
```

We are declaring a number of variables for the TextFields, the DataGrid component, the header inside the rssFeed MovieClip, and then for the XML parsing and finally two array variables for the DataProvider and one array. We also need a reference variable.

```
private var searchItems:TextField;
private var cRight:TextField;
private var lBuilt:TextField;
public var myGrid_dg:mx.controls.DataGrid;
private var header:MovieClip;
public var iXML;
private var xmlFile:String;
private static var myDP:Array;
private static var myData:Array;
private static var myClip:MovieClip;
```

The Constructor

We initiate some settings in the constructor such as creating instances of the arrays. We also set some styles for the DataGrid component using the setStyle method. Styles for the cells will be set separately later.

```
public function RSSFeed ()
{
  myClip = this;
  this.searchItems.html = true;
  this.myGrid_dg.vScrollPolicy = "auto";
  this.myGrid_dg.setStyle ("backgroundColor", 0xFFFFFF);
  this.myGrid_dg.setStyle ("fontSize", 11);
  myDP = new Array ();
  myData = new Array ();
}
```

This first function to call the XML data, or in this case the RSS data, is by now familiar to us.

```
public function init (xmlFile:String, proxy:Boolean):Void
{
  iXML = new InitiateXml ();
  iXML.init (xmlFile, parseFeed, this, proxy);
}
```

The Header of the RSS Feed

When all XML data is received we execute the parseFeed function:

```
private function parseFeed ():Void
{
```

First we create a shortcut to avoid writing the XML node again and again.

```
var shortCut:XMLNode = iXML.defaultXML.firstChild.
  firstChild;
```

We focus on the first child nodes, which cover the copyright, the last update, and the information in the header. Therefore, we call node values from individual child nodes and, in case of text, associate the values with the corresponding TextField instances.

```
var copyRight:String = shortCut.childNodes[3].
  firstChild.nodeValue;
this.cRight.text = copyRight;
var lastBuilt:String = shortCut.childNodes[5].
  firstChild.nodeValue;
this.lBuilt.text = "Last updated:  " + lastBuilt;
```

For the logo we simply create a new MovieClip, myLogo, within the header, which will be automatically placed in the upper left corner of the header. We load the logo into it.

```
var logoPic:String = shortCut.childNodes[6].firstChild.
  firstChild.nodeValue;
var myLogo:MovieClip = this.header.createEmptyMovieClip
  ("myLogo", this.getNextHighestDepth ());
this.header.myLogo.loadMovie (logoPic);
```

The headline is not only text but also serves as a link. We therefore associate the headline with the URL using "a href".

```
var headLine:String = shortCut.childNodes[6].firstChild.
  nextSibling.firstChild.nodeValue;
var hLineLink:String = shortCut.childNodes[6].
  firstChild.nextSibling.nextSibling.firstChild.
  nodeValue;
this.searchItems.htmlText = "<a href=\"" + hLineLink +
  "\">" + headLine + "</a>" + "\n";
```

Adding Data to the DataGrid Component

We are now ready to actually get the data from the XML document and fill the DataGrid component. First we use a "for" loop to cycle through all of the child nodes:

```
for (var i = 0; i < shortCut.childNodes.length; i++)
{
```

We create another shortcut:

```
var b:XMLNode = shortCut.childNodes[i];
```

Then we get each of the nodes that we need by moving along the tree structure. The <title> is the first node.

```
var myTitle:String = b.firstChild.firstChild.nodeValue;
```

The <description> is one of the siblings of the <title> node.

```
var myDescription:String = b.firstChild.nextSibling.
    nextSibling.firstChild.nodeValue;
```

So is the <author> node, which holds the e-mail information.

```
var myAuthor:String = b.firstChild.nextSibling.
    nextSibling.nextSibling.firstChild.nodeValue;
```

Last we catch the <pubDate> node.

```
var dates:String = b.firstChild.nextSibling.
    nextSibling.nextSibling.nextSibling.firstChild.
    nodeValue;
```

We need to create the DataProvider for the DataGrid component. However, we do not want to include any of the header information. So we need to exclude the header child node, which we achieve by using an "if" statement that excludes the child node that matches the URL for the logo and is part of the header. We could have chosen another sibling of the header child node, but this is one of the possibilities.

```
if (b.firstChild.firstChild != null && myTitle !=
    "http://flashscript.biz/book/images/booklogo.gif")
    {
```

We fill the DataProvider myDP with four different variables, for the publication date, e-mail, title, and description:

```
myDP.addItem ({Date:dates, Email:myAuthor, Title:
    myTitle, Description:myDescription});
```

However, we want to enable the user to click on a title and open a new Web site, but we do not want the URL to be a part of the DataGrid information itself. Therefore, we use a separate array, which we will fill with the links:

```
var links:String = b.firstChild.nextSibling.
    firstChild.nodeValue;
    myData.push (links);
    }
```

We associate the DataGrid dataProvider with the array myDP:

```
this.myGrid_dg.dataProvider = myDP;
    }
```

Formatting the Cells

So far we have only added data to the DataGrid, without formatting any of the data. This will be our next task. We set a row height of 50. We have four columns for the four data parameters. Each column is at a certain position in the dataProvider. The date, for example, is the first member and is therefore at position 0. We set different width values for each column:

```
this.myGrid_dg.rowHeight = 50;
this.myGrid_dg.getColumnAt (0).width = 70;
this.myGrid_dg.getColumnAt (1).width = 130;
this.myGrid_dg.getColumnAt (2).width = 170;
this.myGrid_dg.getColumnAt (3).width = 230;
```

Now we add format to each cell and the header using the cellRenderer property. The class associated with each MovieClip, such as "MultiLineCell", which is the base class to format cells, determines this property. I will not go into the details of this class, but shortly discuss how we can have different properties for each cell. First of all, we create several MovieClips, as many as we need to change individual cells. We want two types of cells and the header. We create three MovieClips. The MultiLineCell class has a function called "createChildren". In this function we add new style properties. In MultiLineCell_2 we add a new font, font size, and font weight. "c" is a variable for the individual cell.

```
c.setStyle ("fontWeight", "bold");
c.setStyle ("fontSize", 11);
c.setStyle ("fontFamily", "Chicago");
```

We make similar changes in the class MultiLineHeader, by which we add background color and choose a different style for the text. The default properties for the DataGrid basic format will be overridden.

```
c.background = true;
c.setStyle("backgroundColor",0xFF9473);
c.border = false;
c.wordWrap = true;
c.setStyle ("fontWeight", "bold");
c.setStyle ("fontSize", 12);
c.setStyle ("fontFamily", "Arial");
c.setStyle ("color", 0x520031);
```

Now we need to apply the style to the individual columns. First we set the Boolean resizableColumns to true:

```
this.myGrid_dg.resizableColumns = true;
```

Then we associate the different columns with the individual classes:

```
this.myGrid_dg.getColumnAt (0).cellRenderer =
  "MultiLineCell";
```

```
this.myGrid_dg.getColumnAt (1).cellRenderer =
  "MultiLineCell";
this.myGrid_dg.getColumnAt (2).cellRenderer =
  "MultiLineCell_2";
this.myGrid_dg.getColumnAt (3).cellRenderer =
  "MultiLineCell";
this.myGrid_dg.getColumnAt (0).headerRenderer =
  "MultiLineHeader";
this.myGrid_dg.getColumnAt (1).headerRenderer =
  "MultiLineHeader";
this.myGrid_dg.getColumnAt (2).headerRenderer =
  "MultiLineHeader";
this.myGrid_dg.getColumnAt (3).headerRenderer =
  "MultiLineHeader";
```

We don't like all the headlines that are automatically created from the dataProvider. Therefore, we alter them here using the property headerText:

```
this.myGrid_dg.getColumnAt (1).headerText = "Press to
  send e-mail";
this.myGrid_dg.getColumnAt (2).headerText = "Title
  (Press to see more)";
```

Adding Functionality

We now need to add functionality to some cells, since we plan to use them as buttons. We use a listener and the method cellPress, which allows listening to a button mode of a single cell.

```
var dgListener:Object = new Object ();
dgListener.cellPress = function (evt_obj:Object)
{
```

We have two cells, which we want to use as buttons. To distinguish between them we use the columnIndex property. Starting with 0, from left to right the e-mail-containing column is 1.

```
if (evt_obj.columnIndex == 1)
{
```

To trigger a send e-mail request we need the e-mail address, which is the second variable in the DataProvider (Email). To open an e-mail window we use the getURL() method.

```
var refString:String = evt_obj.target.selectedItem.
  Email;
trace (refString);
getURL ("mailto:" + refString);
}
```

If any of the other cells are pressed we want to open a new window to show the HTML page, which we accomplish with the "if" statement below:

```
var ci:Number = evt_obj.columnIndex;
if (ci == 0 || ci == 2 || ci == 3)
{
```

We create a variable, "refNumber". To get the correct number for the array member we use "itemIndex", which is the number of a particular row:

```
var refNumber:Number = evt_obj.itemIndex;
```

Then we use the ExternalInterface class, which is new in Flash 8 and also applicable in Flash 9 and replaces the getURL method to communicate with the browser. However, the method will work only when the files are uploaded to the server. It will not work on the local computer hard drive.

```
var newWindow:String;
_level0.newWindow = String (ExternalInterface.call
  ("openWindow", myData[refNumber]));
}
};
this.myGrid_dg.addEventListener ("cellPress",
 dgListener);
```

JavaScript in Browser

To open a new browser window we have to have a JavaScript in the HTML page. Within the head tags of the HTML page we add the script as shown below. We use the window.open method. You can change any of the parameters to alter the size and properties of the new browser window.

```
<SCRIPT language="javascript">
<!--
function openWindow(newWindow){
    window.open(newWindow, "myFile", "height=500,
      width=900, scrollbars=yes, top=0");
}
-->
</SCRIPT>
```

This brings to the conclusion to the component section. In the next chapters we will build our final Web site and create a database.

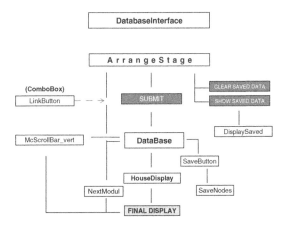

CREATING A REAL ESTATE WEB SITE

12 Creating Your Own Menu Bar

The Difference between Using the MenuBar Component and Creating Your Own Menu Bar

In the final application of the real estate Web site we want to have a multifunctional menu bar, which allows us to jump to other frames and to have individual menus with links. As we have found out, we cannot use the MenuBar component, since buttons on that component will open menus that are created by the Menu component. We would end up with a menu bar that opens only drop-down menus. To accomplish our goal we need to create our own menu bar as shown in Figure 12.1. First we have to design the XML file, which will contain information so that the Flash player can distinguish between individual links and drop-down menus.

Home	Search	New on Market	Just sold	Contact us	Links
					Link1
					Link2
					Link3

Figure 12.1 *Menu bar*

The XML Document

We create a file with individual child nodes for the frames to go to. To distinguish between nodes coding for a drop-down menu and those for going to another frame, we simply create a node with child nodes for the drop-down menu. This will be the signal to create a menu. A sample menu is shown below, which outlines our thoughts for the real estate Web site. There will be several frames, a home frame, a data-search frame, a contact frame, etc. We also want to include links to some other Web sites. These links are child nodes of the <item> node with the attribute "Links". I have selected some links to Flash tutorials and forums. All nodes have label attributes, which are the actual labels for a menu button. We add label attributes to have names that we can display in text fields. In addition, nodes for links or frames to go to have a data attribute.

```
<?xml version="1.0"?>
<menu>
  <item label="Home" data="home" />
  <item label="Search" data="search" />
```

```
<item label="New on market" data="news" />
<item label="Just sold" data="sold" />
<item label="Contact us" data="contact" />
<item label="Links">
  <subitem label="Link1" data="http://flashscript.biz" />
  <subitem label="Link2" data="http://actionscript.
    org" />
  <subitem label="Link3" data="http://flashkit.com" />
</item>
</menu>
```

Creating the Menu

For this menu we need to store a button MovieClip in the movie library that contains a TextField. We also add a MovieClip, "menubar", that is a piece of a bar and used as decoration. We prepare both MovieClips and leave them in the library and add linkage ID. We create one empty MovieClip, "menu", which we link to a class named "FinalMenu". This class will contain the code to make the menu bar functional. We use the menu MovieClip to position the menu bar on the

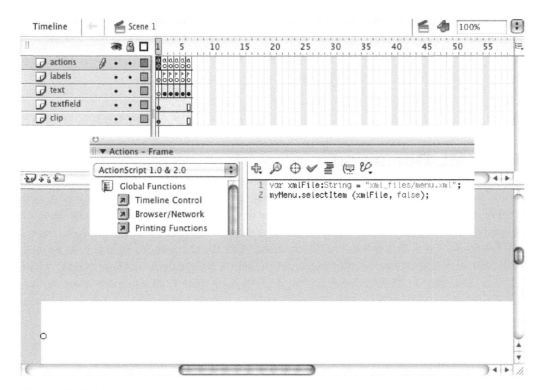

Figure 12.2 *Menu bar movie organization*

stage. We place an instance of this MovieClip on stage and name it "myMenu". We also place a TextField instance on stage and name it "message". This text field is only for demonstration purposes to see if the menu bar is functional and to test the bar functions while writing the script. We leave the first frame empty except for an instance of myMenu. In the first frame we place these two lines to initiate the menu by calling the XML file and the main function.

```
var xmlFile:String = "xml_files/menu.xml";
myMenu.selectItem (xmlFile, false);
```

We create more frames and add labels to each frame corresponding to the data in the XML file for each of the buttons as shown in Figure 12.2.

The FinalMenu Class

We now write the class for our menu. From this chapter on we will first make an outline of the script and how we will proceed, because the scripts for the database search engine for the real estate Web site are rather complex. Basically, after loading the XML file, we parse the data and, using a major "if" statement, create buttons either to go to a new frame or to open a drop-down menu.

We import only one class, which is the InitiateXml class, to load the XML document:

```
import scripts.helper.InitiateXml;
```

We need to extend the MovieClip class. Later within this script I will discuss a certain advantage of doing this, which so far I have not done.

```
class scripts.FinalMenu extends MovieClip
{
```

We declare variables for loading the XML file, for the menu bar decoration MovieClip, and for two arrays, which will hold the data from the XML file for the menu buttons and the link buttons:

```
private static var com;
private var defaultXML:XML;
private var menuBar:MovieClip;
private static var subNodes:Number;
private static var subDataArray:Array;
private static var dataArray:Array;
public function FinalMenu ()
{
```

Within the constructor we create two instances of the arrays and we attach the menu bar MovieClip, which we name "menuBar".

```
subDataArray = new Array ();
dataArray = new Array ();
```

```
this.attachMovie ("menubar", "menuBar", 1);
}
```

The public function of this class has two now well-known parameters. As shown in Figure 12.3 we first load the XML document:

```
public function selectItem (menuXml:String,
 proxy:Boolean):Void
{
  com = new InitiateXml ();
  com.init (menuXml, loadMenu, this, proxy);
}
```

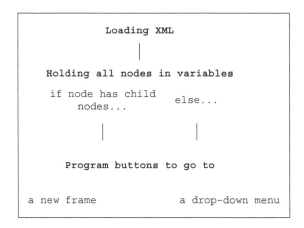

Figure 12.3 *Class script outline for the menu bar*

Then we parse the XML data:

```
private function loadMenu ():Void
{
```

We loop through all child nodes of the first child, which will not only cover the menu buttons, which determine to which frame the main timeline will move, but also cover the <item> node with the links attribute:

```
for (var count01 = 0; count01 < com.defaultXML.
 firstChild.childNodes.length; count01++)
{
```

We create a variable holding each child node:

```
var myNode:XMLNode = com.defaultXML.firstChild.
 childNodes [count01];
```

We access the label attributes and create a variable:

```
var myLabel:String = myNode.attributes.label;
```

Then we do the same with the data attributes:

```
var myData:String = myNode.attributes.data;
```

Now it is time to attach as many buttons as there are labels. I would like to note at this point that we use count01 + 2 for the levels. We have to add +2, because the menu bar MovieClip is on level 0. We could have used this.getNextHighestDepth(), but my personal experience is that this is not always safe. In particular, it can cause problems when we want to remove MovieClips. In ActionScript 3 you will notice that its equivalent, addChild(), seems to be perfectly fine. Also we have no other choice any more.

```
this.attachMovie ("menuButton", "menuButton" + count01,
  count01 + 2);
```

We create a new variable for each button:

```
var mainMenu:MovieClip = this["menuButton" + count01];
```

We need to create a unique identifier for each button, which is equal to the number of counts:

```
mainMenu.counter = count01;
```

We fill the array with the data attributes:

```
dataArray.push (myData);
```

Now it is time to position each button along the *x* axis:

```
mainMenu._x = mainMenu._width * count01;
```

We give each button a label:

```
mainMenu.itemText.text = myLabel;
```

While we add buttons we also extend the width of the menu bar, which will grow with each button:

```
menuBar._width = mainMenu._width * (count01 + 1);
```

At this point we add a function to trigger an animation when the mouse rolls out from the buttons. This function is common to all menu buttons and the Links button. This saves us a few lines of extra coding.

```
mainMenu.onRollOut = function ()
{
  this.gotoAndPlay ("frame11");
};
```

So far we have taken care of the main menu buttons. However, we should not forget the menu for the link buttons. The difference between a node for a "go to a frame" button and a node for a button that opens another menu is that this node has child nodes. We make use of the hasChildNodes() method, which will return true or false. Only the <item> node with the label attribute Links has child nodes. Using an "if" statement we select out the one node with child nodes. If we had more nodes they would have been selected as well and we would have had several drop-down menus. So let's focus on the drop-down menu for the moment before we handle the main menu buttons.

```
if (myNode.hasChildNodes ())
{
```

We now create the button functions for the Links button, which are different from those of the menu buttons. The rollover function triggers a frame-to-frame animation.

```
mainMenu.onRollOver = function ()
{
  this.gotoAndPlay ("frame2");
};
```

The function of the Links button is to create the drop-down menu and add functionality to the buttons from this menu.

```
mainMenu.onPress = function ()
{
```

We loop through the child nodes of the <item> node with the attribute Links:

```
subNodes = myNode.childNodes.length;
for (var count02 = 0; count02 < subNodes; count02++)
{
```

We attach the link buttons that will make the submenu:

```
this._parent.attachMovie ("menuButton", "subMenu" +
  count02, 100 + count02);
```

We add the labels to the buttons:

```
this._parent ["subMenu" + count02].itemText.text =
  myNode.childNodes [count02].attributes.label;
```

We give each button a unique identifier, a number (counter):

```
this._parent ["subMenu" + count02].counter = count02;
```

Then we get the data for each node and store the data in an array:

```
var subMenuUrl:String = myNode.childNodes [count02].
  attributes.data;
subDataArray.push (subMenuUrl);
```

We position the submenu buttons:

```
this._parent ["subMenu" + count02]._x = this._x;
this._parent ["subMenu" + count02]._y = (this._
 parent ["subMenu" + count02]._height + 5) * (count02
 + 1);
```

We now add functions to the submenu buttons. The rollover and rollout functions are the same as for the menu buttons.

```
this._parent ["subMenu" + count02].onRollOver =
 function ()
{
  this.gotoAndPlay ("frame2");
};
this._parent ["subMenu" + count02].onRollOut =
 function ()
{
  this.gotoAndPlay ("frame11");
};
```

When a button is pressed, we want to call a URL. We make use of the button identifier and counter, which allow us to call the correct member of the array that holds all the URLs.

```
this._parent ["subMenu" + count02].onPress = function ()
{
```

The line that is commented out is the actual method that we use in our final application. However, for the purpose of testing the movie, we show the URL in a text field.

```
//getURL (subDataArray [this.counter], "_self");
this._parent._parent.message.text = "getURL (" +
 subDataArray [this.counter] + ")";
};
}
```

We have covered the link buttons and now turn back to the menu buttons:

```
else
{
```

When the drop-down menu is open, we want to close it. The variable "subNodes" has a value when the drop-down menu is opened. We simply loop through all the submenu buttons and remove them using the removeMovieClip() method. We also empty subDataArray using the shift() method.

```
mainMenu.onRollOver = function ()
{
```

```
    if (subNodes != undefined)
    {
      for (var count03 = 0; count03 < subNodes; count03++)
      {
        this._parent ["subMenu" + count03].removeMovieClip
          ();
        subDataArray.shift ();
      }
    }
    this.gotoAndPlay ("frame2");
  };
```

The main function of the menu button is to allow the user to move the timeline to another frame. We make use again of the counter identifier, which is simply a number and can be used to pick up the correct position in the dataArray array.

```
    mainMenu.onRelease = function ()
    {
      this._parent._parent.gotoAndStop (dataArray
        [this.counter]);
      this._parent._parent.message.text = "gotoAndStop(" +
        dataArray[this.counter] + ")";
    };
  }
}
```

The menu bar can now be incorporated into the main movie in the same way we designed it here.

13 Creating the Database (Part 1)

Introduction

We are now approaching the development of the core unit of the real estate Web site, which is the database, which stores information about all of the homes for sale. In the first section of this chapter a feature of AS2 class that we have not yet discussed will be introduced: the interface. The concept is the same for AS3 class files and will not be discussed further in that section. Next we will write the class files for the basic database, which displays data. We will then discuss the structure of the interface. In Part 2 (Chapter 14) we will add features such as saving data using the shared object, dividing the displays into groups with Next and Previous buttons, and displaying HTML pages for more information. We have already covered some of these applications in previous chapters, but now we will put it all together into one application. So feel like a project manager, and imagine that you have to oversee the whole project.

You will notice that the way the movie will be set up is slightly different from previous sections. There will be hardly any MovieClips on the stage, because we will add those by using a script. Furthermore, all MovieClips that will be manipulated by code will be associated with a class. All clips that are static, will be graphics. You are now asking me, why we are doing this? One reason for you to learn AS2 is to get prepared for AS3, and associating MovieClips with classes is something you should get used to now. When you prepare an AS3-based movie all MovieClips, which are manipulated by code, are classes. This can be very handy, because we can manipulate individual MovieClips using their own classes. As you will see, we will do this for some MovieClips in our AS2-based application as well.

Structure of the Search Engine

The main question of each project is: what do we want to achieve? Before we start working on individual projects we have to clarify this point. So we will now list what the user will be able to do when faced with the search engine. We will then prepare an outline of the movie. Let's use the example of a real estate Web site. Now, imagine you are a user and want to buy a house. What are you looking for?

- Select the region where you want to purchase a house
- Select the minimum and maximum price of your house
- Select the size of the house, usually measured in number of bedrooms

- You want to see a list of your selection, preferably with an image
- You want the selection to be arranged, for example, showing the lowest price first and then getting higher
- You want a closer look at homes that you may like, which means that you want to see more details
- You want to be able to save a selection of the houses, so you can come back and look at the houses at a later time

These are the main points we have to consider. In this chapter we will deal with the first five, which cover the database. In Figure 13.1 an outline of the different classes and their interactions is shown. The core of the database consists of the MovieClips ComboPack and infoDisplay, to which the scrollbar and the mask will be attached. We further need the MovieClip houseDisplay to be stored in the library. This MovieClip will display the data for the individual homes, including an image.

Figure 13.1 *Initial class organization of the search engine*

The Design Pattern: Model Viewer Controller

In our design of the application we follow the Model Viewer Controller (MVC) design pattern. The classes for the basic search engine are shown in Figure 13.1. The unit with which the user

interacts is the controller. In our case that would be the ComboBox and a Submit button. The ComboBox has its own classes, but it is added to the movie using the ArrangeStage class and so is the Submit button. The DataBase class represents the model. That is the place where data is processed and stored in variables. The McScrollBar_vert, DisplaySearch, and HouseDisplay classes represent the viewer part of the movie, with the DisplaySearch class as its central class. Later we will extend the controller, the model, and the viewer with some additional classes. We will now discuss the movie arrangement and individual parts of the movie in more detail.

Setting Up the Database.fla

We have already developed the ComboPack, which allows the user to make selections (Chapter 9). We have to modify it slightly for this movie and import it into the library of our Database.fla. Next we need to prepare the MovieClip infoDisplay, which is an empty MovieClip associated with the script scripts.DataBase.DataBase. The scrollbar is a present from me and we will not discuss the script for the scrollbar in further detail. The script that is associated with the scrollbar is McScrollBar_vert.as, which is also indicated in Figure 13.1. Then we need to prepare the mask display_mask, which will be attached to infoDisplay. This is just a rectangle box to which we add some text, which will be shown when the movie plays. The mask will function as a mask only when data will be displayed upon a search. The last MovieClip that we need to add is houseDisplay, which has several text fields; two invisible buttons, which, however, we are currently not concerned with; and an instance of the Loader component (Figure 13.2). This will display the data for the homes, including an image. I have already created the XML files, which we will discuss in more detail when we discuss the individual classes that use them. And I added images of homes, which we want to display. If you want to start from the very beginning and add code by yourself, I have provided starter files and, of course, there is also the finished version.

Figure 13.2 *The MovieClip houseDisplay with buttons, TextFields, and an instance of the Loader component*

If you open DataBase.fla from the FINAL folder, you will see only a background, a TextField, and, outside of the stage, a little square (Figure 13.3). We will arrange everything virtually using the ArrangeStage class. The square that you see outside of the movie is associated with this class and we use this MovieClip as an object on stage. In this way we avoid the use of _root or level0 and instead

Figure 13.3 *The stage of the final version of DataBase.fla*

will stick to "this" and "this_parent", etc. In AS3, "root" (changed from "_root") is the timeline of an object when the object is added to a movie, but is a read-only property.

Interface

Before we actually get into coding the database, I will introduce the interface. Imagine that you have several complex applications in one movie. Then it is wise to have a system that allows separating one application from another. This is achieved by implementing an interface, which is basically a collection of methods from the classes belonging to a certain application. These methods are collected in a separate file, which is the interface class file. In this file a selection of methods from the different classes are listed. Open Chapter 13—Scripts—DataBase—DBaseInterface.as and you will see a list of functions. We will discuss all these functions in detail. Which functions do we select for creating the interface? Do we select all methods of each class? Probably not, because there are just too many methods in each class and that would defeat the purpose of the interface concept. We select only those that interact with other classes, which are all the public classes.

To show that one class belongs to an interface we use the word "implements" followed by the name of the interface, for example:

```
class scripts.DataBase.DataBase extends MovieClip
   implements scripts.DataBase.DBaseInterface
```

In addition we need to add all methods at the end of each class that has been listed in the interface, except for the function that belongs to the class itself. We write only the name of the function and the parameters and the parentheses:

```
function selectSearch (menuXml:String):Void{}
```

When we call another class belonging to the interface, we can now use a different data type for this class, as the example demonstrates:

```
private var scroller:DBaseInterface;
scroller = new McScrollBar_vert ();
scroller.scrollBar_vert (this.mask, this.holder, this);
```

Usually we would have given as data type the class name itself:

```
private var scroller: McScrollBar_vert;
```

However, by using the interface class name as data type all classes are now tied to the same interface and are separate from other interfaces/classes. The concept and its syntax are also used in ActionScript 3.

The Basic Database Classes

We can now start writing the classes. Check the overview in Figure 13.1 again. The classes that are needed are determined by what we want to achieve. But they are also determined by our way of organizing the movie. On top of our classes is the interface, DBaseInterface. Whenever we write a class we add the method that communicates with another class to the interface. The function of the next class, ArrangeStage, which is on top of our application, is to place all objects on the stage and give functions to some of the event-handler objects such as buttons. Then there is the DataBase class, which will handle the searches and control the display of the search. The DataBase class communicates with all other classes, like the SelectCombo class to get the keywords, the DisplaySearch class to display the homes' information, and the McScrollBar_vert class, which receives the size of the display from the DataBase class. The SelectCombo class is already provided, since we wrote it earlier. We need only modify it a little bit for this application. Apart from the major classes shown in Figure 13.1 we add a class for each MovieClip. Some of these are stored in the folder mc. The classes stored in this folder will not be linked to the interface, because these classes do not interact with any of the other classes. Some of them will stay empty. As I said earlier, for AS3 we need to have each object as a class. To facilitate the transition to AS3 we will get used to doing this here. Although in Flash 9 a class is automatically created, in my opinion it is a better habit for the developer to create the class, to have more control. Also it allows adding methods to the class at a later stage, if required.

Writing Classes: DBaseInterface and ArrangeStage

You are now familiar with the concept and what the individual classes will achieve, as well as their interactions among one another. Now it is time to get to work and write the classes. First we create the interface class, DBaseInterface. This is indicated by the word "interface" followed by the path. We leave this class empty except for one function from the ArrangeStage class, which we will discuss in a moment.

```
interface scripts.DataBase.DBaseInterface
}
function aStage (xmlFile:String):Void;
}
```

The functions are added with all parameters as they appear in the original function, but we can omit the word "public". Whenever we have a function that we want to add to the list, we open all files, including the interface file, and immediately add the method. If we forget it, we will always be reminded, when the scripts are compiled. Another possibility is to create the interface at the end of writing all classes. However, then we must not forget to change the data type for class variables as well.

The first class that we focus on is the ArrangeStage class. Open the Starter file (Chapter 13— Starter). I have left comments, so you know where to add script parts. The first line that we need to add is the class declaration, which I have already added:

```
class scripts.DataBase.ArrangeStage extends MovieClip
  implements scripts.DataBase.DBaseInterface
{
```

Since we created a MovieClip with which we associate this class, we need to extend the MovieClip class. Further we indicate that this class belongs to an interface, DBaseInterface. We always need to add the path to the files. If you go back to Figure 13.3, you will see the little square MovieClip on stage, which is associated with this class. Before importing any classes we need to establish which objects will be placed on the stage. So we add all variables. These are the Submit button, which is a button component, and then the MovieClips ComboPack and infoDisplay, which displays the search results. Finally, we need to add the MovieClip scroller, which I have provided. This variable will receive the data type of the interface.

```
private var submitBut:Button;
private var comboPack:MovieClip;
private var infoDisplay:MovieClip;
private var scroller:DBaseInterface;
```

Note: If you add a data type to a variable that is not a Flash internal data type, you will get an error message when you click on the Formatting button, although the script does not contain any errors. That is the reason it is sometimes recommended to eliminate the data type until the movie is finished.

We will now add these two classes under "import classes":

```
import mx.controls.Button;
import scripts.DataBase.McScrollBar_vert;
```

Next we create the constructor:

```
public function ArrangeStage ()
{
```

At this point we add all the objects to the stage, since the constructor function is executed before any other function and we want to make sure all objects are on the stage when any of the other functions are executed. The first object is the button, which we add using the createClassObject method. This method also allows us to immediately add a label and the position where we want to place the button. The number, 1, is the number for the level on the timeline. We do not use _root but this._parent instead.

```
this._parent.createClassObject (Button, "submitBut", 1,
    {label:"Submit", _x:635, _y:60});
```

This is followed by placing infoDisplay on the timeline using the attachMovie() method.

```
this._parent.attachMovie ("infoDisplay", "infoDisplay", 2,
    {_x:42, _y:125});
```

The MovieClip infoDisplay is empty so far, but we want to add a mask and the scroller. We also position the MovieClips using the {} syntax:

```
var myMask:MovieClip = this._parent.infoDisplay.attachMovie
    ("display_mask", "mask", this._parent.infoDisplay.
    getNextHighestDepth (), {_x:0, _y:0});
var myScroll:MovieClip = this._parent.infoDisplay.
    attachMovie ("m_scrollbarver", "m_scrollbarver",
    this._parent.infoDisplay.getNextHighestDepth (),
    {_x:myMask._width+1, _y:myMask._y});
myScroll._height = myMask._height;
```

We position the scroller to the same y-position as the mask and x-position as the width of the mask plus 1 pixel. We set the height to the same height as the mask. The last object that we need for a functional search is the ComboPack MovieClip with all ComboBoxes, which we place in the top of the movie.

```
this._parent.attachMovie ("comboPack", "comboPack", 3,
    {_x:195, _y:5});
}
```

We have now created and attached all the objects that we need for the basic database. Later we will add more objects.

Preparing the SelectCombo Class

Next we modify the classes for this movie, which we created earlier. We have already written the class, SelectCombo, for the ComboBox menu. We need to modify this script slightly from its original version. Open the script and add

```
implements scripts.DataBase.DBaseInterface
```

to the end of line 6 (class scripts.SelectCombo extends MovieClip), since we will implement this class in the interface. Then eliminate lines 127 and 128, which were only for demonstration purposes. Save and close the script. To the ArrangeStage class we add a public function with a parameter, xmlFile, which will be the XML file fed to the ComboBoxes. Open ArrangeStage.as and add this function. As you may remember, this is the function we added to the interface class.

```
public function aStage (xmlFile:String):Void
{
    this._parent.comboPack.selectSearch (xmlFile);
}
```

To do everything correctly, we also need to take care of the interface. Open again SelectCombo.as and at the end add the new function from the ArrangeStage class:

```
public function aStage (xmlFile:String):Void{}
```

You also need to add the function from the SelectCombo class

```
public function selectSearch (menuXml:String):Void{}
```

at the end of the ArrangeStage class, and without the parentheses,

```
public function selectSearch (menuXml:String):Void
```

add the function to the interface DBaseInterface.

Preparing to Test the Movie

We have not yet prepared all the other classes but have already added MovieClips that are associated with these classes and that need to be on stage. These are the DataBase and the McScrollBar_vert classes as well as classes in the folder mc. The final step before we test the movie is to call the ArrangeStage class from the movie. We place an instance of the MovieClip arranger outside the stage and we name it "arranger". Then we call the main method of the class by adding this line in the main timeline:

```
arranger.aStage("xml_files/combo.xml");
```

Now we are ready to test the movie. The ComboBoxes are all functional and we should not get any errors. You can find the classes and the .fla file for this stage in the Starter_B folder. In the following we will continue using the files in there.

The DataBase Class: Introduction

We now turn to the core of the search engine, the DataBase class. Our goals are to (1) find search items that fit into the categories as selected from the ComboBoxes and (2) display them. We will first focus on the first goal, to find the search categories the DataBase class needs to communicate with the SelectCombo class. So under "import classes" add this line, which allows the import of that class:

```
import scripts.DataBase.SelectCombo;
```

We expect that some searches will result in a larger number of displays, which will not fit in the movie any more, and we will need a scrollbar. We need to import this class as well:

```
import scripts.DataBase.McScrollBar_vert;
```

Since this class belongs to the interface as well and an instance will be created using the interface, we need to import the interface also:

```
import scripts.DataBase.DBaseInterface;
```

And of course we need to import our InitiateXml class, since we are loading and parsing XML documents. This class does not belong to the interface, because it could be shared with another interface.

```
import scripts.helper.InitiateXml;
```

The DataBase class is also part of the interface and the class declaration shows that:

```
class scripts.DataBase.DataBase extends MovieClip
  implements scripts.DataBase.DBaseInterface
{
```

Before we go further into writing this class we need to know more about the XML documents that will be parsed. We also want to create a simple outline for this movie, which facilitates writing the class (Figure 13.4).

Retrive information from
the selectCombo class

Loop through the XML file retrieved
from the SelectCombo class

Create variables for all child nodes

Call the displaySearch class
to display all information

Create an instance of the scrollerbar

Figure 13.4 *Outline of the DataBase class*

Basically the function of this class is to get the search parameters and XML file from the ComboSelect class, parse the XML file, and sort out the data. Then a connection to another class will be made to display the data.

Home Search XML Documents

For searching the real estate Web site there exist four different XML files depending upon the area where the user wants to purchase a house: West, East, North, and South. Typically the XML files have the structure shown in the example below:

```xml
<?xml version="1.0"? encoding="utf-8"?>
<text>
  <house id="1">
    <bedroom>3</bedroom>
    <bath>2</bath>
    <cost>239,999</cost>
    <built>1990</built>
    <town>East Sacramento</town>
    <image>images/noimage.jpg</image>
    <details>null</details>
  </house>
  <house id="2">
    <bedroom>2</bedroom>
    <bath>1</bath>
    <cost>139,999</cost>
    <built>1982</built>
    <town>East Sacramento</town>
    <image>images/noimage.jpg</image>
    <details>null</details>
  </house>
</text>
```

There are of course more homes listed in each file, but for demonstration purposes only two nodes are shown here. The <text> node is the first child node. The <house> nodes are child nodes of <text> followed by <bedroom>, <bath>, and other nodes. We keep this in mind for later, when we need to parse the XML document and need to access the nodes. However, we know from the XML document already that we need a number of variables, for the bedrooms, baths, etc. All variables will be local, and at this point we do not need to declare them.

The Function "initLoading"

We turn now to the main functions of the DataBase class. After adding the constructor, which stays empty,

```
public function DataBase ()
{
}
```

we write the main public function by which the loading of an XML document will be initiated. This function will be included later in the methods for the interface.

```
public function initLoading ():Void
{
```

We remove the MovieClip holder. I will explain more about the MovieClip holder below.

```
this.holder.removeMovieClip ();
```

We create a new instance of the scrollbar:

```
scroller = new McScrollBar_vert (this);
```

We also add the variable "scroller" to the variable list under interface variables:

```
private var scroller:DBaseInterface;
```

The XML file is determined by the user's choice of city. However, we want to prevent any search from occurring when the user has set a minimum price equal to or higher than the maximum price by mistake. Therefore we create an "if ... else" statement:

```
if (SelectCombo.lowPrice >= SelectCombo.highPrice)
{
  showMessage ();
}
```

Both variables, "lowPrice" and "highPrice", are public static variables of the SelectCombo class. We can easily call the values for these variables over the class itself, since they are static and therefore should have only one possible value. If the settings are wrong and the maximum price is equal to or smaller than the minimum price, we show an error message and terminate the search by using return. The function "showMessage" has a return type Number.

```
private function showMessage ():Number
{
  this._parent.myMessage.text = "ERROR: Min price must be
   smaller than max price.";
  return SelectCombo.lowPrice;
}
```

If the selection was done correctly the search can proceed:

```
else
{
  pXml = new InitiateXml ();
  var xmlFile:String = SelectCombo.myCityXml;
  pXml.init (xmlFile, loadParse, this);
```

We create an instance of the InitiateXml class. The loaded XML document is held by the public static variable "myCityXml" of the SelectCombo class.

We need to add some more lines now. I mentioned the MovieClip holder above. This MovieClip will contain the displays for all the searches and will be masked. It is the actual MovieClip that will be scrolled. To delete any prior content we delete holder itself and then immediately attach and position a new instance of holder. Later we will deal with the class associated with this MovieClip.

```
this.attachMovie ("holder", "holder", this.
 getNextHighestDepth ());
this.holder._x = this.mask._x;
this.holder._y = this.mask._y;
}
}
```

We need to add "holder" now to the list of variables. We also add the variable "mask", which holds the mask MovieClip of holder.

```
private var holder:MovieClip;
private var mask:MovieClip;
```

We are now ready to parse the XML document.

Parsing the XML Document

The name of the function to parse the XML document is loadParse. The function is private, since it is an internal function of this class:

```
private function loadParse ():Void
{
```

Before we loop through all the child nodes we need to do some preparations. First we declare a local variable, "count02", which we use in the "for" loop as a marker.

```
var count02:Number = 0;
```

We give another counter variable, which is not local, a value:

```
count03 = 0;
```

If this variable does not increment further, there are no search items to display, which we show by a message:

```
if (count03 == 0)
{
  this._parent.myMessage.text = "Sorry, no matches found.
  Change the settings.";
}
```

myMessage is a text field in our movie. Open DataBase.fla and create a long text field somewhere in the top of the movie and name it "myMessage" in the property inspector. You can correct the position later. We now create instances of two arrays. Both array variables are local. You will see in a moment which values the arrays will store.

```
var houseArray:Array = new Array();
var counterArray:Array = new Array();
```

And we are ready to collect all the data by looping through the child nodes of the first child of the XML data:

```
for (var count01 = 0; count01 < pXml.defaultXML.
 firstChild.childNodes.length; count01++)
 {
```

We create a shortcut. This is a large family of child nodes and we need to write quite a bit to access all the nodes:

```
var nNode:XMLNode = pXml.defaultXML.firstChild.
 childNodes[count01];
```

We first identify the id attribute of each of the parent nodes, which have child nodes and hold the data:

```
var houseId:String = nNode.attributes.id;
```

We can now access all individual data nodes starting with the number of bedrooms. The data nodes are child nodes of the <house> node. If you are confused now, check the structure of the XML document again. Basically we start from the top in chronological order.

```
var bedRoom:String = nNode.firstChild.firstChild.
 nodeValue;
```

We add consecutively nextSibling after the first firstChild, since that is an easy way to access all nodes:

```
var baRoom:String = nNode.firstChild.nextSibling.
 firstChild.nodeValue;
```

Next let's deal with the <cost> node. We need to convert the value of this node to a number. But first, we need to eliminate the comma. The node value is a number with a comma, which for display purposes looks nicer. However, there is a problem when we want to use this number as a numeric value. We get the node value:

```
var stringPrice:String = nNode.firstChild.nextSibling.
 nextSibling.firstChild.nodeValue;
```

Then we use the split method to split the string where the comma is. We join both substrings without the comma and create a new local variable:

```
var splitted:Array = stringPrice.split (",");
var prTag:Number = Number (splitted.join (""));
```

Now we can list all the other nodes. We access the nodes as next siblings of previous nodes. That is easy, because we just add another nextSibling before "firstChild.nodeValue". The only problem is that the lines can be very long depending on the number of nodes.

```
var yearBuilt:String = nNode.firstChild.nextSibling.
 nextSibling.nextSibling.firstChild.nodeValue;
var houseLocation:String = nNode.firstChild.nextSibling.
 nextSibling.nextSibling.nextSibling.firstChild.
 nodeValue;
var houseImage:String = nNode.firstChild.nextSibling.
 nextSibling.nextSibling.nextSibling.nextSibling.
 firstChild.nodeValue;
var viewDetails:String = nNode.firstChild.nextSibling.
 nextSibling.nextSibling.nextSibling.nextSibling.
 nextSibling.firstChild.nodeValue;
```

When we get hold of all the individual data, we collect it in the array houseArray. We need to add the data to an array first because later we want to display the data starting with the lowest price. With the aid of an array it is easy. We can use the array.sortOn method and arrange the data numerically according to the price pt:prTag:

```
houseArray.push({id:houseId, br:bedRoom, pt:prTag,
 st:stringPrice, yb:yearBuilt, hl:houseLocation,
 hi:houseImage, vd:viewDetails});
houseArray.sortOn("pt", Array.NUMERIC);
```

At the end we increment count02:

```
count02++;
```

When the value of count02 is equal to or higher than the number of child nodes (<house>), we move on to deal with the data. We set count05 to 0. We need this variable, which is incremented, to collect data within the "if" statements:

```
if(count02 >= (pXml.defaultXML.firstChild.childNodes.
 length))
{
  count05 = 0;
```

We need to go through the data once more, but now we use the houseArray, which contains already sorted data, as our basis.

```
for (var count04=0; count04 < houseArray.length;
 count04++)
 {
```

We associate each piece of data with variables again:

```
houseId = houseArray[count04].id;
bedRoom = houseArray[count04].br;
baRoom = houseArray[count04].ba;
prTag = houseArray[count04].pt;
stringPrice = houseArray[count04].st;
yearBuilt = houseArray[count04].yb;
houseLocation = houseArray[count04].hl;
houseImage = houseArray[count04].hi;
viewDetails = houseArray[count04].vd;
```

Now we can select and sort out the user's original search, selecting the number of bedrooms first. We sort out a search when the selection is more than 4, since this string cannot be cast to a number unless we remove all the nonnumeric parts. However, that is not necessary.

```
if (SelectCombo.bedrNum == "more than 4")
{
```

Then we use an "if" statement to sort out all <house> nodes with more than four bedrooms.

```
if (Number (bedRoom) > 4)
{
```

Now we select for the price that the user has entered, which has to be larger than the minimum set and smaller than or equal to the maximum price:

```
if (prTag > SelectCombo.lowPrice && prTag <=
  SelectCombo.highPrice)
  {
```

We fill a new array, which we already instantiated earlier, with the prices:

```
counterArray.push(prTag);
```

Then we transfer all the data to a new function, not to make the current function too large.

```
this.displaySelection (bedRoom, baRoom,
  stringPrice, yearBuilt, houseLocation,
  houseImage, viewDetails, houseId, count04,
  counterArray);
count05++;
}
}
}
```

We repeat for all other bedrooms and include searches, which are independent of the number of bedrooms. When you later test the final version of the movie, you will see that if you selected houses with three bedrooms to search, only those will be displayed.

```
if (bedRoom == SelectCombo.bedrNum ||
 SelectCombo.bedrNum == "show all")
{
  if (prTag > SelectCombo.lowPrice && prTag
   <= SelectCombo.highPrice)
  {
    counterArray.push(prTag);
    this.displaySelection (bedRoom, baRoom,
     stringPrice, yearBuilt, houseLocation,
     houseImage, viewDetails, houseId, count04,
     counterArray);
  count05++;
  }
}
```

At this point we initiate the MovieClip scrollbar. The holder MovieClip will likewise be filled with the correct number of displays by every loop through the array. Currently the displays do not contain any data.

```
scroller.scrollBar_vert (this.mask, this.holder,
 this);
    }
   }
  }
 }
```

In the next function, "displaySelection", we will attach the MovieClip houseDisplay for the displays and position the displays:

```
private function displaySelection (bedRoom, baRoom,
 stringPrice, yearBuilt, houseLocation, houseImage,
 viewDetails, houseId, count04, counterArray:Array):Void
{
```

We attach instances of homeDisplay:

```
var homeDisplay:MovieClip = this.holder.attachMovie
 ("houseDisplay", "h_Dp" + count04, 10000 - count04);
```

We position each instance on the *y* axis:

```
homeDisplay._y = (count03 * 110) + 5;
```

We increment count03. This is an important step and will be discussed in the next chapter.

```
count03++;
```

We use the length of the array counterArray as the number of matches found and show the value in the text field on stage:

```
var mf:Number = counterArray.length;
this._parent.myMessage.text = "Matches found: " +
 mf.toString ();
}
```

We add the interface functions to the DataBase class:

```
function aStage (xmlFile:String):Void {}
function scrollBar_vert (mo_thMask:MovieClip,
 mo_tMclip:MovieClip, root:MovieClip):Void {}
function selectSearch (menuXml:String):Void {}
```

If we have not yet done so we add the missing interface functions to all other classes as well. We can test the movie and select and see the number of selections without data being displayed. We should also be able to scroll the display.

Preparation of the DataBase Class for the Display

To complete the first part of the database search we need to display all data, including images, in the individual display boxes. We do that using a separate class, since we need that class also when we display a saved search. In this section you will further learn how to apply the EventDispatcher, which is similar in its use to the AsBroadcaster (Chapter 10, WebServiceConnector). If you want to continue where we left off, open the folder Chapter 13—Starter_D. I have already added a template for the DisplaySearch class and transferred all other files from Starter C. You will find the completed version, which is covered in this chapter, in the FINAL folder.

Before we write the DisplaySearch class we need to go back to the DataBase class and make some changes. We need to import the DisplaySearch class. You know by now where we need to place the import script line.

```
import scripts.DataBase.DisplaySearch;
```

Now we move down to the displaySelection function. To indicate that the data is not yet loaded we add a Boolean and set it to false:

```
var loaded:Boolean = false;
```

We create a new instance of the DisplaySearch class and add the function. Note here that we can use the interface class as the data type, because the function is part of the interface methods.

```
var ds:DBaseInterface = new DisplaySearch ();
ds.handleBoolean (homeDisplay, loaded, bedRoom, baRoom,
 stringPrice, yearBuilt, houseLocation, houseImage,
 viewDetails, houseId);
```

Since the DataBase class script is already in front of you, you might want to add the "handleBoolean" function to the list of interface functions as well:

```
function handleBoolean (homeDisplay, loaded, bedRoom,
 baRoom, stringPrice, yearBuilt, houseLocation,
 houseImage, viewDetails, houseId):Void {}
```

Now you can close that script and we can focus on the DisplaySearch class. However, do not forget to add the "handleBoolean" function to all other interface scripts.

The DisplaySearch Class

We start by importing various classes. Importing the Delegate class should already be a habit. The developers of ActionScript 3 have recognized that and extended the scope of functions for which the Delegate class is required. We further import the EventDispatcher class. We need to use this class to allow enough time for each event to occur in the order it is required.

```
import mx.utils.Delegate;
import mx.events.EventDispatcher;
```

This is followed by the class declaration.

```
class scripts.DataBase.DisplaySearch implements scripts.
 DataBase.DBaseInterface
 {
```

We then declare variables for all the parameters from the function that hold the data from the XML file:

```
private var homeDisplay:MovieClip;
private var loaded:Boolean;
private var bedRoom:String;
private var baRoom:String;
private var stringPrice:String;
private var prTag:Number;
private var yearBuilt:String;
private var houseLocation:String;
private var houseImage:String;
private var viewDetails:String;
private var houseId:String;
```

Since we are using the EventDispatcher class we also need to create the corresponding variables and load and remove the listener for the function in which the EventDispatcher is initialized. The variable "myTimer" is a setInterval variable.

```
private var addEventListener:Function;
private var removeEventListener:Function;
private var dispatchEvent:Function;
private var myTimer:Number;
```

After adding the constructor we declare the main function of this class with all its parameters. The function "handleBoolean" has to be public to be accessed from other classes.

```
public function DisplaySearch ()
{
}
public function handleBoolean (homeDisplay, loaded,
  bedRoom, baRoom, stringPrice, yearBuilt, houseLocation,
  houseImage, viewDetails, houseId):Void
{
```

To execute events in the correct order, we need to add an extra function, which is part of the EventDispatcher class. We could have also used the AsBroadcaster instead. The EventDispatcher requires a listener. The function "waitAsecond" will listen to a signal from the function "dispatchEvent" in which the EventDispatcher was initialized. Using the variable "evObj" we can transfer all the parameters of that particular function:

```
var myListener:Object = new Object ();
myListener.waitAsecond = function (evObj:Object)
{
```

We need to choose a parameter that has a value when the dispatch event is finished. We choose the Boolean loaded, which we had originally set false in the DataBase class. We create a variable, "moment", which we need as a timer for a "setInterval" function. We create an interval of 1 millisecond, which is sufficient to load the image and text fields. Then we create an instance of a function, which we call CreateDispatcher. We could have named it differently as long as the name is the same as the function that follows:

```
var moment:Number = 1;
var myDispatch:Function = new CreateDispatcher
  (moment, loaded, bedRoom, baRoom, stringPrice,
   yearBuilt, houseLocation, houseImage, viewDetails,
   houseId);
myDispatch.addEventListener ('waitAsecond',
  myListener);
```

We write the "CreateDispatcher" function:

```
function CreateDispatcher (timed:Number,
  myLoaded:Boolean, bRoom:String, bathRoom:String,
```

```
pTag:String, yBuilt:String, hLocation:String,
hImage:XMLNode, vDetails:String, sNode:String)
{
```

We initialize the EventDispatcher by calling a static function with one parameter of data type Object. This parameter in our case is the function "CreateDispatcher":

```
EventDispatcher.initialize (this);
```

We redefine all parameter variables:

```
loaded = myLoaded;
bedRoom = bRoom;
baRoom = bathRoom;
prTag = pTag;
yearBuilt = yBuilt;
houseLocation = hLocation;
houseImage = hImage;
viewDetails = vDetails;
houseId = sNode;
```

We use "setInterval" to allow enough time to end one event before the next event is initiated:

```
myTimer = setInterval (Delegate.create (this,
 dispEvent), timed);
}
```

The function that is subject to the interval is called "dispEvent". This is a local function. We choose a local function because all the variables that we declared earlier are still defined within the local function.

```
function dispEvent ():Void
{
```

Now we initiate the loading of the Loader component instances in the HomeDisplay MovieClip. We anticipate that this event will last longest and we make the interval dependent on the duration of this event.

```
homeDisplay.myLoader.contentPath = houseImage;
```

When the images are loaded into the MovieClip of the Loader component, which we access by the name of the component instance and the name content, we clear interval and trigger the "dispatchEvent" function. The name of this function cannot be changed, because it is a function of the EventDispatcher class. The function has one parameter of data type Object, which automatically refers to the EventDispatcher class itself, when undefined. We need to define the type of object, which is the function "waitAsecond", that is triggered when the "dispatchEvent" function is executed.

```
var imageLoaded:Number = homeDisplay.
 myLoader.content.getBytesLoaded ();
var imageTotal:Number = homeDisplay.myLoader.
 content.getBytesTotal ();
if (imageLoaded > 0 && imageLoaded >= imageTotal)
{
  clearInterval (myTimer);
  loaded = true;
  this.dispatchEvent ({type:'waitAsecond',
   m_1:loaded, m_2:bedRoom, m_3:baRoom, m_4:prTag,
   m_5:yearBuilt, m_6:houseLocation,
   m_7:houseImage, m_8:viewDetails, m_9:houseId});
}
   }
}
```

The following event is the execution of the function "waitAsecond". We again add a security lock by introducing an "if" statement. This can be executed only when the variable loaded (see parameter m_1 of the "dispatchEvent" function) is true. All the text fields will be filled with data, and any other function that we might add in the future will be executed as well. So we need to go back to the "myListener.waitAsecond" code and enter all the missing data into the function.

```
if (evObj.m_1)
{
  homeDisplay.bRoom.text = "bedrooms " + evObj.m_2;
  homeDisplay.bathRoom.text = "baths " + evObj.m_3;
  homeDisplay.prText.text = "$" + evObj.m_4;
  homeDisplay.yBuilt.text = "built " + evObj.m_5;
  homeDisplay.wCity.text = evObj.m_6;
  homeDisplay.vDetails = evObj.m_8;
  homeDisplay.idNum.text = evObj.m_9;
  loaded = false;
}
   }
```

If you want to learn more about the EventDispatcher, Patrick Mineault has some excellent, in-depth examples and a tutorial at the site http://actionscript.org/tutorials/advanced/using_eventdispatcher/index.shtml.

As the last task, we have to add the interface functions. We also need to add interface functions to the classes for which we have not yet done it. Open all the .as files in the Scripts folder and make sure that the interface functions are present except for the one function belonging to each of the classes. Classes in the mc folder are not included. You can now test the movie. If you get errors you

need to repair them step by step. This is a good exercise to get familiar with the script. The complete version for this chapter is located in the FINAL folder.

The Holder Class

If you have successfully executed the movie you will see that the data and images for the homes to sell are all displayed, but the background is white. We want to add a little bit of color to that. However, adding background color directly in the holder MovieClip would not give the expected result, because the size of the holder changes according to the number of displays. We now make use of the fact that we have created a separate class, Holder, for the MovieClip, which allows us to add background color using a script. You realize now how useful it is to have a separate class for each and every MovieClip.

In the mc folder open the Holder.as file. It has become routine now that we import classes. That is important, since it must be done routinely if you write your own class scripts. We also need the Delegate class and the EventDispatcher class. To create a gradient fill we use the Matrix class, which is unique to Flash 8:

```
import mx.utils.Delegate;
import flash.geom.Matrix;
import mx.events.EventDispatcher;
```

We declare the class Holder, which extends the MovieClip class:

```
class scripts.DataBase.mc.Holder extends MovieClip
{
```

We need to declare only one global variable, which is for the "setInterval" function. All other variables will be local.

```
private static var myTimer:Number;
```

Then we write the constructor, in which all the functions will be located. It is the most convenient way for what we are planning, since there is no function that will be triggered by any other class.

```
public function Holder ()
{
```

We declare the variables for the EventDispatcher as local variables:

```
var addEventListener:Function;
var removeEventListener:Function;
var dispatchEvent:Function;
```

We create a listener and a function that is triggered when the listener is activated. This is exactly the same as what we did previously when we added data to the display (see previous section).

```
var myListener:Object = new Object ();
myListener.waitAsecond = Delegate.create (this,
 dpFunction);
function dpFunction (evt:Object)
{
```

We skip the function contents for the moment and move to the event-handler function "myDispatch", which has one parameter, which is the delay in milliseconds for the "setInterval" function. We assume that a waiting period of 1000 milliseconds is more than enough time to create all the home displays. We need to wait for the end of loading all the displays, since this will determine the final height of the holder MovieClip. If the number of displays is much larger than in our movie, we may have to wait a little longer and set the time higher. Changing the time can test this:

```
var moment:Number = 1000;
var myDispatch:Function = new Dispatcher (moment);
myDispatch.addEventListener ('waitAsecond',
 myListener);
```

We execute the "Dispatcher" function and initialize the EventDispatcher. We use the Delegate class to broaden the scope of the interval function "dispEvent", since we want the "dispatchEvent" function of the EventDispatcher class to have a reference to Dispatcher:

```
function Dispatcher (timed:Number)
{
  EventDispatcher.initialize (this);
  myTimer = setInterval (Delegate.create (this,
   dispEvent), timed);
}
```

We execute the interval function. We set a Boolean variable, loaded, to true and trigger the "dispatchEvent" function, to which the listener myListener listens. We immediately clear interval after dispatching the event:

```
function dispEvent ()
{
  var loaded:Boolean = true;
  this.dispatchEvent ({type:"waitAsecond",
   m_1:loaded});
  clearInterval (myTimer);
}
```

We can now go back to the "waitAsecond" function and fill in the gaps. Our goal here is to create a gradient background. We call the object evt, which is the listener, and the variable "m_1" holds the contents of the variable loaded, which is true. We introduce another safety lock and make sure that the width (or height) of the holder MovieClip is not 0, which means that something has been loaded.

```
if (evt.m_1 && this._width > 0)
{
```

We now prepare for the gradient fill. We set two colors for the fill, which are different shades of gray. The color values must be hexadecimal values.

```
var colors:Array = [0xCCCCCC, 0xF6F6F6];
```

We set the alpha values for the two colors to 100:

```
var alphas:Array = [100, 100];
```

The variable "ratios" is an array defining the distribution of the color over the gradient.

```
var ratios:Array = [0, 255];
```

The width of the gradient is equal to the width of the mask, while the height will be the height of holder, when the display objects are loaded.

```
var w:Number = this._parent.mask._width;
var h:Number = this._height;
```

We create a new instance of the Matrix class and use a method to create the gradient with the width (w) and height (h) of the holder:

```
var matrix:Matrix = new Matrix ();
matrix.createGradientBox (w, h);
```

We execute the fill script with all the parameters that we have defined before. The gradient will be linear.

```
this.beginGradientFill ("linear", colors, alphas,
 ratios, matrix);
this.moveTo (0, 0);
this.lineTo (w, 0);
this.lineTo (w, h);
this.lineTo (0, h);
this.endFill ();
   }
}
```

When you test the movie you should see a gray area when the displays are shown.

The Mask Class

You may have noticed when you tested the movie that the mask for the holder is visible at the beginning, when the movie is loaded and before we start a search. We could dynamically add some text fields to the mask, but we choose an easier solution and add two hard copy TextFields.

We cannot see the text fields if we do not do anything with them, which gives us also the possibility of leaving them empty. We create the class Mask, which extends the MovieClip class:

```
class scripts.DataBase.mc.Mask extends MovieClip
{
```

We declare variables for the two TextFields:

```
private var headLine:TextField;
private var instructionField:TextField;
```

Within the constructor we add a script. We give the TextField displaying the headline a background, add text to this field and the second field, and we are done:

```
public function Mask ()
{
  this.headLine.background = true;
  this.headLine.backgroundColor = 0xFFFFFF;
  this.headLine.text = "Search for a new Home!";
  this.instructionField.text = "Select from the menu and
   press 'SUBMIT'";
}
}
```

In the next chapter we continue with the database and add two more features. We use the current files as our base.

14 Creating the Database (Part 2)

Introduction

We have completed the basic classes for the database. We can perform a search and see the result in the form of a scrollable display. However, if we have a large number of displays, do we want to scroll all the way to the last display? To avoid that, we will introduce a "next so and so many" and "previous so and so many" system, whereby the user presses a button and can see the next row of displays. We limit the number of displays to 5, but that is completely up to the developer. We will add another feature, which is already familiar to us. We allow the user to press a button and have an XHTML page displayed that shows more details for a particular item. The third feature we will add is to allow the user to save all the searches. We use the shared object for that, which will save the data for a search on the user's computer. This will give you an idea how to create a system to save data, and you will be able to use server-side scripts to allow saving data on a server. The scheme from Chapter 13 is now extended as shown in Figure 14.1. The new classes manipulate or interact with the houseDisplay MovieClips, including the class DisplaySaved, which triggers the display of saved items.

XHTML, SWF, and htmParser

To view more details of a particular search we need to establish what we want to achieve.

1. We want to see a link to open a new file in the home display

All the data is shown in the homeDisplay MovieClip (houseDisplay). Therefore, it is reasonable to add a button to open additional files in homeDisplay.

2. This link should be present only when it is coded in the XML file to be so

We need to add code in the DisplaySearch class as to whether an additional file is available.

3. We want to be able to open either an XHTML or a Flash movie (.swf)

To open a Flash movie we have to create an empty MovieClip and load the movie. To achieve both goals we create a MovieClip, which we name htmParser. We add two TextFields, a small field for

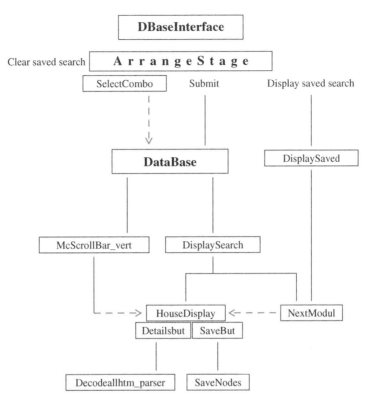

Figure 14.1 *Classes of the database search engine and their interactions*

only one line, titleText, which will show the title of the XHTML page, and a larger multiline field, myText, for the actual page. If necessary a scrollbar will be added. In the original XHTML parser we have used an instance of the TextArea component, but now we prefer a TextField, for which we can add and remove a scrollbar. You will see why we want to remove the scrollbar.

4. We want to be able to parse an XHTML file

We have already developed an XHTML parser in an earlier chapter (Chapter 6), using the Decodeallhtm_parser class. We will make use of this parser to show XHTML pages.

We add a MovieClip button, detailsBut, to the homeDisplay MovieClip and associate a class, Detailsbut, to the MovieClip button. This class will also belong to the interface. However, before we start writing this class, we need to know at which point we call it. When functions from the DataBase class are executed home display units are still empty. The home display units are filled with data when the DisplaySearch class is executed. At this point we want to make sure that buttons have functionality and are present when needed. We have already coded the command for

adding functionality to such buttons in the XML files. Open one of the XML files, for example, North.xml. If you look at the <details> node you will find either a path to a URL,

```
<details>detailed_htms/north_id1.htm</details>
```

or null as the node value. This will make it easy for us to distinguish whether a button should have functionality.

The Detailsbut Class

The button to view details is part of the houseDisplay MovieClip. If you open Chapter 14—Starter_1—DataBase.fla and go to the library and open the mc folder you will see that I have already added a button. It is just a simple MovieClip, which, when you check the properties, has a class, scripts.DataBase.Detailsbut, associated with it. This button is not visible, because it is located above a text field named detailsLink. See also Figure 14.2 for details (arrow). We will start writing the class first before changing other scripts to connect the class to the interface. The detailsBut MovieClip is part of the houseDisplay MovieClip.

Figure 14.2 *The detailsBut MovieClip button (arrow) is added to the houseDisplay MovieClip*

I do not show any outline for this class, because there is only one major function, which is a button "onPress" function to load an XHTML page or a movie. We start the class by declaring the class, which extends the MovieClip class, since this class is associated with the detailsBut MovieClip. The class is also part of the interface.

```
class scripts.DataBase.Detailsbut extends MovieClip
  implements scripts.DataBase.DBaseInterface
{
```

We need to declare only one variable, which is the MovieClip htmParser, where the XHTML page or a new movie is shown:

```
private var htmParser:MovieClip;
public function Detailsbut ()
{
}
```

The main function of this class, addDetails, is called from the DisplaySearch class and has two parameters, one for the button instance and one for the URL. We redefine both variables and equalize myLink with the class itself, since myLink refers to the button MovieClip. By passing the variable each time a home display receives data, each detailsBut instance in the homeDisplay units receives its individual function.

```
public function addDetails (myLink:Detailsbut,
 myUrl:String):Void
{
  this = myLink;
  var mUrl:String = myUrl;
```

We add button behavior when the mouse rolls over, which is a simple change in text color and style:

```
this.onRollOver = function ()
{
  this._parent.detailsLink.htmlText = "<font color=
    '#B40052'><u><i>View details!</i></u></font>";
};
this.onRollOut = function ()
{
  this._parent.detailsLink.htmlText = "<font color=
    '#000066'><u>View details!</u></font>";
};
```

The "onPress" function will load an XHTML page or a movie.

```
this.onPress = function ():Void
{
```

We first delete any object from a previous operation:

```
holder.removeMovieClip ();
```

We again make sure that there is a valid URL:

```
if (mUrl != undefined)
{
```

Since we have the option to load either an XHTML page or a movie (.swf), we need to distinguish between these possibilities. The main difference in the file that we call is the file extension, .htm or .swf or .jpg, if we want to load an image. We can examine the file extension by creating a substring from the URL, which starts three characters from the end of the string (-3).

```
var ext:String = mUrl.substr (-3);
```

If the extension is .htm, we call the function "xmlLoad" of the htmParser MovieClip, which will load the contents of an XHTML page into the TextField myText, as we have discussed in Chapter 6:

```
if (ext == "htm")
{
  var proxy:Boolean = false;
  this._parent._parent._parent._parent.
   htmParser.xmlLoad (mUrl, proxy);
}
```

If the extension is .swf, then we attach an empty MovieClip from the library at certain coordinates in the movie:

```
else if (ext == "swf")
{
  var holder:MovieClip = this._parent._parent._
   parent._parent.attachMovie ("holder", "holder",
   this._parent._parent.getNextHighestDepth (),
   {_x:450, _y:125});
```

We eliminate any scrollbar associated with the TextField myText:

```
this._parent._parent._parent._parent.htmParser.
 destroyObject ("myScroller");
```

We then load the movie:

```
holder.loadMovie (mUrl);
      }
    }
   };
}
```

We could have chosen a simple "else" statement without another "if (ext == "swf")", which would allow any other file to be loaded into the movie, such as .jpg, .png, or .gif. However, we need to decide one way or another.

Calling the Detailsbut Class

Now that the class is written, we need to connect it to the interface. As discussed earlier, we will create instances of the class when the data is loaded into the homeDisplay MovieClip. We need to open the DisplaySearch class and search for the line "myListener.waitAsecond = function (evObj:Object)". This is the function when loading of data occurs. Open the DisplaySearch class in the Starter_1—DataBase folder and look for this line. We create an "if" statement and ask if "evObj.m_8", which is equivalent to the node value of the <details> node, is not null. Remember that we have set the node value in the XML files to null when there was no detailed

information available. If there is a URL, we create an instance of the Detailsbut class, which we name shDetails:

```
if (evObj.m_8 != "null")
{
   shDetails = new Detailsbut ();
```

We call the main function of the Detailsbut class and use the detailsBut MovieClip as one parameter. The button is a detailsBut object and has to be data type as such. The two parameters of this function are now the button id and the URL.

```
var dBut:Detailsbut = homeDisplay.detailsBut;
shDetails.addDetails (dBut, evObj.m_8);
dBut.enabled = true;
```

We add a value to the TextField instance that is associated with the detailsBut object and set HTML to true, since we use HTML tags to manipulate the text:

```
homeDisplay.detailsLink.html = true;
homeDisplay.detailsLink.htmlText = "<u>View details!</u>";
}
```

We should not forget to import the Detailsbut class before testing the movie. Otherwise we will get an error message.

```
import scripts.DataBase.Detailsbut;
```

We also need to define the variable, "shDetails", which is of data type DBaseInterface, because the Detailsbut class is part of the interface.

```
private var shDetails:DBaseInterface;
```

Do not forget to add the main method of the Detailsbut class, addDetails, to the collection of interface methods.

Changing the DataBase Class

When a new search is initiated, we want to eliminate displays of the previous search. When an XHTML page was shown the UIScrollBar in the myText TextField would still be visible, as well as any text or images. Therefore, we need to add code in the DataBase class. To destroy the UIScrollBar we create two variables, a function variable and a variable for the scrollbar itself. Although the function "destroyObject" is a Flash function, we need to declare it first to avoid an error message:

```
private var destroyObject:Function;
private var myScroller:mx.controls.UIScrollBar;
```

We destroy the scrollbar when the function "initLoading" is executed:

```
this._parent.htmParser.destroyObject ("myScroller");
```

We eliminate any background in the TextField:

```
this._parent.htmParser.myText.background = false;
```

We remove any text from both the titleText and the myText TextFields:

```
this._parent.htmParser.myText.htmlText = "";
this._parent.htmParser.titleText.text = "";
```

We need to add one more line in the "displaySelection" function to disable the detailsBut instances, which will be activated only when additional information is available as discussed earlier:

```
homeDisplay.detailsBut.enabled = false;
```

Furthermore, we need to import the Detailsbut class into every class belonging to the interface, because the variable "myLink" has the data type Detailsbut ("function addDetails (myLink:Detailsbut, myUrl:String):Void"). We are now ready to test the movie, but before that we need to create movies and pages to show. I have prepared a movie, which is called showroom.swf, and also several XHTML pages. When you test the movie and search for "all homes" in "North" there will be eight matches. Click on all matches that show "View details" and one of them is the showroom movie. I have added one of my components, which reduces the frame rate, since child movies have the same frame rate as their parents. This component is also part of the package on the CD.

The NextModul Class: Planning

So far we have been dealing with small numbers of displays like 8–14. However, if the number increases to 100 or 200, it is difficult and inconvenient for the user to scroll all the way down. We, therefore, divide the displays into groups of 5. We could choose groups of 10 or 15, but that is up to you and can easily be changed in the script. We will create a new class, the NextModul class, which is associated with the nextModul MovieClip. This MovieClip has two buttons, for the next row and the previous row of displays, and several TextFields to show the number of displays. One question is, with which class or classes will the new NextModul class communicate? For the NextModul class to function properly it is important that the number of displays is known. Therefore, the answer would be either the class that determines the number of displays or the class that fills the displays will interact with the NextModul class. We have chosen the class that is responsible for filling the data, the DisplaySearch class. The reason we have chosen this class is that the displays are filled with data and, therefore, the number will definitely be known. The NextModul class will also communicate with the DataBase class for clearing an array. We always have to consider a way (1) to clear previous searches and (2) to do it in a timely fashion. This is demonstrated in Figure 14.3. Functions from the DataBase class are executed first, followed by

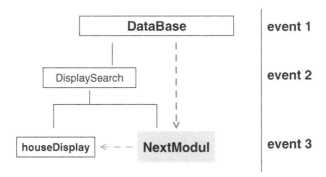

Figure 14.3 *Interaction of the NextModul class with other classes*

functions from the DisplaySearch class. Clearing any previous data has to be done when the DataBase class is executed. However, we first need to write the class before we can add methods in any of the other classes.

Our goal is to show only five displays at a time. This means that we need to hide all other displays. When I originally designed this site the idea was to have clusters of five stacked on top of each other. That worked out, but there was a problem, which is shown in Figure 14.4. If a hidden display had an active detailsBut instance but the display above did not, then the mouse would still react to the hidden button, since we cannot hide the button behavior. I came up with the solution to move all display clusters that are not shown to the right and outside of the mask area. They will not be displayed and the mouse will not react to these buttons, because they are outside of the mask. So we need to make changes in the DataBase class, in which the clusters are originally arranged, as well. So far they have all been displayed in one row, but now all displays from number 6 on need to be moved outside of the mask area. We will do that after we have completed the NextModul class script.

detailsBut

Figure 14.4 *Stacking of displays will not hide buttons and hidden buttons are still active*

We will make a brief outline for this class. We need a function with one parameter, for the number of displays. This function is called when the DisplaySearch class is executed. We need two "onPress" button functions for the Next and Previous buttons. We need a counter variable to remember the number of the stack that is being shown. We will create an array that holds all display units and will aid in shuffling the stacks. We create an additional function, which is a public static function,

"renewArray". The DataBase class will call this function when a new search is initiated. Then the array will be renewed before being filled with data during execution of the DisplaySearch class as shown in Figure 14.3.

Additions to Other Classes

We first need to place the nextModul MovieClip on stage. We add one line in the script for the class ArrangeStage:

```
this._parent.attachMovie ("nextModul", "nextModul", 5,
  {_x:72, _y:105});
```

To connect the NextModul class to the search engine, we have to call the main function of the NextModul class from the DisplaySearch class. Basically this is also one line, which we place within the listener, in which all data is added to the display units. The main function name is "showNextFive".

```
homeDisplay._parent._parent._parent.nextModul.showNextFive
  (homeDisplay);
```

We are not yet finished and need to add some lines to the DataBase class. We want to renew the array every time a new search is initiated. We will call the static function of the NextModul class "renewArray". Therefore, we need to import the class first. Add an import statement in the DataBase class:

```
import scripts.DataBase.NextModul;
```

Then somewhere where we load the XML data we call the static function "renewArray" using the class name:

```
NextModul.renewArray();
```

This will make sure that when a new search is initiated a new array instance is created to collect all displays. Within the "displaySelection" function we need to add a few lines. We want to display the results in groups of five house displays. We count from 0 to 4 and then use the value of count05. All displays will be oriented to be under the mask. All others will be oriented to be on the right side of the mask and will be hidden.

```
if (count03 < 5)
{
  homeDisplay._y = (count03 * 110) + 5;
  if (count05 < 5)
  {
    homeDisplay._x = 0;
  }
  else
  {
```

```
        homeDisplay._x = this.mask._width;
      }
    }
    else if (count03 == 5)
    {
      count03 = 0;
      homeDisplay._y = (count03 * 110) + 5;
      homeDisplay._x = this.mask._width;
    }
```

We are now ready to write the NextModul class.

The NextModul Class: Script

After we have finished all of these preparations we can focus on writing the script for the NextModul class. The main functions in this class are those associated with the Next and Previous buttons. For these button events we need the Delegate class to extend the scope of the function:

```
import mx.utils.Delegate;
```

We need to import also the Detailsbut class because of a listed interface function (see above):

```
import scripts.DataBase.Detailsbut;
```

The NextModul class also belongs to the interface, which we express in the class declaration. The class extends the MovieClip class, because it is associated with the MovieClip nextModul.

```
class scripts.DataBase.NextModul extends MovieClip
  implements scripts.DataBase.DBaseInterface
{
```

We need a few variables, which are mainly the buttons and a TextField that displays the current row number of displays.

```
      private var prevBut:MovieClip;
      private var nextBut:MovieClip;
      private var noDisplays:TextField;
```

We need a variable for an array that will hold the total number of displays:

```
      private static var displayArray:Array;
```

Finally, we declare a static variable for the row number:

```
      private static var count:Number;
      public function NextModul ()
      {
      }
```

Before we add the button functions we add the public static function "renewArray", which is called from the DataBase class and which creates a new instance of the displayArray. This indicates that a new search has started.

```
public static function renewArray ():Void
{
  displayArray = new Array ();
}
```

Now we add the main function of this class, which is called from the DisplaySearch class. The function has one parameter, homeDisplay, which is the instance name for a display unit.

```
public function showNextFive (homeDisplay:MovieClip):Void
{
```

Since this function is called whenever a display unit is created, we collect all units in the array using the push method:

```
displayArray.push (homeDisplay);
```

If the number of displays is larger than 5 the module will be visible but with only the Next button. We also indicate the numbering of the displays. Since these are the first five, the text shown will be "From 1–5".

```
this._visible = true;
if (displayArray.length > 4)
{
  this.prevBut._visible = false;
  this.nextBut._visible = true;
  this.noDisplays.text = "From 1 - 5";
}
else
{
```

If the total number of displays is smaller than or equal to 5 we do not need any buttons but still want to show the number of displays. The last number is the array length.

```
this.prevBut._visible = false;
this.nextBut._visible = false;
this.noDisplays.text = "From 1 - "+displayArray.
  length;
}
```

We set the row count variable, "count", to 0:

```
count = 0;
```

Then the button functions follow and we incorporate the Delegate class:

```
this.nextBut.onPress = Delegate.create (this,
 nextFunction);
function nextFunction ():Void
 {
```

First we need to pull back the scrollbar to its original null position:

```
this._parent.infoDisplay.m_scrollbarver.
 m_scroller._y = 0;
```

Since the Next button has been pressed, we increment the row number by 1:

```
count++;
```

Now it is time to make the Previous button visible, so that the user has a choice to go back:

```
this.prevBut._visible = true;
```

Then we loop through the displayArray array to catch the number of displays and arrange them, moving displays that we do not need out of sight. To facilitate this we create a separate variable, "display", for each member of the array.

```
for (var counter = 0; counter < displayArray.length;
 counter++)
 {
   var display:MovieClip = MovieClip
    (displayArray[counter]);
```

In the first part of the "if" statement, all displays above "count * 5" will be shown when the Next button is pressed and when the total number of displays is smaller than "count * 5" plus 5. Then there is also no need for the Next button to be visible, because the end was reached.

```
if (counter >= (count * 5) && counter
 < ((count + 1) * 5))
 {
   display._x = 0;
   this.nextBut._visible = false;
```

If there are more than one page of items to display we write "From ... - ...". Otherwise we just indicate that this is the last display ("No:").

```
if(((count * 5)+1) < displayArray.length)
 {
   this.noDisplays.text = "From "+((count * 5)+1)
    +" - "+displayArray.length;
 }
```

```
        else
        {
          this.noDisplays.text = " No: "
          +displayArray.length;
        }
      }
```

Coming back to the first "if" statement, if there are more than "count * 5" plus 5 displays, all others are placed outside the mask area and we keep the Next button still visible for the next row of displays. We indicate the numbers for the displays in the noDisplays TextField.

```
        else
        {
          display._x = this._parent.infoDisplay.
           mask._width;
          this.nextBut._visible = true;
          this.noDisplays.text = "From "+((count * 5)+1)
           +" - "+((count + 1) * 5);
        }
      }
    }
```

The Previous button works in a similar fashion.

```
    this.prevBut.onPress = Delegate.create (this,
     prevFunction);
    function prevFunction ():Void
    {
      this._parent.infoDisplay.m_scrollbarver.
       m_scroller._y = 0;
```

Here we need to decrease the count by 1 to go back before we loop through all the displays:

```
    count--;
    for (var counter = 0; counter < displayArray.length;
     counter++)
    {
      var display:MovieClip = MovieClip
       (displayArray[counter]);
```

We have three independent "if" statements. This first "if" statement serves only to make the Next button visible or invisible and to display the number of displays currently shown:

```
      if (counter >= (count * 5))
      {
```

```
      this.nextBut._visible = true;
      this.noDisplays.text = "From "+((count * 5)+1)
       +" - "+((count + 1) * 5);
   }
   else
   {
     this.nextBut._visible = false;
     this.noDisplays.text = "From "+((count * 5)+1)
      +" - "+displayArray.length;
   }
```

The second "if" statement is in case the variable count is smaller than 1. Then the Previous button will become invisible and the text message indicates that the displays from 1 to 5 are shown.

```
   if (count < 1)
   {
     this.prevBut._visible = false;
     this.noDisplays.text = "From 1 - 5";
   }
```

The third "if" statement is responsible for the placement of the displays and only those within the current count (*5) plus 5 will be displayed.

```
   if (counter >= (count * 5) && counter
    < (count + 1) *5)
   {
     display._x = 0;
   }
   else
   {
```

All others are placed outside.

```
     display._x = this._parent.infoDisplay.
      mask._width;
   }
   }
   }
}
```

We finish the NextModul class by adding all the interface functions. We are now ready to test the movie. If you have followed the tutorial by adding lines by yourself and you get error messages, try to fix the errors by yourself. Otherwise, check the Starter2_completed folder for the completed version.

Saving Data: Introduction

Imagine that users who have used the search engine are interested in several homes and want to see them again later. If the users have to search every time among hundreds of items to find their original choices, it would be tedious and they might miss some of their favorite items. Since we are customer friendly, we try to avoid this and allow users to save their searches on their computer. To accomplish this task, we need to give the user the possibility of

- saving any home that is displayed
- displaying all the search items, or
- deleting the search

Then we need to think about the method with which the user can save data. One possibility is to store data on the server. A second simpler solution is to store the data on the user's computer. This is accomplished using the shared object in Flash. The disadvantage is that the user can retrieve the stored data only from his/her own computer.

We create again an outline of how we proceed. To save each display we need to know to which XML file it belongs to and which display it is. The information about the XML file will come from the DataBase class. The activation for the Save buttons will occur when the data is loaded, which is done by the DisplaySearch class (Figure 14.5).

Figure 14.5 *Connections of SaveNodes class to save displays to the search engine*

Therefore, there are two public functions, one function returning the value for the XML file and a second function, which activates the buttons. Within this function there is a function for an onPress button script.

Adding a Save Option to the Database.fla

We need buttons to save data. We add a button to save data to the houseDisplay MovieClip underneath the Loader component instance and name it "saveBut" (Figure 14.6). We also add a dynamic TextField and name it "saveField". We associate a class, SaveBut, to the button. The class file is located in the mc folder. Later we will give some function to saveBut for button rollover behavior. We add another MovieClip, displaySaved, which stays empty, to the library. We will use this MovieClip,

Figure 14.6 *Adding a saveBut MovieClip and a saveField TextField to the houseDisplay MovieClip*

which will be placed in the infoDisplay MovieClip as a holder for the DisplaySaved class. Therefore, we give this MovieClip linkage and add the path to the class file, "scripts.DataBase.DisplaySaved". This will be convenient for us, because we can easily access objects in the movie from this MovieClip using the "this" word. The DisplaySaved class is functionally very similar to the DataBase class and will call the DisplaySearch class to display the data.

In addition we will need a button to display the saved data and a button to clear the data. The functions for these buttons will be coded in the ArrangeStage class, since this is the most suitable place.

Adding Function to the saveBut Button

How do we proceed to add a "save" function to the saveBut button in the houseDisplay MovieClip? We need to recall when the displays are called and filled with data. That happens when the data from a search is displayed. The class that performs the display is the DisplaySearch class. As you can see the DisplaySearch class is central to the interface and connects various objects and functions to the search engine. Open DisplaySearch.as in either the Starter_3 or the FINAL folder, if you just want to look at the final script. Within the function "waitAsecond" we load all data into the MovieClip instances homeDisplay (houseDisplay MovieClip in the library) that are the display units. Here we also call a function to save the data and associate the function with the saveBut instances. We create a new instance of the SaveNodes class, which we have not yet written. However, to test the class later we need to create instances of the class at this point.

```
saveNode = new SaveNodes ();
```

We call a function, "addImagebut", which has two parameters, homeDisplay.saveBut and evObj.m_9. The first parameter is the saveBut instance for each display, which allows us to associate unique identifiers to each button instance. The second parameter is the id attribute value, which has a unique value, usually a number. Why do we choose the id attribute? This question is answered by another question. How do we save the information? Since all the information of one homeDisplay MovieClip is contained in the child nodes of a <house> node, we can retrieve

a complete <house> node using the idMap property. Therefore, we will store the id number and when we want to display the data again we just call the <house> node using the id number and idMap. We make use of the saveField TextField to give the saveBut MovieClip a text. When the saved selection is shown, the first part of the "if" statement will be executed.

```
saveNode.addImagebut (homeDisplay.saveBut, evObj.m_9);
homeDisplay.saveField.html = true;
if (!homeDisplay.saveBut._visible)
{
  homeDisplay.saveField.htmlText = "<u>Saved
    selection</u>";
}
else
{
  homeDisplay.saveField.htmlText = "<u>Save!</u>";
}
```

The Save buttons are now activated and we need to add functionality. Do not forget to import the class SaveNodes before closing the DisplaySearch class file.

Saving XML Nodes: The SaveNodes Class

We need to write two classes, one class to save data, the SaveNodes class, which gives functionality to the saveBut MovieClips, and one class, the DisplaySaved class, that allows the display of saved data. Initially we want to save all the information for one home, which is contained in a <house> node with its child nodes. Then we need to store not only the node data but also to which XML file it belongs, since there are several XML files, depending on the city. So the strategy is to get the URL for the XML file of one node and the node itself and store the information using the shared Object method. The storage base will be an XML file by itself.

For the SaveNodes class we first need to import some classes and declare the class, which is also part of the interface.

```
import mx.utils.Delegate;
import scripts.helper.InitiateXml;
import scripts.DataBase.Detailsbut;
class scripts.DataBase.SaveNodes implements
 scripts.DataBase.DBaseInterface
{
```

We further declare a static variable, which will hold the XML file for one location. We create a variable for a new XML object to load and parse the XML file using the InitiateXml class.

```
private static var selectXml:String;
private var pXml:InitiateXml;
```

We need variables to create the XML file in which the data will be stored. This also includes "nodeId", which is the id attribute of a <house> node. Related to this is the variable "sl_nd", which will hold the id number as a reference to a Save button.

```
private static var newXML:XML;
private var element1:XMLNode;
private var nodeId:String;
private static var sl_nd:Number;
```

We need a variable for an array that will collect all the different <house> nodes. As usual the constructor follows:

```
private var dataArray:Array = new Array ();
public function SaveNodes ()
{
}
```

We create a public function, which is called by the DataBase class. The purpose of this function is to store the URL for an XML file for each node. Whenever a new search is initiated the variable "selectXml" will get a new value. Later I will show where we call this function from the DataBase class.

```
public function saveXmlFile (myXml:String):String
{
  selectXml = myXml;
  return selectXml;
}
```

The next function is also public and is the major function of this class that is called by the DisplaySearch class. This function has two parameters, for each saveBut instance and for the id attribute.

```
public function addImagebut (saveLink:MovieClip,
 nId:String):Void
{
```

For the player to know which button was pressed, we associate each saveBut with the id number:

```
saveLink.nodeId = nId;
```

Next we write the function for the saveBut. We use the Delegate class here to widen the scope of the function:

```
saveLink.onPress = Delegate.create (this,
 butFunction);
function butFunction ():Void
{
```

In the "if" statement we reconfirm that the button pressed actually has an id number:

```
if (saveLink.nodeId != undefined)
{
```

We create a new variable to hold this number. The variable value will be stored in the XML data file:

```
sl_nd = saveLink.nodeId;
```

We load and parse the XML file that contains the node to be stored:

```
pXml = new InitiateXml ();
pXml.init (selectXml, loadParse, this);
```

We create a new XML object, which is the object to store the data:

```
newXML = new XML ();
```

We add the root node to the XML object with a node name of <realtor>. This is just coincidence. We could have chosen another name. We append the root node to the XML object:

```
element1 = newXML.createElement ("realtor");
newXML.appendChild (element1);
        }
    }
}
```

The next function is the XML parser function:

```
private function loadParse ()
{
```

We create a new SharedObject object, which will be the cookie on the user's computer:

```
var my_so:SharedObject = SharedObject.getLocal
 ("kookie");
```

Then we add XML nodes to the dataArray array using the id number and the idMap property. This will store all the <house> nodes with child nodes in the array.

```
dataArray.push (pXml.defaultXML.idMap[sl_nd]);
```

We need the array, because every time we loop through the array, we increase the virtual XML file by another node. In fact, we always create a new XML object by using a "for" loop and add child nodes to it:

```
for (var counter = 0; counter < dataArray.length;
 counter++)
{
  element1.appendChild (dataArray[counter]);
```

When we reach the array length (-1) we store the XML as data of the shared object:

```
if (counter == (dataArray.length - 1))
{
  my_so.data.xml = newXML;
}
}
}
```

The data will be saved in a .sol file with the name "kookie", which is the name that we gave the SharedObject. You can open the file using a text editor. A typical saved file will look like this:

```
‾˘TCSOkookiexml |<realtor><house id="2"><bedroom>2</bedroom>
<bath>1</bath><price>139,999</price><built>1982</built>
<city>North Sacramento</city><image>images/house2.jpg
</image><details>null</details></house><house id="4">
<bedroom>1</bedroom><bath>1</bath><price>56,000</price>
<built>1985</built><city>North Sacramento</city>
<image>images/house4.jpg</image><details>null</details>
</house></realtor>
```

Now that we have stored the data, we want to be able to call it when we need to.

Adding Display/Clear Buttons

To display saved information or allow the user to clear it we need to add buttons first. Open the ArrangeStage class, with which we will add code to place the buttons on the main timeline. We use button components and we add the buttons savedSearchBut and clearBut, using the createClassObject method. We also add the MovieClip displaySaved within the infoDisplay MovieClip. We need this MovieClip to display the saved data.

```
this._parent.createClassObject (Button, "savedSearchBut",
 6, {label:"Display saved search", _x:20, _y:29,
 _width:150});
this._parent.createClassObject (Button, "clearBut", 7,
 {label:"Clear saved search", _x:20, _y:5, _width:150});
this._parent.infoDisplay.attachMovie ("displaySaved",
 "displaySaved", this._parent.infoDisplay.
 getNextHighestDepth ());
```

We give the two buttons function by adding code to the "aStage" function. First we create a listener for the savedSearchBut button:

```
var saveListener:Object = new Object ();
saveListener.click = Delegate.create (this, display);
function display ():Void
{
```

We make the nextModul MovieClip invisible, in case we had done a prior database search. Then we call the function "displayData", which belongs to the class DisplaySaved, which extends the MovieClip displaySaved.

```
        this._parent.nextModul._visible = false;
        this._parent.infoDisplay.displaySaved.displayData ();
    }
    this._parent.savedSearchBut.addEventListener ("click",
      saveListener);
```

Next we add the code to the clearBut button. We know from the SaveNodes class the name of the SharedObject object, which is "my_so". After creating a listener and a function we declare a new SharedObject object with the same name:

```
    var clearListener:Object = new Object ();
    clearListener.click = Delegate.create (this, clearData);
    function clearData ():Void
    {
      var my_so:SharedObject = SharedObject.getLocal
        ("kookie");
```

To clear the data we use the clear() method:

```
        my_so.clear ();
```

We also clear other parameters and make the nextModul invisible and clear several text areas and text fields. We remove the holder MovieClip, which is located in the infoDisplay MovieClip, and adjust the scrollbar to the original status:

```
        this._parent.nextModul._visible = false;
        this._parent.htmParser.myText.text = "";
        this._parent.htmParser.titleText.text = "";
        this._parent.infoDisplay.holder.removeMovieClip ();
        scroller = new McScrollBar_vert ();
        scroller.scrollBar_vert (this._parent.infoDisplay.mask,
          this._parent.infoDisplay.mask, this._parent.
          infoDisplay);
    }
    this._parent.clearBut.addEventListener ("click",
      clearListener);
```

Displaying Saved Data: The DisplaySaved Class

The DisplaySaved class is nearly identical to the DataBase class except for the part that deals with the shared object. We discuss only the lines that are new to this class. We need to create a SharedObject object, which we call "my_so". The name of the data file is "kookie".

```
var my_so:SharedObject = SharedObject.getLocal ("kookie");
```

Then we ask if data is associated with this SharedObject:

```
if (my_so.data.xml != undefined)
{
```

If so, we create a new XML object and associate it with the saved data. We also trigger a function, "disSaved", which is very similar to the parse function "loadParse" of the DataBase class:

```
var doc:XML = new XML (my_so.data.xml);
this.disSaved (doc);
}
else
{
```

If the shared object does not exist, because no data had been saved, we remove the holder MovieClip and inform the user that there is no saved data:

```
this._parent.holder.removeMovieClip ();
this._parent._parent.myMessage.text = "No saved data
 available!";
}
```

The "disSaved" function will get all child nodes by a "for" loop and then the data will be displayed using the DisplaySearch class. This brings us close to the conclusion of the Database interface. However, there is still something we need to add. Do not forget to add all the interface functions.

Adding a Function Call to the Database Class

I need to refresh your memory now. In the SaveNodes class we had a function, "saveXmlFile", which recorded the URL for the XML file. This information is received from the DataBase class, in which the function call is made. If you open DataBase.as at the end of the function "initLoading" you need to add two lines of code:

```
saveNode = new SaveNodes ();
saveNode.saveXmlFile (xmlFile);
```

This creates a new SaveNodes object and will call the "saveXmlFile" function. You also need to import the SaveNodes class and create a variable. Once you are done you can test your own movie or open the DataBase.fla in the FINAL folder and test that movie.

Putting the Pieces Together, the Real Estate Web Site

We are now at an exciting stage. We have completed all the individual parts for the big movie. If we were working as a team, we would now have a meeting and discuss how to put the parts together. All files are in the folder Real_Estate_final. The first question that arises is whether we create one large movie incorporating all parts or split it into several movies. If we create a large movie, we have the problems of long loading and publishing times. We may need to create a pre-loader for this movie. None of these problems will occur if we split the site into several small movies. This means that we just use the .swf files from the individual movies and copy them to the folder of our main movie.

The next question is how we organize the movie. We already answered this question when we pre-pared the menu bar (Chapter 12). At that point we had to decide how many frames the movie would have, although we have not included any fancy introductory movie yet. There are five frames, "Home", "New Houses", "Search", "Just Sold", and "Contact Us". In each frame we place empty MovieClips into which the movies will be loaded. There are of course some graphics and images, too. In the following we will go through the individual frames, but mainly discuss the first frame, "Home".

The Home Frame

We create a new .fla, which we name Real_Estate_final.fla. We create five frames and give frame names as described in Chapter 12. In the Home frame there will be two movies loaded, mort-gage_ad.swf and Rss_feed.swf. We create one empty MovieClip with symbol name "holder". We place instances of holder on the stage where we want to have the loaded movies located (Figure 14.7). The MovieClips for the menu bar are in the library. We create an empty MovieClip, Menu, which has linkage id and is associated with the class Finalmenu. We place this MovieClip on stage and name it myMenu. We also want to preload some XML files or images, if required. I have supplied a pre-loader, which can be used for text/XML files or for images. The XMLloader class, which we do not discuss here, is associated with a MovieClip, preload (symbol name "XMLpreload"). Since we load movies that contain various components, it is important to have the components present in the library of the main movie as well. Otherwise, the components will behave abnormally. We can now add scripts to finalize the first frame. The first lines after "stop()" are variables for the script for the pre-loader for XML or images. If we preload XML files, we enter "text" as the itemType. If we wanted to jump to another frame after the preloading was completed, we would enter a frame name for the variable "gotPlay". The individual files are listed in an array, a_items. We will preload only the data-base XML files, which we expect will be large in size:

```
stop ();
var itemType:String = "text";
var barheight:Number = 10;
var myColor:Number = 0x000000;
var path:String = "xml_files/";
```

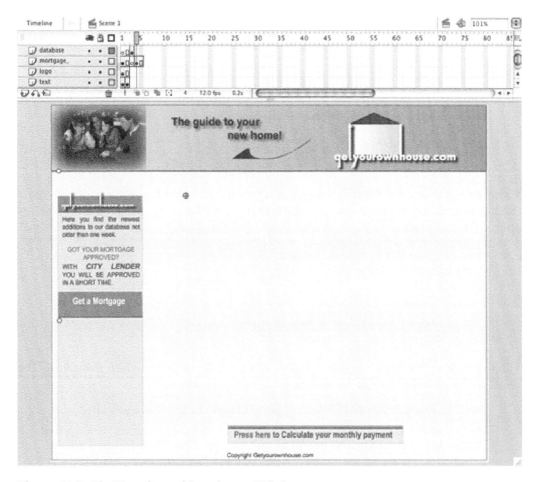

Figure 14.7 *The Home frame of the real estate Web site*

```
var a_items:Array = [path + "East.xml", path + "West.xml",
 path + "North.xml", path + "South.xml"];
var gotPlay:String = "null";
var counter:Number = 0;
preload.loadTheMovie (itemType, barheight, myColor,
 a_items, gotPlay, counter);
```

We then load an image into the Loader component, which is on the stage with the name "mainPic":

```
mainPic.contentPath = "images/front_pic.jpg";
```

Next we load the Rss_feed movie into a MovieClip named "rssFeed".

```
rssFeed.loadMovie ("Rss_feed.swf");
```

We load the XML file for the menu bar and activate the menu bar by calling its main function:

```
var menuFile:String = "xml_files/menu.xml";
myMenu.selectItem (menuFile, false);
```

We load the mortgage_ad movie:

```
mortgage_ad.loadMovie ("mortgage_ad.swf");
```

We call the mortgage calculator Web service from a button. We need to import the ExternalInterface class and put a JavaScript in the corresponding HTML page. The two parameters for the call function are the openWindow JavaScript function and the HTML page to load.

```
import flash.external.ExternalInterface;
mortgageBut.onRelease = function ()
{
  var newWindow:String = String (ExternalInterface.call
    ("openWindow", "Mortgage.html"));
};
```

This is the JavaScript for opening a new window, which is in the head part of Real_estate.html. The height and width of the window are sized to the size of the movie.

```
<script language="javascript" type="text/javascript">
<!--
function openWindow(newWindow) {
  window.open(newWindow, "myFile", "height=420, width=570,
    scrollbars=no, top=0");
}
-->
```

In the treeMenu movie we had to use _root throughout. Because of that we need to use _lockroot for the MovieClip, which loads treeMenu.swf. This shows that using _root can be of disadvantage and should be avoided.

We proceed adding scripts to the other frames in the same way. Please look at the final Real_Estate.fla file. We can now upload all files and test them on the server.

15 Content Management

Introduction

Now that we have created the real estate Web site and a database, we would like to facilitate working with the database without constantly changing the XML files manually and uploading them back to the server. We need to consider that a client may not have the experience doing so and may make syntax mistakes in writing the XML file. We, therefore, create a simple content management system (CMS). Using the CMS the client will be able to add nodes to any XML file or to delete nodes by just filling out a simple form. To accomplish this we need to write some server-side scripts as well. In the following chapter we will create two different types of CMS, one that is based on writing into XML files and one that is based on MySQL.

The Non-MySQL Version

How do we start? We need to look at the XML files first. We have the <house> nodes, which are the parent nodes for the child nodes that contain all the information. We are lucky that we have given the <house> nodes id tags, since we will make use of them when we delete nodes. What do we need for the movie? For adding nodes we need TextInput fields and a Submit button. For deleting nodes we need only one TextInput field to enter the node id tag and a Submit button. We need a menu to select the XML file to process (Figure 15.1).

We plan on writing five ActionScript files:

- A script to set the stage
- A script to show the menu
- A script to add nodes
- A script to delete nodes
- A script for the interface

We further plan on writing two PHP scripts, to add nodes and to delete nodes. An outline of what we are trying to accomplish is shown in Figure 15.2.

First we will create the graphics and MovieClips that we need for the ContentManagement movie. We create a MovieClip, which we name contentManager. We associate this MovieClip with the ContManagement class. This class will place all the objects on stage and in addition create the

Figure 15.1 *The ContentManagement movie*

ContManagement

1. place all Movieclips

ContMenu

1. create Menu
2. call XML file to be modified
3. control DeletNode and AddNodes

DeleteNode

1. delete Node
 from TextInput

AddNodes

1. add TextInput
 fields
2. create XML
3. call php file
 and send data

Figure 15.2 *Outline for the ContentManagement movie*

interface with all the objects to add nodes. The contentManager MovieClip itself contains only some simple graphics and one TextField, which we use to announce messages. ActionScript will add all other objects. When the movie is loaded we will show only the button with 100% alpha, which opens a menu, since the user has to select an XML file before doing anything else. Once selected, all other objects will appear with 100% alpha as well. We achieve this effect with a shape that is only partially transparent. We will also need Alert boxes, which pop up when the user has not filled out TextFields. We need a headline for the part of the CMS in which the user adds nodes. Then we need a MovieClip, which contains all the objects necessary to delete nodes. This MovieClip is associated with the DeleteNode class. The button to open the menu will be placed in a MovieClip that is associated with the ContMenu class. There will also be a button that leads back to the real estate Web site.

The ContManagement Class

We divide the stage into three parts (Figure 15.1). The first part consists of the button with which the user opens a menu and selects the XML file. The second part is a MovieClip that contains all the objects required to add nodes. The third part is a MovieClip that contains the required objects to delete nodes. The class script, which places all the objects on stage, is the ContManagament class. We will go through this class step by step. For this class we do not need to import any other class, but start with the class declaration. This class extends the MovieClip class and is associated with the main MovieClip contentManager. In the MovieClip hierarchy, this MovieClip is at the top and all other MovieClips are inside of contentManager.

```
class scripts.management.ContManagement extends MovieClip
  implements scripts.management.ManageInterface
{
```

We need these variables to load an XML file:

```
public var xmlFile:String;
public var proxy:Boolean;
```

The following variables hold the MovieClips:

```
private var addNodes:MovieClip;
private var deleteNode:MovieClip;
private var mask:MovieClip;
private var contentMenu:MovieClip;
```

The function "init" is called from the movie and has parameters to position all MovieClips.

```
public function ContManagement ()
{
}
```

```
public function init (addn_x:Number, addn_y:Number,
 dn_x:Number, dn_y:Number):Void
{
```

We first place the addNodes MovieClip and position it:

```
addNodes = this.attachMovie ("addNodes", "addNodes",
 this.getNextHighestDepth ());
addNodes._x = addn_x;
addNodes._y = addn_y;
```

Then the deleteNode MovieClip follows:

```
deleteNode = this.attachMovie ("deleteNode",
 "deleteNode", this.getNextHighestDepth ());
deleteNode._x = dn_x;
deleteNode._y = dn_y;
```

It is important that those two MovieClips are placed first, since we want to hide them partially behind a shape. We achieve this by placing the shape (mask) on top of the two MovieClips and increasing the transparency by 25% (decreasing alpha by 25%).

```
mask = this.attachMovie ("mask", "mask",
 this.getNextHighestDepth ());
mask._width = Stage.width;
mask._height = Stage.height - 20;
mask._alpha = 75;
```

We place the contentMenu MovieClip one level above the mask MovieClip and this will keep its full visibility:

```
contentMenu = this.attachMovie ("contentMenu",
 "contentMenu", this.getNextHighestDepth ());
}
```

We currently do not add any interface functions but wait until we have completed the movie. However, we need to create the interface class ManageInterface.

The ContMenu Class: XML File

Before any nodes can be added or deleted we have to determine in which database file this will happen. There are currently four XML files for the cities. We have several choices for what kind of menu we use. We could use the ComboBox or the List component or we could create our own menu. Since we are familiar with the Menu component we create a menu using this component and a Button component as we learned in Chapter 8. We first create a MovieClip, contMenu, which we associate with the ContMenu class, and leave it in the library. The MovieClip has a component Button instance. As you know from the previous paragraph, contMenu is placed on stage

by the ContManagement class. We are now quite familiar with XML files and, therefore, we first write the XML file for the ContMenu class.

```
<?xml version="1.0" encoding="utf-8"?>
<keywords>
  <main>SELECT CITY
  <kword data="xml_files/North.xml">North-Sacramento</kword>
  <kword data="xml_files/South.xml">South-Sacramento</kword>
  <kword data="xml_files/East.xml">East-Sacramento</kword>
  <kword data="xml_files/West.xml">West-Sacramento</kword>
  </main>
</keywords>
```

If you check Chapter 8 again and look at the XML file keywords.xml, you will notice that the above XML file is very similar. The only difference is that we have added data attributes. It will, therefore, not be new to you to write the class. Going back to Chapter 8 you should be able to do it on your own. However, we will nonetheless discuss the class here, because it will be important to connect this class with the AddNodes and DeleteNode classes.

The ContMenu Class: Script

So let's start writing the script. I will skip the head part of the class this time and go directly to the XML loading function, "managerMenu", with two parameters, for the XML file and the proxy. I will also skip parts that have been dealt with in the Menu tutorial (Chapter 8) and concentrate on what is specific or new in this class.

```
public function managerMenu (xmlFile:String,
 proxy:Boolean):Void
 {
```

We give the Button instance, which will open the menu and which we already placed in the MovieClip, a label:

```
this.menu_button.label = "Select File from Menu";
```

We create a menu using the Menu component and then load the XML file:

```
var my_menu:Menu = Menu.createMenu ();
iniXml = new InitiateXml ();
iniXml.init (xmlFile, menuLoad, this, proxy);
```

As you see here, we do not always need to create a new class function but can make use of a local function, which is the function to parse the XML file:

```
function menuLoad ():Void
 {
```

We create a shortcut variable to avoid writing the whole expression every time:

```
var menukw:XMLNode = iniXml.defaultXML.firstChild;
```

We fill the menu component with data. We first create a headline (SELECT CITY from the XML file):

```
my_menu.addMenuItem
(menukw.firstChild.firstChild.nodeValue);
```

Since we do not want to have the menu directly underneath the headline we add an empty line next:

```
my_menu.addMenuItem ("");
```

We disable the button functions for both lines:

```
my_menu.getMenuItemAt (0).attributes.enabled = false;
my_menu.getMenuItemAt (1).attributes.enabled = false;
```

We loop through the child nodes to get the values and data for the XML file URLs:

```
for (var i = 0; i < menukw.firstChild.childNodes.
 length; i++)
{
  var menuItem:String = menukw.firstChild.
   childNodes[i].firstChild.nodeValue;
  var dataItem:String = menukw.firstChild.
   childNodes[i].attributes.data;
  if (menuItem != undefined)
  {
```

We add labels, which are the node values, and data, which is the data attributes, to the menu:

```
    my_menu.addMenuItem ({label:menuItem,
     data:dataItem});
  }
 }
}
```

We give the button that opens the menu a function by using the Menu.show method (Chapter 8). Then we give the menu items button functions:

```
var menuListener:Object = new Object ();
menuListener.change = Delegate.create (this,
 menuFunction);
function menuFunction (evt_obj:Object)
{
```

We remove the shape for the management modules to indicate to the user that the XML file is loaded and everything is ready to proceed, adding or deleting nodes. We achieve this by setting the alpha value of the shape (mask) to 0. We further enable the Submit buttons of the addNodes and deleteNode MovieClips, which were disabled:

```
this._parent.mask._alpha = 0;
this._parent.addNodes.submitBut.enabled = true;
this._parent.deleteNode.deleteBut.enabled = true;
```

We select the menu item that had been pressed and the corresponding data attribute, which holds the URL for the XML file. The function "whichXML" will load and initiate parsing the XML file selXML. "evt_obj.menuItem" refers to a node.

```
        var item_obj:Object = evt_obj.menuItem;
        var selXML:String = item_obj.attributes.data;
        var proxy:Boolean = false;
        this.whichXML (selXML, proxy);
      }
    my_menu.addEventListener ("change", menuListener);
  }
  private function whichXML (contXML, proxy):Void
  {
    contentXML = contXML;
    iniXml = new InitiateXml ();
    iniXml.init (contXML, contLoad, this, proxy);
  }
```

The "contLoad" function is the XML parsing function. Using a "for in" loop we catch all the id numbers of the child nodes and collect them in the array idArray.

```
  private function contLoad ():Void
  {
    dataXML = iniXml.defaultXML;
    idArray = new Array ();
    for (var lastId in iniXml.defaultXML.idMap)
    {
      var idNum:Number = Number (iniXml.defaultXML.
        idMap[lastId].attributes.id);
      idArray.push (idNum);
    }
```

When we write the AddNodes class we will call the idArray array, which is public static. We will select the first member of the array, idArray[0], which is the id from the last node, since a "for in" loop starts with the last node first and ends with the first node.

The AddNodes Class: Adding and Arranging Objects

The AddNodes class has several functions (see Figure 15.2). TextField instances and a Submit button will be created and arranged. In a second function a new XML node will be created, which will be sent to the server and added to an existing XML file. This node will get a new id number. How do we know how many TextField instances we need to create? How do we know their names? All this information is located in one <house> node. So instead of adding TextField instances manually and giving names manually, we let the Flash player do all the work by calling and parsing an XML file. Our sample XML file is shown below. It contains the minimum information that we need to create the form. Except for the <image> and <details> nodes we do not need to add any node values.

```xml
<?xml version="1.0" encoding="utf-8"?>
<house>
  <bedroom />
  <bath />
  <price />
  <built />
  <city />
  <image>noimage.jpg</image>
  <details>null</details>
</house>
```

We can now concentrate on writing the script. In this first part we create and format all TextField instances and add a Submit button. All objects except for a headline text will be created virtually using the above XML file as a template. As we are now used to doing, we need to import classes and add a number of variables, which I do not show any more and which you can look up when you open the AddNodes class. We start directly with the public function, which is called from the movie and has two parameters for loading the above XML file, Sample.xml and the "proxy" variable. We create a new instance of an array, textArray, which will hold node names and values of the XML file. We will need this array later when we create the XML node that will be sent to the server.

```
public function manager (sampleXML:String, proxy:
 Boolean):Void
   {
     textArray = new Array ();
     iniXml = new InitiateXml ();
     iniXml.init (sampleXML, cityLoad, this, proxy);
   }
```

Within the XML-parsing function "cityLoad" we loop through all the child nodes of the <house> node to determine the number and names of the TextField instances, which need to be created:

```
private function cityLoad ():Void
   {
```

```
for (var count = 0; count < iniXml.defaultXML.
  firstChild.childNodes.length; count++)
{
```

We create a variable, "children", for all child nodes:

```
var children:XMLNode = iniXml.defaultXML.
  firstChild.childNodes[count];
```

The variable "textNode" will hold the names for the TextField instances that are the node names of the child nodes.

```
var textNode:String = children.nodeName;
```

We first create TextField instances for the text field labels using the createTextField method. We name the text fields consecutively, "textLabel" plus a number. We position (_x is 0 and _y is 25*count) and size them:

```
this.createTextField ("textLabel" + count, this.
  getNextHighestDepth (), 0, (25 * count), 100, 25);
```

We add text, which is the node name of the child nodes:

```
this["textLabel" + count].text = textNode;
```

Next we create the input text fields using the createTextField method and position and size them:

```
this.createTextField ("tf_" + textNode, this.
  getNextHighestDepth (), 110, (25 * count), 100, 15);
```

The text fields will be formatted. We give them a border and a grayish background and make sure to typecast them as input text fields:

```
this["tf_" + textNode].border = true;
this["tf_" + textNode].background = true;
this["tf_" + textNode].backgroundColor = 0xF4F4F4;
this["tf_" + textNode]._name = "tf_" + textNode;
this["tf_" + textNode].type = "input";
```

We set tabIndex to facilitate typing and moving the cursor using the Tab button on the keyboard:

```
this["tf_" + textNode].tabIndex = count;
```

Now we restrict the use of characters to numbers in several TextInput instances:

```
if (textNode == "bedroom")
{
  this["tf_" + textNode].restrict = "0-9";
}
if (textNode == "bath")
```

```
    {
      this["tf_" + textNode].restrict = "0-9/.";
    }
    if (textNode == "price")
    {
      this["tf_" + textNode].restrict = "0-9/,";
    }
    if (textNode == "built")
    {
      this["tf_" + textNode].restrict = "0-9";
    }
```

We add default text in the details text field, which is the node value of the <details> node:

```
    if (textNode == "details")
    {
      this["tf_" + textNode].text = children.firstChild.
       nodeValue;
      detailsContent = this["tf_" + textNode].text;
    }
```

We do something similar for the image text field. The text is the path to the default image, in case there is no image available for this home.

```
    if (textNode == "image")
    {
      imageLabel = textNode;
      imageInitial = children.firstChild.nodeValue;
      this["tf_" + imageLabel].text = imageInitial;
      imageContent = this["tf_" + imageLabel].text;
    }
```

We create an array with the name and label of all TextInput instances:

```
    textArray.push ({name:this["tf_" + textNode]._name,
     label:textNode, clipContent:this["tf_"
     + textNode]});
  }
```

Finally, we place a Submit button on stage and position it following the TextInput instances. The button is a Button component. We disable the button. It will be enabled once the city XML file has been selected.

```
    this.createClassObject (Button, "submitBut", this.
     getNextHighestDepth (), {label:"Submit", _x:75,
     _y:25 + (25 * count)});
    this.submitBut.enabled = false;
```

The following text field, showNode, will show the XML node after it was added to the XML file. We also format this text field:

```
this.createTextField ("showNode", this.
 getNextHighestDepth (), 0, (this._height), 250, 0);
this.showNode.multiline = true;
this.showNode.wordWrap = true;
this.showNode.autoSize = true;
this.showNode.background = true;
this.showNode.backgroundColor = 0xFFFFFF;
this.showNode.border = true;
this.showNode.borderColor = 0xCCCCCC;
```

Then we create a function for the Submit button:

```
var submitListener:Object = new Object ();
submitListener.click = Delegate.create (this,
 submitFunction);
```

The function has a return value of data type String.

```
function submitFunction ():String
{
```

If the user did not select a city, an Alert box will appear. It is unlikely to happen now, since we have secured that the user has to select a city first. We keep it as a double lock.

```
if (ContMenu.contentXML == undefined)
{
  Alert.show ("Select a file name first.", "ERROR:",
   Alert.OK);
  contentXML = "error";
  return contentXML;
}
else
{
```

Otherwise we proceed and give the image TextField instance the complete URL for the default image:

```
this["tf_" + imageLabel].text = "images/" +
 imageContent;
```

This is followed by a new function, which will create the XML node, which is sent to the server:

```
this.createXML ();
 }
}
this.submitBut.addEventListener ("click",
 submitListener);
}
```

The AddNodes Class: Creating and Sending the XML Node

In the function that follows, the XML node is created from the input data from the TextInput instances. The XML node is then sent to the server together with the current XML file, which we want to modify. We do not need only the XML data and input data from the TextInput instances, we also need the id number of the last node. We will get the id by calling the array that we created when the contMenu class was executed.

The function to create the XML node is "createXML" and has a return type String.

```
private function createXML ():String
{
```

Prior to anything else we create new LoadVars objects for sending and receiving data. We are not using the XML.sendAndLoad method, since we will perform pure string operations and the XML node to be sent will be regarded as string.

```
lv = new LoadVars ();
lvReceive = new LoadVars ();
```

We need to give the node a unique id. The id will be the last id plus 1. We get the last id by calling the static array idArray[0] from the ContMenu class. Then we add 1 to the last id number:

```
lastId = Number (ContMenu.idArray[0]);
lastId = lastId + 1;
```

We now create the new XML node. First we create a new instance of the XML object:

```
var doc:XML = new XML ();
```

We create a parent node and a node name, <house>, and add this to the XML object using the appendChild method. By the way, I recommend that you do trace actions of every step, if you write this class by yourself.

```
var element0:XMLNode = doc.createElement ("house");
doc.appendChild (element0);
```

We add the id attribute:

```
element0.attributes.id = lastId;
```

We create a new array, which holds the user input from the TextInput instances:

```
var tfContArray:Array = new Array ();
```

We loop through the length of the array textArray (see the last section). The length is equivalent to the number of TextInput instances. This array holds the values of all TextInput instances.

```
for (var j = 0; j < textArray.length; j++)
{
```

We ask for the content of the TextInput instances:

```
var tfContent:String = textArray[j].clipContent.
  text;
```

If any content is empty, we show an Alert box and break up. This is the String return statement.

```
if (tfContent == "")
{
  Alert.show ("Fill out all fields.", "ERROR:",
   Alert.OK);
  tfContent = "error";
  return tfContent;
}
```

We store the content in the tfContArray array:

```
tfContArray.push (tfContent);
```

When all the TextInput instances have been checked …

```
if (j >= textArray.length - 1)
{
```

… we loop through the textArray array again:

```
for (var i = 0; i < textArray.length; i++)
{
```

Except now we create new nodes with the labels stored in the array as node names:

```
var element:XMLNode = doc.createElement
  (textArray[i].label);
```

We create node values. All node values are stored in the tfContArray array, which we've just now created:

```
var node:XMLNode = doc.createTextNode
  (tfContArray[i]);
```

We append all the nodes to the main XML node, <element0>:

```
element0.appendChild (element);
```

Then we append the node values to each node <element>:

```
element.appendChild (node);
}
```

To merge the new XML node with the existing XML file, which is accomplished by the PHP script, we need to remove the closing tag </text> first, and later we add it back. We, therefore, create a variable, "removed", holding the string to remove:

```
var removed:String = "</text>";
```

We call the XML file selected from the menu to which the new XML node will be added. We convert the XML data to a string:

```
var stringXML:String = String (ContMenu.dataXML);
```

Since the XML data is in strings now, we can apply string methods like the split method to remove the last closing tag:

```
var splitted:Array = stringXML.split (removed);
```

Using the join method we merge the modified XML file with the new XML node and add the closing tag. The variable "sendXML" should contain the complete newly created XML file. We can easily test this using a trace action:

```
var sendXML:String = splitted.join (String (doc) +
    "</text>");
```

We send the new file to the server using the LoadVars object. However, we first write the "onLoad" function for the response from the server. The LoadVars object to hold the response is lvReceive. We use an onLoad event to make sure the data for the response is completely loaded.

```
lvReceive.onLoad = function ():Void
{
```

We, again, create a shape (mask) and disable the Submit button, to prevent the user from a second accidental action. We need to use the reference variable "myClip" to refer to objects beyond the scope of the function.

```
myClip._parent.mask._alpha = 50;
myClip.submitBut.enabled = false;
```

The variable "result" is a variable from the PHP script.

```
if (this.result == "Okay")
{
```

If the new file successfully replaced the XML file, we indicate that by a message:

```
myClip._parent.message.text = "Data are
    stored.";
```

If the user had added a different URL for an image or HTML file from the default values, we remind the user not to forget to upload the items:

```
if (imageContent != imageInitial ||
 detailsContent != "null")
{
  myClip._parent.message.text = "Data are
    stored. Do not forget to upload new images
    and/or html files.";
}
```

We execute a function to restore the original status of the movie:

```
myClip.upDateStatus ();
}
```

We also include the possibility of something going wrong in replacing the former XML file. The message will come from the PHP file.

```
else
{
  myClip.message.text = this.result;
}
};
```

We now send the new XML file and the file URL to the PHP script on the server:

```
contentXML = ContMenu.contentXML;
lv.sendXML = sendXML;
lv.contentXML = contentXML;
lv.action = "info";
lv.sendAndLoad ("newxml.php", lvReceive, "POST");
}
}
}
```

The function "upDateStatus" is required to remove the old XML file from the browser cache. We achieve this by adding a unique extension to the file URL. If we did not do this, we would not see the modified version of the XML file, because the cached version would always be shown. We would run into the danger that upon the addition of a new node the id would stay the same and two nodes would have the same id.

```
private function upDateStatus ():Void
{
  contentXML = ContMenu.contentXML;
  if (System.capabilities.playerType != "External" &&
   System.capabilities.playerType != "Standalone")
```

```
    {
      contentXML += "?" + new Date ().getTime () +
      Math.floor (Math.random () * 10000);
    }
```

We load and parse the new XML file with the unique extension:

```
        iniXml = new InitiateXml ();
        var proxy:Boolean = false;
        iniXml.init (contentXML, contLoad, this, proxy);
    }
```

To test if the update was successful, we show the added node from the updated XML file, which should be identical to the new XML node:

```
    private function contLoad ():Void
    {
      var newId:String = String (iniXml.defaultXML.
       idMap[lastId]);
      this.showNode.text = "New node was added:\n\n" + String
       (newId);
```

Then we make the variable "contentXML" undefined to prevent another action without selecting a file from the file menu:

```
      contentXML = undefined;
      this._parent.deleteNode.showNode = "";
    }
```

This concludes the ActionScript part and we turn now to the PHP file.

newxml.php: For Adding Nodes

The PHP code to process the new XML file on the server is relatively simple, since all we need to do is replace the old file with the new one. We first test if the two variables from the Flash movie are defined. We add a fail function, if there was a problem:

```
    <?
    if (!isset($sendXML) || !isset($contentXML)) {
      fail("Enter valid xml file name.");
      }
```

We then eliminate slashes from the XML file. When the file arrives at the server, it will receive a number of backslashes, which we need to get rid of.

```
    $sendXML = stripslashes($sendXML);
```

If the variable action from the movie is defined as "info", we can proceed. Otherwise the process is terminated:

```
switch($action) {
  case "info":
    addinfo($sendXML, $contentXML);
    break;
  default:
    fail("Unknown action: $action");
}
```

In the function "addinfo" we open the file contentXML, with the URL for the correct XML file. We give write permission by adding 'w':

```
function addinfo($sendXML, $contentXML)
{
  $file = fopen($contentXML, 'w');
```

If the file is not open we throw an error message. The correct execution of this function depends on the server. Many servers require a permission of 777 for files to write in.

```
if (!$file)
{
  fail("Error: Couldn't open xml file");
}
```

Otherwise we write the new data into the file, which will erase the former data. We then close and execute the "success" function:

```
fwrite($file, "$sendXML");
fclose($file);
success();
}
```

If there were problems anywhere, the fail function would be executed.

```
function fail($errorMsg)
{
  echo "&result=$errorMsg";
  exit;
}
```

If the process was successful, we send the string "Okay" back to the movie, which will trigger the onLoad event. We then exit:

```
function success()
{
```

```
      echo "&result=Okay";
      exit;
   }
   ?>
```

Deleting Nodes: The DeleteNode Class

Part of a CMS is not only to add items but also to delete what is not needed any more. In our case we want to be able to delete old nodes for houses that have been sold. What is the best way to do it? The method that we use to delete nodes makes use of the id tag and the idMap property. Every <house> node has a unique id tag. Each id tag represents one whole node. However, there is no simple delete method. Therefore, we need to develop a strategy to delete the node without changing the whole XML file. There are two ways to delete the node. We could do it in the Flash movie and then send the new XML file to a PHP script on the server. Alternatively, we could delete the node on the server. I have chosen the second possibility for no particular reason other than to show how you can do it. What, in detail, do we want to accomplish? To select a node with a certain id tag we need to parse the XML file that contains this node. We need to send the node information as well as the whole XML file to the server. You have probably often experienced the case in which, when you want to delete something, you are asked beforehand if you are sure about that. We will also add this type of security, so that when the node to be deleted is shown to the CMS manager, confirmation to delete the node is required.

Now we are ready to write the scripts. You can find all scripts in the Chapter 15 folder. We create a new class, the DeleteNode class. As before we skip the head part of the class and discuss only the methods. The public function of this class is "deleteMenu". We set a static variable, "confirmation", to 0. This variable will be used later in the step in which the manager is asked to confirm the deletion. It will delay deleting the node by one more button press. We disable the deleteBut for submitting the data. As before the manager has to select an XML file to enable the button.

```
      public function deleteMenu ():Void
      {
        confirmation = 0;
        this.deleteBut.enabled = false;
```

We have two buttons, to submit data or to reset the form. We give the buttons labels:

```
        this.deleteBut.label = "Delete";
        this.resetBut.label = "Reset";
```

We restrict the possible characters for the id tag in the TextInput instance to numbers:

```
        this.idInput.type = "input";
        this.idInput.restrict = "0-9";
```

We write a function for the Reset button. Basically, we set parameters back to where we started and add a return statement to break up the process:

```
var reset:Object = new Object ();
reset.click = Delegate.create (this, resFunction);
function resFunction ():String
{
  this.idInput.text = "";
  this.showNode.text = "";
  action = null;
  return this.idInput.text;
}
this.resetBut.addEventListener ("click", reset);
```

Then we write the function for the deleteBut:

```
var delListener:Object = new Object ();
delListener.click = Delegate.create (this, delFunction);
function delFunction (evt_obj:Object):String
{
```

We call the selected XML "contentXML", which is a static variable of the ContMenu class:

```
contentXML = ContMenu.contentXML;
```

Although when the button is enabled there should be a value for contentXML, we add another security step and make sure the variable is defined. If there was a problem, an Alert box would appear and the process would be terminated.

```
if (contentXML == undefined)
{
  Alert.show ("Select a file name first.", "ERROR:",
   Alert.OK);
  contentXML = "error";
  return contentXML;
}
```

Otherwise, we will proceed and call the XML load and parse function, "selectedXML", which has two well-known parameters.

```
else
{
  var proxy:Boolean = false;
  this.selectedXML (contentXML, proxy);
}
}
```

```
this.deleteBut.addEventListener ("click", delListener);
}
```

We create a new InitiateXml object to load and parse the XML data:

```
private function selectedXML (contentXML, proxy):Void
{
  iniXml = new InitiateXml ();
  iniXml.init (contentXML, contLoad, this, proxy);
}
private function contLoad ():Number
{
```

We create a variable for the id tag of the node to delete:

```
var deleteIdnum:Number = Number (this.idInput.text);
```

Using the idMap property we select the node to delete from the XML file. We create a function, "exit", which will check if the node is valid:

```
var deleteIdnode:XMLNode = iniXml.defaultXML.
 idMap[deleteIdnum];
exit (deleteIdnode);
```

Then we show the whole node in a text field to the CMS manager to verify that it is the correct node. Keep in mind that the data has not yet been sent.

```
this.showNode.text = deleteIdnode.toString ();
```

At this point we create LoadVars objects for sending and receiving data:

```
var lv:LoadVars = new LoadVars ();
var lvAnswer:LoadVars = new LoadVars ();
```

The "onLoad" function is associated with the lvAnswer LoadVars object:

```
lvAnswer.onLoad = function ():Void
{
```

We first eliminate text in some text fields, set the shape back to partially hiding the stage, and disable the deleteBut:

```
myClip.showNode.text = "";
myClip._parent.addNodes.showNode = "";
myClip._parent.mask._alpha = 50;
myClip.deleteBut.enabled = false;
```

We ask if the PHP file was correctly executed. If so, we assume the node was deleted and we declare the XML file held in contentXML as undefined to prevent any further action without selecting another XML file again. If there was a problem we show the message from the PHP file.

```
    if (this.result == "Okay")
    {
      contentXML = undefined;
      myClip._parent.message.text = "Data are deleted.";
    }
    else
    {
      myClip._parent.message.text = this.result;
    }
};
```

We now go back in time and focus on the part when we actually send the data. Before we send any data, we want the CMS manager to confirm that the correct node was deleted. Therefore, we do not trigger any action to send the data to the server at this point. Instead we use an "if" statement and ask if the variable confirmation is equal to 0. If so we ask if the manager wants to delete the node. This will now set the variable confirmation to 1. We create a return statement to prevent the script from being executed further:

```
if (deleteIdnode != undefined)
{
  if (confirmation == 0)
  {
    myClip._parent.message.text = "Do you want to
      delete ID " + deleteIdnum + "? Then press 'DELETE'
      again. To abort press 'RESET'.";
    confirmation = 1;
    return confirmation;
  }
```

If the button is pressed again, the next part of the script will be executed and the data will be sent to the server. We make sure here that the node to delete is converted to a string, since the PHP file will deal with strings. If the manager forgot to enter an id number we open an Alert box and terminate further execution.

```
  else if (confirmation == 1)
  {
    action = "deleteNode";
    lv.contentXML = contentXML;
    lv.deleteIdnode = deleteIdnode.toString ();
    lv.action = action;
    lv.sendAndLoad ("delinfo.php", lvAnswer, "POST");
    confirmation = 0;
  }
 }
}
```

The final function is the "exit" function, which we define here. The function has a return type XMLNode, which is the node to delete.

```
private function exit (delNode:XMLNode):XMLNode
{
```

If the user did not enter an id, the user will be reminded. Also if the node does not exist, the execution will be terminated.

```
if (delNode == undefined)
{
  action = "";
  Alert.show ("Enter a valid ID number.", "ERROR:",
   Alert.OK);
  return delNode;
}
```

Otherwise the node will be shown for verification.

```
else
{
  this.showNode.text = delNode.toString ();
}
}
```

This brings us to the end of this script. In the next section we will concentrate on writing the PHP file.

Deleting Nodes: delinfo.php

When the data has been sent to the server we need to search for the node to delete within the XML file by using a comparison method. We then replace the node in the XML file with a blank space. First we make sure that all the data from the movie is defined:

```
if (!isset($contentXML) || empty($contentXML) ||
 !isset($deleteIdnode) || empty($deleteIdnode))
{
  fail("Failure, data not loaded.");
}
```

We strip off any slashes:

```
$findIt = stripslashes($deleteIdnode);
```

We trigger the delete action:

```
switch($action)
```

```
  {
    case "deleteNode":
      delinfo($contentXML, $findIt);
      break;
    default:
      fail("Unknown action: $action");
  }
```

The function to delete the node has two parameters, the URL for the XML file and the node to delete:

```
function delinfo($myxml, $delData)
{
```

We create a variable for replacing the node, which has blank space:

```
$replaceIt = "";
```

We create an array using the file() method. file() returns the XML file in an array.

```
$allDates = file($myxml);
```

We loop through the array and create a variable, "$findMatch":

```
for($count=0; $count<count($allDates);$count++) {
  $findMatch = $allDates[$count];
```

If "$findMatch" matches the contents of $replaceIt, which is the node to delete, we replace with blank space:

```
$repItem = ereg_replace($delData, $replaceIt,
  $findMatch);
```

If the original XML data array is the same as the data array, which should lack the node, then something was not OK and we terminate the further execution:

```
$newInfo = "$repItem";
if($findMatch == $newinfo)
{
    fail("Could not find the search terms. Try
      again.");
}
```

Otherwise we open the file and allow writing into the file. If opening is not possible for some reason, we give an error message:

```
$file = fopen($myxml, 'w');
if (!$file)
```

```
     {
          fail("Error: Couldn't open xml file");
     }
```

We write the new string, which has the node deleted, into the file and then close the file and execute a "success" function:

```
          fwrite($file, "$newInfo");
          fclose($file);
          success();
     }
}
```

We end the script with the "success" and "fail" functions and exit:

```
function fail($errorMsg) {
  $errorMsg = urlencode($errorMsg);
  print "&result=$errorMsg";
  exit;
}
function success() {
  print "&result=Okay";
  exit;
}
?>
```

It should be noted here that the XML files have to be written lacking any blank space. If there is blank space, the whole file will be deleted. I have included one file, North.xml, in which that is demonstrated.

The MySQL Version

If you are using a server that allows creating a MySQL database, then this is the preferred choice of storing and getting data. I will not go into the details of MySQL itself and how to create tables. There are excellent tutorials and books explaining how to install and use MySQL. One book in particular, which I can recommend is Foundation PHP for Flash from Steve Webster. I further recommend using phpMyAdmin (www.phpmyadmin.net/), which will allow you to create tables on your computer and get the SQL script, which you can use to create the database on the server. Some servers have phpMyAdmin already installed and you can create the table directly. For our purpose we will create four tables for each of the search districts, North, South, West, and East, and those are also the names of the tables. In the following the SQL script for the table for the North district is shown:

```
CREATE TABLE 'north' (
'id' INT( 5 ) NOT NULL AUTO_INCREMENT PRIMARY KEY ,
```

```
'bedroom' INT( 2 ) NOT NULL ,
'bath' INT( 1 ) NOT NULL ,
'cost' VARCHAR( 10 ) NOT NULL ,
'built' INT( 4 ) NOT NULL ,
'town' VARCHAR( 50 ) NOT NULL ,
'image' VARCHAR( 50 ) NOT NULL ,
'details' VARCHAR( 50 ) NOT NULL
) ENGINE = MYISAM ;
```

What this basically says is that the name of the table is north. We have eight cells. The first cell is the primary key and is the id number. With every entry the id number will increase automatically. We don't need to do that in Flash any more and that saves us work. The next seven cells will store the data for the houses, either as strings or, as in "built", as numbers. The numbers in parentheses are the maximum numbers of characters that we allow for the individual data. When you create the database you will also be asked to have a username and a password to access the database. So before we move to the Flash and the PHP part we make sure that we have a valid username and password and have created four tables of the structure shown above.

We do not create all new Flash files but make use of the CMS .fla file, which we have already created. We also need to make some changes to the database .fla file, since we need to get data from a PHP file instead of loading an external XML file directly, as we have so far done.

The ContManagement .fla File

First we will modify the CMS file. To make it simple for us we now add TextInput field component instances and include also those for the username and password. We name them "tf_" and add a description, for example, tf_bedrooms. We make the changes in the addNodes MovieClip as shown in Figure 15.3. We also add a Button component and add the label "Submit". We name it submitBut. We need to change the deleteNode MovieClip as well, which we can do while the .fla file is open. We add

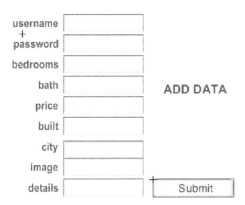

Figure 15.3 *The modified addNodes MovieClip*

also two TextInput component fields for the username and password and name them tf_username and tf_password. And these are all the changes we need to make in the .fla file.

The AddNodes Class

The first class that we change is the class to add data to the database. Up to line 41 in the previous file there are no changes, except that we need to add "import mx.controls.TextInput;" in the class header. Then we delete lines 42–61 and add the variables for the TextInput fields:

```
private var tf_bedrooms:TextInput;
private var tf_bath:TextInput;
private var tf_price:TextInput;
private var tf_built:TextInput;
private var tf_city:TextInput;
private var tf_image:TextInput;
private var tf_details:TextInput;
private var tf_username:TextInput;
private var tf_password:TextInput;
```

We now delete the former line numbers 69–388, because we need to write new code for the database management. We create a function, "manager()", which we call from the main movie and so is public:

```
public function manager ():Void
{
```

As before we add default text for the image and the text field to add HTML files, tf_details:

```
this.tf_image.text = "images/noimage.jpg";
this.tf_details.text = "null";
```

Then we create a listener for the Submit button and use the Delegate class to extend the scope of the function:

```
var submitListener:Object = new Object ();
submitListener.click = Delegate.create (this,
  submitFunction);
```

The button function will have a return statement for a string:

```
function submitFunction ():String
{
```

If the user did not select a district, an alert will appear. Otherwise we can proceed. "contentXML" now has a different value. Before, it encoded the path to an XML file. Now it encodes the name of a table in the database. So keep in mind to change the XML file Combo.xml and replace all

XML file paths to the table names. We don't need to make any changes in the class file for the ComboBoxes.

```
        if (ContMenu.contentXML == undefined)
        {
          Alert.show ("Select a file name first.", "ERROR:",
           Alert.OK);
          contentXML = "error";
          return contentXML;
        }
        else
        {
          this.proceedData ();
        }
      }
    this.submitBut.addEventListener ("click",
     submitListener);
  }
```

The next function will handle the data from the TextInput fields and, using the LoadVars object, send them to the server.

```
      private function proceedData ():Void
      {
```

We create new LoadVars objects for sending and receiving data and write the function to receive data:

```
      lv = new LoadVars ();
      lvReceive = new LoadVars ();
      lvReceive.onLoad = function ():Void
      {
        myClip._parent.message.text = "processing...";
        myClip._parent.mask._alpha = 50;
        myClip.submitBut.enabled = false;
```

The variable "result" is a variable that was sent from the PHP script. If there were no problems, we inform the user with a message and reset all values back to the original status, when the movie was opened. Otherwise there will be an error message from the PHP script.

```
        if (this.result == "Okay")
        {
          myClip._parent.message.text = "Data are stored.";
          myClip.upDateStatus ();
        }
        else
```

```
                    {
                      myClip.message.text = this.result;
                    }
                };
```

We pack all the data in variables and make sure that there is no null data:

```
            var username:String = this.tf_username.text;
            var password:String = this.tf_password.text;
            var myTable:String = ContMenu.contentXML;
            var bedroom:String = this.tf_bedrooms.text;
            var bath:String = this.tf_bath.text;
            var cost:String = this.tf_price.text;
            var built:String = this.tf_built.text;
            var town:String = this.tf_city.text;
            var image:String = this.tf_image.text;
            var details:String = this.tf_details.text;
            if (username != "" && password != "" && bedroom != ""
             && bath != "" && cost != "" && built != "" && town !=
             "" && image != "" && details != "")
            {
```

We associate the data with the LoadVars object and send them to the server where they are processed with the addinfo.php file:

```
                lv.username = username;
                lv.password = password;
                lv.myTable = myTable;
                lv.bedroom = bedroom;
                lv.bath = bath;
                lv.cost = cost;
                lv.built = built;
                lv.town = town;
                lv.image = image;
                lv.details = details;
                lv.sendAndLoad ("addinfo.php", lvReceive, "POST");
            }
            else
            {
                Alert.show ("Not all parameters were entered.",
                 "ERROR:", Alert.OK);
                return;
            }
        }
```

The final function resets some variables, as we have learned already.

```
private function contLoad ():Void
{
  contentXML = undefined;
  this._parent.deleteNode.showNode = "";
}
```

Getting Data: The DataBase Class

Of course we want to test if we can successfully retrieve data from the database. Therefore, we need to change the Database class file. The main change is that we do not load an XML file located on the server but an XML file that is created by executing a PHP file. This XML file is then processed in the same way as a file that we would load from the server. We basically delete the part where we load the XML file and instead we create a LoadVars object. Before that we need to define the name of the table from the database that we want to extract. We get this name, of course, from the ComboBox.

```
var myTable:String = SelectCombo.myCityXml;
lv = new LoadVars ();
```

We then write the function to receive data from the PHP file:

```
lv.onLoad = function ()
{
```

We load the data from the database if there was no error during the processing of the data. We create a new XML file. The data that comes from the server is not XML data but of data type String. Therefore, we need to create a new XML object. The data is processed in the "loadParse" function as if we had loaded an external file. To create the same type of XML file, for which we have already written the parser, we need to add a root node, <text>:

```
if (this.erResult == null)
{
  pXml = new XML ("<text>" + this.myResult +
  "</text>");
  myClip.loadParse (pXml,myClip);
```

We also send the XML file to the SaveNodes class to allow saving of data:

```
saveNode = new SaveNodes ();
saveNode.saveXmlFile (pXml);
```

If there was an error we inform the user:

```
}
else
```

```
        {
            myClip._parent.myMessage.text = this.erResult;
        }
    };
```

Then after writing the "onLoad" function we write the lines to send the data to the PHP file get-data.php. And these are all the changes we need to make in this class.

```
        lv.myTable = myTable;
        this._parent.myMessage.text = "processing...";
        lv.sendAndLoad ("getdata.php", lv, "POST");
    }
}
```

Before changing any other class we first need to write the PHP file to get data from the database.

Deleting Nodes

We are left with one more task, which is to delete nodes from the database using our CMS. We need to add two TextInput fields for the username and password to access the database. See the ContManagement.fla for details. We need to alter the DeleteNode.as and, again as before in other scripts, eliminate loading an XML file. Instead we use LoadVars to send the table, username, and password to a PHP script. See DeleteNode.as for details. The script becomes much simpler, since we eliminate not nodes from an XML file but rows from tables in the MySQL database.

Writing php files to add nodes, get data and delete nodes

I will not go into all details of connecting to the database, but describe only the part, which is required for this tutorial. After connecting to the database the data are added using the INSERT INTO table name method.

```
$query = "INSERT INTO $myTable (bedroom, bath, cost, built,
  town, image, details) VALUES('$bedroom', '$bath', '$cost',
  '$built', '$town',
  '$image', '$details')";
$result = @mysql_query($query);
```

If the data was inserted, we send an Okay back to the Flash file.

```
if ($result)
{
    echo "&result=Okay";
}
```

To retrieve nodes from the database we need to define the query. By adding ASC we make sure that the nodes will be arranged with the lowest number first, if we want that.

```
$query = "SELECT * FROM $myTable ORDER BY id ASC";
$result = @mysql_query($query);
```

If there are rows in the table, they will now be listed. We use a while loop and the mysql_fetch_array() method to get all rows.

```
while($row = mysql_fetch_array($result))
{
```

Then we define variables for each cell.

```
$id = $row['id'];
$bedroom = $row['bedroom'];
$bath = $row['bath'];
$cost = $row['cost'];
$built = $row['built'];
$town = $row['town'];
$image = $row['image'];
$details = $row['details'];
```

We create XML nodes to store the data. This is not the final XML file, as you know, since the root node is missing, which we add in the Flash file. We then send the data back to the Flash file or send an error, if there was a problem.

```
$xmlNodes .= "<house id=\"$id\"><bedroom>$bedroom</bedroom>
 <bath>$bath</bath><cost>$cost</cost><built>$built</built>
 <town>$town</town><image>$image</image><details>$details
 </details></house>";
   }
echo "&myResult=" . urlencode($xmlNodes);
```

For deleting nodes we make the query to delete rows using the id of the row. We use the MySQL DELETE FROM statement and that is basically all, which we need to do. We want to inform the user of the success and therefore we send a message back if it was all properly done.

```
$query = "DELETE FROM $myTable WHERE id=$deleteIdnum";
$result = @mysql_query($query);
if ($result)
{
    echo "&result=Okay";
}
```

And this concludes the MySQL part of this tutorial.

Another way of communicating with a database is using the Flash Remoting components, which you can download for player 8 at this location: http://www.adobe.com/products/ flashremoting/downloads/components/#flr_fl8. Flash Remoting allows you to execute Remote Procedural Calls (RPCs) using the Flash player. I will not go into details further, but you can learn more and find excellent tutorials when you search for "MySQL flash remoting".

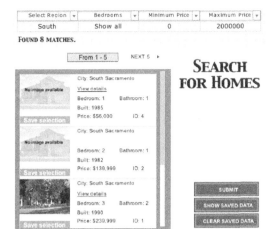

ACTIONSCRIPT 3

16 ActionScript 3: Basic Tutorial

Introduction

Flash actionscripting is moving with exponential speed. AS2 was the new generation of ActionScript introduced with Flash 7 (MX 2004). Just about 2 years later we needed to learn a new version of ActionScript, AS3. Do we? I leave this answer to you. If you know AS2 classes you will be interested in AS3. If you are not familiar with AS2 classes you may want to get a glimpse of AS3, because it seems AS3 allows endless possibilities for developing Flash applications. AS3 is used with the Flex 2 builder and is part of Flash CS3. A main reason to develop in AS3 is the performance increase. AS3 source code is first compiled into byte code and then passed on to a new ActionScript virtual machine called AVM2, which results in about a 10-fold performance increase compared to AS2. However, the performance increase is restricted to AS compiling, which allows working with large datasets. Animations like CPU-intensive tweens of complex MovieClips, which are known to slow down during playing, are not affected. ActionScript is therefore now closer to other programming languages like C or Java. There are other reasons to learn AS3, since AS3 allows applications that were not possible with AS2. Also, Adobe will develop AS3 further, but not AS2.

AS3 is based on ECMAScript (ECMA-262 version 4), which was originally Netscape's JavaScript. This is important for parsing XML files because an extension of ECMAScript is ECMAScript for XML (E4X), which was standardized as ECMA-357. This allows us to access nodes directly by their names. AS3 uses the document object model. AS3 has support for regular expressions, which allows easy string manipulations. Although many classes that we know from AS2 still exist in AS3, there are a number of changes because of the different concept of AS3 compared to AS2. We will cover these changes throughout the next chapters. One question that may arise is whether you need to convert all your movies applying AS3. You do not have to. If you have obeyed the concept of creating child movies (instead of one large movie), which you load into a parent movie as we did in the previous section, you will still be able to do so. Movies created with AS1 or AS2 can be loaded into an AS3-based movie. In fact this is what we are going to do in the next section. It is not possible, however, to load AS3 movies into a movie created with AS1 or AS2. It is also not possible to mix AS1 or AS2 with AS3 code.

AS3 Overview

In the following paragraphs we will cover AS3 starting from a very simple "Hello world" example and in this way get acquainted with many new features of AS3. Although AS3 can be used in a way

similar to former versions of AS solely in the .fla file, we will stick to the class file concept for reasons extensively covered in the AS2 section. In this chapter we will deal with

- AS3 packages
- public, private, internal, protected
- null–undefined
- the timeline
- object handling
- namespaces
- events and event bubbling

We will not cover what we have already learned in the AS2 section, for example Getter–Setter or the definition of static. However, in a later chapter we will cover the concept of super- and sub-classes. In the following sections we will convert some of the applications that we developed using AS2. Included also is the MovieClip scroller. We will start, however, with very simple scripts. You may have downloaded the AS3 preview from Adobe or you may have purchased the new Flash CS3. It is a good idea to bookmark the online Flex 2 language reference guide (http://livedocs. macromedia.com/flex/2/langref/index.html), which contains additional classes that can be used only with Flex 2. If you pull down the upper left scrollbar to the bottom you will find links to compiler errors and also a link to an "AS2 to AS3 migration" site.

AS3 Packages: Hello World

When you have downloaded the AS3 preview or you have purchased Flash CS3 and opened it for the first time, at first sight there is nothing new except for the box shown in Figure 16.1, which is called the Document class and which is located in the property inspector. In this text box we write the path for a class that we want to execute. You don't have to create a Document class. However, as you will see later there may be some advantages to creating a Document class. For the next several tutorials we will use this text box to write the name of the class we want to execute.

Figure 16.1 *Flash 9 preview or Flash CS3*

The files for this chapter are located in the folder ActionScript3-tutorial and for this section in the subfolder AS3 packages.

In AS3, classes are present in packages. When you open Starter_1a.as you will see a basic AS3 package. The file starts with the package declaration.

```
package
{
```

This is also where the path to a package is expressed. If the file were in a folder named "supplement" we would express this as "package supplement". Next all the classes are imported. Here we import the Sprite class. If we omit it we would get a lengthy error message:

```
**Error** /Users/......./ActionScript3-tutorial/AS3
packages/Starter_1a.as : Line 9, Column 34 : [Compiler]
Error #1017: The definition of base class Sprite was not
found.
  public class Starter_1a extends Sprite
  ReferenceError: Error #1065: Variable Starter_1a is not
  defined.
```

All error messages have numbers and are distinguished between compiler errors and runtime errors. You can find links for lists of these error messages in the menu of the language reference site. Compiler errors are reported when the file is compiled. Run-time errors are those that occur when the actual movie is played and an error occurs. The question is if we actually need to extend to the *Sprite* class. The answer is "yes". If we omit the extension we will get the following error message:

```
TypeError: Error #2023: Class Starter_1a$ must inherit from
  Sprite to link to the root.
```

The class would be without any root if we omitted the file extension to the Sprite class. We just started with a simple file and already there are so many problems and a new class, which, so far, we have never even heard of. The Sprite class is new in AS3 and is a basic display list building block. A Sprite object is similar to a MovieClip, but does not allow frames. Therefore, the Sprite class is a base class for objects that do not require timelines, such as the trace action in our simple movie. Since the Sprite class is related to the MovieClip class and actually the MovieClip class is a subclass of the Sprite class, we could also extend to the MovieClip class in our example. However, there is another important difference that we need to consider. The MovieClip class is a dynamic class and we can add new properties to instances of the MovieClip class. This is a big advantage over a Sprite object, but comes with a pitfall. Objects created from a dynamic class require more memory and are more error prone. We, therefore, use the Sprite class over the MovieClip class here for the reasons stated above.

```
import flash.display.Sprite;
```

As you may have noticed, there is another new feature in AS3 that is different from AS2. We are declaring the class as "public". If we did not do that we would get an error message. Unlike in AS2, in which all variables are by default public, in AS3 all variables are by default internal and not always accessible. Therefore, the main class in a package has to be declared as public. Again my advice is always to use the declaration even if the declaration would match the default value. It makes debugging easier and the script more complete and readable for the compiler.

```
public class Starter_1a extends Sprite
{
```

As with the class we also declare the constructor as public:

```
public function Starter_1a ()
{
  myTest();
}
```

In our little example we have one more function, which we declare as private. Although it is not required, we add return values for functions. Note that a return value of void is written in lower-case letters, unlike in AS2 (Void).

```
private function myTest():void
{
  trace("Hello world");
}
}
}
```

Finally, to get this script executed, we write Starter_1a in the Document class text box. And this concludes the first script.

Hello World: Second Thoughts

In the first example we have made use of the Document class. However, we do not need to have a Document class. Instead we can call classes from a frame, which is documented in the file Starter_1b. We create instances of the Starter_1a class (see previous section) using the "new" operator. This class will be executed without any further requirements and "Hello world" is traced.

```
var a:Starter_1a = new Starter_1a ();
```

The Starter_1b class requires us to call the function "myTest()" public.

```
package
{
  import flash.display.Sprite;
  public class Starter_1b extends Sprite
  {
    public function Starter_1b ()
    {
    }
    public function myTest ():void
    {
      trace("Hello world again");
    }
  }
}
```

In the .fla file we write the following lines. This must be very familiar to you from the AS2 classes.

```
var b:Starter_1b = new Starter_1b ();
b.myTest ();
```

However, as we will see in the next section, AS3 offers more possibilities.

The Package Deal

Remember that we are not dealing with just a class any more, as in AS2, but that every class is located in a package. We can have more than one class in one source file, as shown below for the Starter_1c package. An .as file can have several classes; however, only the classes within a package can be public classes. A typical example is shown below.

```
package
{
  import flash.display.Sprite;
  public class Starter_1c extends Sprite
  {
    public function Starter_1c ()
    {
      myTest();
    }
    private function myTest():void
    {
      var a:Suplemental_1 = new Suplemental_1 ();
      a.thisTest ();
    }
  }
}
import flash.display.Sprite;
class Suplemental_1 extends Sprite
{
  public function Suplemental_1 ()
  {
  }
  internal function thisTest ():void
  {
    trace("Hello world");
  }
}
```

Note that for the second class, classes need to be imported regardless of whether they have been imported for the public class. If there were a third class, which also requires the importing of the Sprite class, we would not need to import the Sprite class again, since the third class would share

the Sprite class with the second class. An AS3 file can contain more than one package. Usually if, apart from the public class, we add another class, then this class would be a "helper" class for the public class. For example, we would use the second class to create an object that is used in the public class. Later, we will see examples.

Two Packages

To complete this section we have, of course, another possibility for interacting with other classes, by creating different independent packages. This is similar to AS2, in which we have different classes that interact. The example is Starter_1d, in which we create an instance of another package, which is located in a folder. We have now covered extensively the new AS3 package concept. It is time to focus on syntax-related questions.

Public, Private, Internal, Protected

We have mostly covered the changes in public and private and we are familiar with their use from AS2. However, in AS3 we have the possibility of declaring variables, including functions, as "internal". The word "public" makes a variable completely accessible among packages, and the word "private" allows accessibility only within one class. There is a third possibility. We can declare variables as "internal". This allows accessibility of variables among the classes of a single package. The internal attribute is the default value if we do not add any attribute. We have seen an example under "The Package Deal", in which a function in a class outside of a package, but within the same ActionScript file, was internal. If you want to test this, open the Starter_1d.fla file, then open the Suplemental_1.as file within the supplement folder, and change line 12, "public function thisTest ():void to internal function thisTest ():void". When you test the Starter_1d movie now, there will be a compiler error message notifying you that you have tried to access an inaccessible method. Therefore, "internal" can be used for limited access of variables if we want to avoid the use of public but still need access. AS3 also offers a fourth possibility, "protected". If a variable of a class has the attribute protected it is available to subclasses. Example files with the name "Protected" in the AS3 packages folder show the difference between private and protected. Protected_1.as is the superclass in which the protected variable is declared.

```
private var aa:String = "can not be accessed from
  subclass";
protected var bb:String = "can be accessed from subclass";
```

Protected_2 is the subclass in which the protected variable is successfully called.

```
import Protected_1;
public class Protected_2 extends Protected_1
{
    public function Protected_2 ()
  {
      trace("The protected var bb: "+bb);
  }
```

In the .fla file we create instances of both classes:

```
var a:Protected_1 = new Protected_1 ();
var b:Protected_2 = new Protected_2 ();
```

The trace would give the value of the variable "bb". If we asked for "aa" there would be a compiler error. This is also an example of a super- and a subclass. Later we will cover that topic more extensively.

Null–Undefined

Former ActionScript versions had several flaws. One example is "null" and "undefined", which were not clear. In the strict sense, however, a variable that has no value has a null value, and a variable that does not exist is undefined. In AS2, for example, a variable with a null value was actually undefined. In AS3 this is now strictly regulated. If a variable is undefined, there will be a compiler error and the script will not be executed. Instead a reference error is shown. This may cause a bit of inconvenience, since in former ActionScript versions we could make use of that by using "if" statements such as "if (soandso == undefined) { then do this". This is no longer possible and is also not regarded as good ActionScript practice. There are example files, Starter_2a and Starter_2b, in the null–undefined folder. Starter_2a.as is shown below. From now on only the important parts for understanding the sample scripts are shown, in case you wonder why parts of the scripts are missing. The traces will be "I am not null" and "I am a string".

.

```
        private function myTest():void
        {
          var a:Testvar = new Testvar ();
          trace(a.test);
          if(a.test != null)
          {
            trace("I am not null");
          }
          else
          {
            trace("I am null");
          }
```

.

```
    import flash.display.Sprite;
    class Testvar extends Sprite
    {
      internal var test:String;
      public function Testvar()
      {
        test = "I am a string";
      }
```

If we omit the line "test = "I am a string";" the traces will be "null" and "I am null".

The Timeline

We know that in AS2 the main timeline of a movie was automatically defined as the _level0 or _root, if we did not lock the timeline of a MovieClip (_lockroot). We could then place objects on the timeline and manipulate them. It is not that simple any more in AS3. In AS3 the stage is the primary container into which all display objects are loaded. However, if we place objects directly on the stage we may have a problem when the movie is loaded into another movie, since the stage would now be the parent movie's stage. While in AS2 we could always refer to _root to access any display object in AS3, this is not possible any more. We have already seen that we need to extend a class to the Sprite or MovieClip class to obtain a root. There are several ways to create a timeline or let the Flash player create it for you. An easy way to create a defined timeline is to have a Document class. The Document class object itself is the timeline. The following example demonstrates that:

```
package
{
  import flash.display.Sprite;
  public class Starter_3a extends Sprite
  {
    public function Starter_3a ()
    {
      trace(this.root);
    }
  }
}
```

In AS2 the word "_root" was a property. In AS3 "_root" no longer exists. Instead there is the word "root", which is a read-only property, which belongs to the DisplayObject class. The root of an object is the topmost display object in a movie. This is very similar to the root or level0 of a movie created with AS2. Coming back to our little example, the trace would give "[object Starter_3a]", which means the object itself is the root of this movie. Since we have extended the Sprite class, the "this" word can refer to properties and methods of the Sprite class. For example, we could make the whole timeline invisible by using "this.visible = false;".

In the next example we create a variable that will represent the root of the movie. The variable "_root" is of data type Sprite. Note that we can freely use the word "_root" as a variable, because in AS3 this word is no longer reserved. We may feel comfortable using it, since it is an indicator of what we are dealing with. The trace would be the same as in the previous example, except now we have a variable to which we can refer.

```
package
{
  import flash.display.Sprite;
  public class Starter_3b extends Sprite
  {
    private var _root:Sprite;
```

```
  public function Starter_3b ()
  {
    _root = this;
    trace(_root.root);
  }
  }
}
```

Next we want to put objects on stage. We want to have frames and there will also be some code or comments. If we use one of the above scripts and add only a comment, like …

```
// copyright so and so
```

… we will get an error message like this:

```
[Compiler] Error #1180: Call to a possibly undefined method
 addFrameScript.
```

The reason is that the Sprite class does not have any method to add frames. However, the MovieClip class has such a method. Therefore, to work with frames we extend the MovieClip class and there will be no error. The body part of the script is shown below. Instead of having a simple variable we create a public static variable, since it is easy to refer to a static variable.

```
import flash.display.MovieClip;
public class Starter_3c extends MovieClip
{
  public static var _root:MovieClip;
  public function Starter_3c ()
  {
    _root = this;
    trace("inclass: "+_root.root);
  }
```

And in the .fla file we write a few lines to see which object is the root of the movie:

```
trace("inframe: " + Starter_3c._root);
trace("this: " + this);
```

This would be the trace:

```
inclass: [object Starter_3c]
inframe: [object Starter_3c]
this: [object Starter_3c]
```

This means that we now have as a timeline the object Starter_3c, which we can use as a reference object. When we deal with objects we will come back to this class.

Now what would happen if we did not have a Document class? Would we get an error message that we need to create a timeline? We will find out when we ask for the movie's root (Starter_3d):

```
trace("inframe: "+this.root);
```

The answer is, in the Flash 9 preview:

```
inframe: [object Timeline0_567a54de76311db8c3603933f52b2]
```

And in Flash CS3:

```
inframe: [object MainTimeline]
```

During compilation a timeline is automatically created. The timeline object has a long id consisting of numbers and letters. This has changed in Flash C3, in which the timeline object is referred to as "MainTimeline". I have added another line in the .fla file. If you uncomment this line an instance of the Starter_3c class will be created. If you test the movie the trace will give null as the root for this object, since Starter_3c is no longer the Document class and a root does not yet exist.

Override

The attribute override is new in AS3. This attribute allows the overriding of a function that was created in a superclass. Open the files in the folder Override. The Starter_4a class contains a function, "myTest()".

```
public function Starter_4a ()
{
  myTest();
}
public function myTest():void
{
  trace("Hello world");
}
```

In the subclass of Starter_4a, Override_1a, myTest() is overridden, which means that the inside of the function is different from myTest() in the Starter_4a class.

```
import Starter_4a;
public class Override_1a extends Starter_4a
{
  public function Override_1a ()
  {
  }
  override public function myTest():void
  {
    trace("Overridden");
  }
}
```

We create instances of both classes in the .fla file.

```
var a:Starter_4a = new Starter_4a ();
var b:Override_1a = new Override_1a ();
```

The traces are the traces in the original and the overridden function.

Object Handling

You may have noticed so far that a class stands for an object and every object is a class. This becomes obvious when we create objects, which are present in the library. If you have a MovieClip, for example, which you do not manipulate further with a script, it is recommended that you convert it to a graphic. A MovieClip uses more memory than a graphic. There are two ways to work with visible objects, which are usually MovieClips. We will look at one example, which shows you a big difference between AS2 and AS3. Open Starter_5a.fla and .as in the Objects folder and test the movie. There is a MovieClip on stage, which has the name "circle". In the script we ask for the *x* coordinate of circle.

```
package
{
  import flash.display.MovieClip;
  public class Starter_5a extends MovieClip
  {
    private var circle:MovieClip;
    public function Starter_5a ()
    {
      myTest ();
    }
    private function myTest ():void
    {
      trace (circle.x);
    }
  }
}
```

We will get an error message:

```
ReferenceError: Error #1056: Cannot create property circle
  on Starter_5a.
```

Does this mean we cannot just place an object on the stage and manipulate it by a script? No, we still can; however, we need to make the object public. As you see here we have defined the circle MovieClip as private. The example Starter_5b demonstrates that. In AS2 the object could be declared as private. We needed to add, however, a path, like root. Just for demonstration purposes you can see that, in Starter_5e. If we omitted _root for the circle we would get undefined in the trace. That is another difference. In AS3 the compiler would give an error in case of undefined.

Remember, every object is a class. And that gets us to the second possibility of working with objects. So far we did not create any class for the circle MovieClip. Actually, we don't have to create a class, since Flash is going to do that for us. The Starter_5c files demonstrate this. What we do is give linkage id as shown in Figure 16.2.

Figure 16.2 *Giving linkage id to a MovieClip*

If you do that and you have not created any class for this MovieClip, you will be asked if a class should be automatically generated (Figure 16.3).

This is a big difference from AS2, in which we did not need to generate a class. If you answer "yes", a class will be generated and this is indicated by the word "(Auto-generated)" after the class name

Figure 16.3 *Autogenerating a class*

in the Flash 9 preview. In Flash CS3 the word "(Auto-generated)" has been omitted. However, the class that extends the newly created class is added, which is by default the MovieClip class. We can now work with this MovieClip using scripts as in Starter_5c.as.

```
package
{
  import flash.display.MovieClip;
  public class Starter_5b extends MovieClip
  {
    private var circle:MovieClip;
    public function Starter_5b ()
    {
      circle = new Circle ();
      this.addChild(circle);
      trace ("Starter_5b: " + this.circle.root);
    }
  }
}
```

We declare a variable to name the MovieClip. We create a new instance of the MovieClip object, which replaces the former createEmptyMovieClip() method. To place the MovieClip on the main timeline, we use the addChild() method, which replaces the attachMovie() method. Automatically a level is created for this MovieClip, and we do not have to enter any number. The trace for this action will give

```
Starter_5b: [object Starter_5b]
```

The object is correctly recognized and its root is the object (class) where it was created and placed. We can of course write our own class and do the same. The Starter_5d files are examples for that. We are now able to create and place objects on the stage and handle the objects using AS. We will deal with the methods when we develop applications rather than introduce the methods individually here.

In Flash CS3 another option was added to work with objects. Press on the Publish: Settings button or open the settings from the main menu and you will see something similar to Figure 16.4.

Now press the Settings button and a new window will open as shown in Figure 16.5.

Figure 16.4 *Publish settings*

ActionScript 3.0 Settings

Document class: Starter_5a

Export classes in frame: 1

Errors: ☐ Strict Mode
☑ Warnings Mode

Stage: ☐ Automatically declare stage instances

Optimizer: ☑ Reduce file size and increase performance

Dialect: ActionScript 3.0 (Recommended)

Classpath: + − ⊕ ▲ ▼

Cancel OK

Figure 16.5 *ActionScript 3 settings*

If you check the "Automatically declare stage instances" check box, the original error will not occur any more. Instead you will get a different error message:

```
Starter5a.as line 9 1151: A conflict exists with definition
  circle in namespace internal:
private var circle:MovieClip;
```

The message appears because we have two objects with the same name. This option is handy when we do not use external classes. For the following tutorials we leave the option unchecked.

Events

Now that we know how to place objects on the stage we can associate events with the objects. Event handling is different in AS3 compared to AS2, although not quite, if you are familiar with event handling of components. All events are handled with listeners, including loading XML files or movies/images and handling buttons and MovieClips. It is also possible now to separate child–parent

mouse events. In AS2 or AS1 if a MovieClip with button functions or a button had a child, which also had button functions, it was not possible to handle the event of the child. Only the event of the parent was handled. In AS3 it is now possible to separate parent from child events. Because of this there is a phenomenon known as event bubbling. That means that the event from the child bubbles to the parent. A mouse event of the child will also result in a mouse event of the parent. This can sometimes be useful and later there will be an example in which this is demonstrated. However, fortunately we can also separate the events, so that the parent will not listen to the child event handler.

We will now get to an example, which describes a button function associated with a MovieClip. We create a simple MovieClip and associate this MovieClip with the Starter_6 class when we establish linkage. We place an instance of this MovieClip on the stage but avoid naming it. The main function of this button MovieClip is to load a TextField and change the text content depending on the mouse event. We first need to import several classes, among which is the flash.events.MouseEvent class.

```
package
{
   import flash.display.MovieClip;
   import flash.text.TextField;
   import flash.events.MouseEvent;
   public class Starter_6 extends MovieClip
   {
      private var tField:TextField;
      public function Starter_6 ()
      {
```

In AS3 the mouse icon is not automatically shown when the cursor is over the button area. Therefore, we need to signal the player that the object will have buttonMode:

```
         this.buttonMode = true;
```

We create an instance of a TextField and position it. All objects are created with the "new" operator. Also note that properties are no longer written with an underscore (for example, _x). This was already introduced with Flash 8 components.

```
         tField = new TextField();
         this.tField.x = 50;
         this.tField.y = 10;
```

The TextField will be a child of the button MovieClip and will react strangely to any Mouse-over event. To prevent this we disable any event caused by the mouse:

```
         this.tField.mouseEnabled = false;
         myTest();
      }
```

The main function contains all the event listeners. Unlike in AS2 in which we use the "Object. eventhandler = function ()" syntax, in AS3 we use only event listeners for all events. We specify the event class, for example, MouseEvent, followed by the event type, which is a constant such as

MOUSE_OVER. Then the name of the event-handler function follows. The second argument is the name of the function, which can be any name. However, it is reasonable to give a name that identifies the event:

```
private function myTest():void
{
  this.addEventListener (MouseEvent.MOUSE_UP,
   mouseUpHandler);
  this.addEventListener (MouseEvent.MOUSE_OUT,
   mouseOutHandler);
  this.addEventListener (MouseEvent.MOUSE_OVER,
   mouseOverHandler);
  this.addEventListener (MouseEvent.MOUSE_DOWN,
   mouseDownHandler);
}
```

Then we write the individual functions. We have to add one function argument, for example, "event", which has the data type MouseEvent, to the event-handler function. When the mouse moves over the button, we will actually place the TextField instance into the MovieClip and add text. In all other functions we change the text.

```
private function
 mouseOverHandler(event:MouseEvent):void
{
  this.tField.text = "over"
  this.addChild(tField);
}
private function mouseUpHandler(event:MouseEvent):void
{
  this.tField.text = "up"
}
private function mouseDownHandler(event:MouseEvent):void
{
  this.tField.text = "down"
}
```

Only when the mouse moves out from the button area do we remove the TextField instance using the removeChild() method:

```
private function mouseOutHandler(event:MouseEvent):void
{
  this.removeChild(tField);
}
  }
}
```

This concludes this little tutorial. In the next chapters we will learn other event handlers and go into more detail.

Namespaces

Our next tutorial will be more complex. We will combine what we have learned so far to create a simple application. However, as the title of this section says, we will also learn a new feature introduced with AS3, the namespace. In short, namespaces are variables that hold properties or functions and hide them until they are called. We have learned about namespaces in connection with XML. There is a connection if we look at the syntax, how a namespace can be referenced (see below). The namespace usage is similar to the override attribute usage, in the sense that one variable or method can replace another. An alternative to both could be, for example, to write a subclass with a different function. However, namespaces provide an easy way to have properties, values or functions ready when they are needed without writing and calling another class. We are already acquainted with attributes, which are predefined namespaces such as public, private, internal, and protected.

In the following example we will use the namespace to replace functions in a mouse–button event. The public class of the package contains the mouse event functions. There are two more classes, which draw and create button objects from scratch. Therefore, the movie library is completely empty, since all objects are created at runtime. We start with importing classes and declaring variables.

```
package
{
  import flash.display.Sprite;
  import flash.text.TextField;
  import flash.events.MouseEvent;
  public class Starter_7 extends Sprite
  {
    private var button:CustomSimpleButton;
    public var aField:TextField;
    public var bField:TextField;
    private var myIndex_a:Number;
    private var myIndex_b:Number;
    private var myIndex_c:Number;
```

While all other variables are kind of familiar to us, except for variables with unfamiliar data types, we have not seen namespace variables so far. They have an attribute, such as public, followed by the word "namespace" and the variable name, which in this case is the indicator name of the function.

```
public namespace Test_1;
public namespace Test_2;
```

In the same place where we declare the variables, we also write their values. In this case the values are complete functions. We write the variable name followed by the variable value:

```
Test_1 function test_1 ():void
{
  aField = new TextField ();
  aField.text = "This is test 1.";
  addChild(aField);
  if(bField!=null)
  {
    removeChild(bField);
  }
}
Test_2 function test_2 ():void
{
  bField = new TextField ();
  bField.text = "This is test 2.";
  addChild(bField);
  if(aField!=null)
  {
    removeChild(aField);
  }
}
```

We can write the constructor and the main function of this class:

```
public function Starter_7 ()
{
  myTest();
}
private function myTest():void
{
```

Let's go through this script, so you can learn some more AS3 syntax, which is useful and gets you familiar with the code. We create a button, again using the "new" operator. The class itself is described below. We place the button and add event handlers to the button instances:

```
button = new CustomSimpleButton();
button.x = 100;
button.y = 100;
button.addEventListener(MouseEvent.MOUSE_OUT,
  mouseOutHandler);
button.addEventListener(MouseEvent.MOUSE_OVER,
  mouseOverHandler);
addChild(button);
}
```

Now when we write the functions for the button event handlers we call the namespaces. There are two ways to do that:

```
private function mouseOutHandler(event:MouseEvent):void
{
```

We use the word "use" followed by namespace and the variable name. We then need to add the actual function name itself:

```
use namespace Test_1;
test_1 ();
}
private function mouseOverHandler(event:MouseEvent):void
{
```

The second way is simpler. We write the variable name followed by "::" and the function name. This is similar but not identical to XML documents with namespaces (Chapter 3).

```
Test_2::test_2 ();
}
}
}
```

The above script would not do anything if we did not code for any objects now. This is also a good example of the use of additional classes within a file. The following classes are a kind of auxiliary class.

We import classes. Most of these are not familiar to us, such as the Shape or the SimpleButton class. However, the names tell us what they are made for. In the first class, CustomSimpleButton, we create a button. In the second class, ButtonDisplayState, we create the actual shape of the button. One could say that the second class is an auxiliary class for the CustomSimpleButton class.

```
import flash.display.DisplayObject;
import flash.display.Shape;
import flash.display.SimpleButton;
```

First we create a button using the SimpleButton class. We add variables to change the color of the button in the different states. We use the new uint data type.

```
class CustomSimpleButton extends SimpleButton
{
  private var upColor:uint    =   0xFFCC00;
  private var overColor:uint  =   0xCCFF00;
  private var downColor:uint  =   0x00CCFF;
  private var size:uint = 80;
```

We now determine the properties of the button at the different button states. The variables "downstate", "overstate", "upstate", "hitTestState", and "useHandCursor" are properties of the

SimpleButton class. We create an instance of the ButtonDisplayState class for each of the button states and change color and (if we want) size as well:

```
public function CustomSimpleButton ()
{
  downstate =  new ButtonDisplayState(downColor, size);
  overstate =  new ButtonDisplayState(overColor, size);
  upstate = new ButtonDisplayState(upColor, size);
  hitTestState  = new ButtonDisplayState(upColor, size);
  hitTestState.x = hitTestState.y = (size/4);
  useHandCursor = true;
}
}
```

The ButtonDisplayState class is a subclass of the Shape class. The main function is "draw()", which will draw a rectangle shape, in our case, with color and of a certain size every time, when the button is pressed.

```
class ButtonDisplayState extends Shape
{
  private var bgColor:uint;
  private var size:uint;
  public function ButtonDisplayState(bgColor:uint,
   size:uint)
  {
    this.bgColor = bgColor;
    this.size       = size;
    draw();
  }
  private function draw():void
  {
    graphics.beginFill(bgColor);
    graphics.drawRect(0, 0, size, size);
    graphics.endFill();
  }
}
```

When you now test the movie, there will be a button, and in its over and out state the color will change and, of course, because of the namespaces, the text in the TextField will change. This brings us to the end of the AS3 introductory tutorial. We will cover other aspects, in particular XML or advanced topics, in the next chapters.

17 XMLDocument, XMLNode, XML, and XMLList Classes

Overview

In this chapter all the properties and methods of the existing XML-related classes are shown with examples. For all examples there are working files in the Chapter 17 folder, in the corresponding subfolders. As in the AS2 section we also develop an XML file loading class, which can be called whenever we need to load an XML file. This loading class also has another function, with which we can load images and movies. We use this class for all the examples and later tutorials, since we do not want to rewrite the loading code over and over again. This makes our scripts simpler and easier to read. This class can also be used to call XML files from an external domain using the proxy method. This class will be the tutorial of this chapter after all the XML classes have been introduced.

In AS3, new classes that are related to XML have been added. The former XML class still exists but has been renamed the XMLDocument class. We will not repeat all the examples of this class in this chapter but only mention the properties and methods. Examples are in the subfolder XMLDocument. The first new class is the XML class, which now has methods to access nodes, attributes, etc., directly and modify them. This makes long code statements like those we have seen in the AS2 section, such as "firstChild.nextSibling....", unnecessary. The DOM (document object model) array properties of an XML file are now fully exploited. XML parsing in AS3 is now adjusted to ECMAScript for XML (E4X), which was standardized as ECMA-357. A third class is the XMLList class. This class uses some of the methods of the XML class. An XMLList object is any XML data or "fragment". If the object has one element, all methods, as for the XML object, are available. For methods of both classes there will be example code shown and there are example files in the subfolders XML and XMLList. A full description of all methods and properties can also be found in the Flash Help files.

Full Example Code

The following example shows the whole class script, which is used for all examples. When the individual properties and methods are discussed only the final part of the code within the "loadParse" function is shown. The following example is for the attribute method. We import the Sprite, Event, and LoaderClass classes, the last of which contains a method to load XML. When we parse XML the old-fashioned way, we need to import the XMLDocument class. We do not need to import the XML class, which is a final class.

226

```
package
{
  import flash.display.Sprite;
  import flash.events.Event;
  //import flash.xml.*;
  import scripts.helper.LoaderClass;
```

We declare the public class and extend it to the Sprite class. We need only one main variable for a LoaderClass object.

```
  public class Attribute extends Sprite
  {
    private var pXml:LoaderClass;
    public function Attribute ()
    {
    }
```

There is one main public function, which we call from the movie, which has one argument, the path and name of the XML file. We then create a new LoaderClass object and call its main function "initXML", with two arguments, for the name of the XML file and the name of the function, which will be called after the XML data is reloaded.

```
  public function parseData (xmlFile:String):void
  {
    pXml = new LoaderClass ();
    pXml.init (xmlFile, loadParse);
  }
```

When the XML file is loaded, the function "loadParse" is initiated. We then create either an XMLDocument object or an XML object as shown here. Then class-specific code follows for the attribute method shown here:

```
  private function loadParse (event:Event):void
  {
```

The part from here on will be shown as the class-specific code for the examples:

```
    var xmlData:XML = XML(event.target.data);
    trace(xmlData.house[1].attribute("id"));
    trace(xmlData.house[1].built);
    trace(xmlData.house.(@id = = 2).built);
    trace(xmlData.house.(built = = 1982).image);
  }
 }
}
```

When we want to work with the XMLNode or XMLDocument class we need to write a few more lines within the function "loadParse". We need to eliminate white space and parse the XML:

```
private function loadParse (event:Event):void
{
  var myXML:XMLDocument = new XMLDocument ();
  myXML.ignoreWhite = true;
  myXML.parseXML (event.target.data);
  var node:XMLNode = myXML.firstChild.firstChild;
  var myData:String = node.firstChild.attributes.
   description;
  trace(myData);
}
```

The XMLDocument Class

Properties

The XMLDocument class is identical with the former XML class. See Chapter 3 for definitions. .fla files for every method and property can be found on the CD in the Chapter 17 folder.

docTypeDecl property
```
public var docTypeDecl:Object
```

Specifies information about the XML document's DOCTYPE declaration.

idMap property
```
public var idMap:Object
```

An object containing the nodes of the XML that have an id attribute assigned.

ignoreWhite property
```
public var ignoreWhite:Boolean
```

When set to true, text nodes that contain only white space are discarded during the parsing process.

xmlDecl property
```
public var xmlDecl:Object
```

A string that specifies information about a document's XML declaration.

Constructor detail: XMLDocument() constructor
```
public function XMLDocument(source:String)
```

Creates a new XMLDocument object.

Methods
createElement() method
```
public function createElement(name:String):XMLNode
```
Creates a new XMLNode object with the name specified in the parameter.

createTextNode() method
```
public function createTextNode(text:String):XMLNode
```
Creates a new XML text node with the specified text.

parseXML() method
```
public function parseXML(source:String):void
```
Parses the XML text specified in the value parameter and populates the specified XMLDocument object with the resulting XML tree.

toString() method
```
public override function toString():String
```
Returns a string representation of the XML object.

XMLNode Class
The XMLNode class is the same as in AS2. Only the members and short description are summarized here. For more details check Chapter 3. For AS3 examples of this class check the XMLNode folder in the Chapter 17 folder.

Properties
attributes : Object
An object containing all of the attributes of the specified XMLNode instance.

childNodes : Array
[Read-only] An array of the specified XMLNode object's children.

constructor : Object
A reference to the class object or constructor function for a given object instance.

firstChild : XMLNode
Evaluates the specified XMLDocument object and references the first child in the parent node's child list.

lastChild : XMLNode
An XMLNode value that references the last child in the node's child list.

localName : String
[Read-only] The local name portion of the XML node's name.

namespaceURI : String
[Read-only] If the XML node has a prefix, namespaceURI is the value of the xmlns declaration for that prefix (the URI), which is typically called the namespace URI.

nextSibling : XMLNode
An XMLNode value that references the next sibling in the parent node's child list.

nodeName : String
A string representing the node name of the XMLNode object.

nodeType : uint
A nodeType constant value, either XMLNodeType.ELEMENT_NODE for an XML element or XMLNodeType.TEXT_NODE for a text node.

nodeValue : String
The node value of the XMLDocument object.

parentNode : XMLNode
An XMLNode value that references the parent node of the specified XML object or returns null if the node has no parent.

prefix : String
[Read-only] The prefix portion of the XML node name.

previousSibling : XMLNode
An XMLNode value that references the previous sibling in the parent node's child list.

prototype : Object
[Static] A reference to the prototype object of a class or function object.

Public Methods
XMLNode(type:uint, value:String)
Creates a new XMLNode object.

appendChild(node:XMLNode):void
Appends the specified node to the XML object's child list.

cloneNode(deep:Boolean):XMLNode
Constructs and returns a new XML node of the same type, name, value, and attributes as the specified XML object.

getNamespaceForPrefix(prefix:String):String

Returns the namespace URI that is associated with the specified prefix for the node.

getPrefixForNamespace(ns:String):String

Returns the prefix that is associated with the specified namespace URI for the node.

hasChildNodes():Boolean

Indicates whether the specified XMLNode object has child nodes.

insertBefore(node:XMLNode, before:XMLNode):void

Inserts a new child node into the XML object's child list, before the beforeNode node.

removeNode():void

Removes the specified XML object from its parent.

toString():String

Evaluates the specified XMLNode object; constructs a textual representation of the XML structure, including the node, children, and attributes; and returns the result as a string.

XML Class

The XML class is new in AS3 and allows direct access of nodes and attributes using the names. The example code presented here is the one from the sample files. The following XML files were used for the examples.

File 1

```
<?xml version = "1.0"?>
<!DOCTYPE house SYSTEM "house.dtd">
<RealEstate>
  <house id = "1">
    <bedroom description = "Bedroom:">3</bedroom>
    <bath description = "Bath:">2</bath>
    <price description = "Price:">239,999</price>
    <built description = "Built in">1990</built>
    <city description = "City:">North Sacramento</city>
    <image description = "Image:">images/house1.jpg</image>
    <details description = "Details:">null</details>
  </house>
  <house id = "2">
    <bedroom description = "Bedroom:">2</bedroom>
    <bath description = "Bath:">1</bath>
    <price description = "Price:">139,999</price>
```

```
          <built description = "Built in">1982</built>
          <city description = "City:">South Sacramento</city>
          <image description = "Image:">images/noimage.
           jpg</image>
          <details description = "Details:">null</details>
        </house>
```

File 2

```
      <?xml version = "1.0"?>
      <!DOCTYPE house SYSTEM "house.dtd">
      <RealEstate>
        <house id = "1">
          <!- This house is in a beautiful area. -->
          <?xml-stylesheet href = "foo.xsl" type = "text/xml"
           alternate = "yes"?>
          <bedroom description = "Bedroom:">3</bedroom>
          <bath description = "Bath:">2</bath>
          <price description = "Price:">239,999</price>
          <built description = "Built in">1982</built>
          <city description = "City:">North Sacramento</city>
          <image description = "Image:">images/house1.jpg</image>
          <details description = "Details:">null</details>
        </house>
        </RealEstate>
```

File 3

```
      <?xml version = "1.0" encoding = "UTF-8"?>
      <hs:Agency xmlns:hs = "http://www.getyourownhouse.com">
        <hs:Body>
          <hs:Built text = "Built in ">1990</hs:Built>
          <hs:Location text = "Located in ">Sacramento</hs:
           Location>
          <hs:Price text = "Price: ">$239,000</hs:Price>
        </hs:Body>
      </hs:Agency>
```

Properties

ignoreComments property

```
      ignoreComments:Boolean [read-write]
```

Determines whether XML comments are ignored when XML objects parse the source XML data. By default, the comments are ignored (true). To include XML comments, set this property to false. The ignoreComments property is used only during the XML parsing, not during the call to any method such as myXMLObject.child(*).toXMLString(). If the source XML includes comment nodes, they are kept or discarded during the XML parsing.

Example (file 2)

When set to false, all comments will be shown.

```
XML.ignoreComments = false;
var xmlData:XML = XML(event.target.data);
trace(xmlData);
```

Traces the entire XML file with the comment:

```
<!-- This house is in a beautiful area. -->
```

ignoreProcessingInstructions property

```
ignoreProcessingInstructions:Boolean [read-write]
```

Determines whether XML processing instructions are ignored when XML objects parse the source XML data. By default, the processing instructions are ignored (true). To include XML processing instructions, set this property to false. The ignoreProcessingInstructions property is used only during the XML parsing, not during the call to any method such as myXMLObject.child(*).toXMLString(). If the source XML includes processing instructions nodes, they are kept or discarded during the XML parsing.

Example (file 2)

```
XML.ignoreProcessingInstructions = false;
var xmlData:XML = XML(event.target.data);
trace(xmlData);
```

Traces the entire XML file with instructions.

```
<?xml-stylesheet href = "foo.xsl" type = "text/xml"
 alternate = "yes"?>
```

ignoreWhitespace property

```
ignoreWhitespace:Boolean [read-write]
```

Determines whether white space characters at the beginning and end of text nodes are ignored during parsing. By default, white space is ignored (true). If a text node is 100% white space and the ignoreWhitespace property is set to true, then the node is not created. To show white space in a text node, set the ignoreWhitespace property to false.

Example (file 2)

```
var xmlData:XML = XML(event.target.data);
trace(xmlData.house.length());
```

This would usually trace 1, if set to true (default). In the current example there is an error, because the node could not be found. "True" is the default value.

prettyIndent property
```
prettyIndent:int [read-write]
```

Determines the amount of indentation applied by the toString() and toXMLString() methods when the XML.prettyPrinting property is set to true. Indentation is applied with the space character, not the tab character. The default value is 2.

Example (file 2)
```
var xmlData:XML = XML(event.target.data);
trace(XML.prettyIndent);
```

Example will trace

```
2
```

prettyPrinting property
```
prettyPrinting:Boolean [read-write]
```

Determines whether the toString() and toXMLString() methods normalize white space characters between some tags. The default value is true.

Example
There is no example for this property.

Methods

Constructor detail: XML() constructor
```
public function XML(value:Object)
```

Creates a new XML object. You must use the constructor to create an XML object before you call any of the methods of the XML class. Use the toXMLString() method to return a string representation of the XML object regardless of whether the XML object has simple content or complex content.

addNamespace() method
```
addNamespace(ns:Object):XML
```

Adds a namespace to the set of in-scope namespaces for the XML object. If the namespace already exists in the in-scope namespaces for the XML object (with a prefix matching that of the given parameter), then the prefix of the existing namespace is set to undefined. If the input parameter is a Namespace object, it is used directly. If it's a QName object, the input parameter's URI is used to create a new namespace; otherwise, it is converted to a string and a namespace is created from the string.

Example (no file)

```
var myXml1:XML = new XML('<hs:Body xmlns:hs = "http://www.
 getyourownhouse.com/houses" />');
var nsNamespace:Namespace = myXml1.namespace();
var myXml2:XML = <Body />
myXml2.addNamespace(nsNamespace);
trace(myXml2.toXMLString());
```

Trace is

```
<Body xmlns:hs = "http://www.getyourownhouse.com/houses"/>
```

appendChild() method

```
appendChild(child:Object):XML
```

Appends the given child to the end of the XML object's properties. The appendChild() method takes an XML object, an XMLList object, or any other data type that is then converted to a string.

Example (file 1)

We append a child to the child node with the id=2. The node is added as another child node of the house node.

```
var xmlData:XML = XML(event.target.data);
xmlData.house.(@id==2).appendChild('<seller
 mood = "motivated" />');
trace(xmlData);
```

Trace is

```
<RealEstate>
  <house id = "1">
.......................................
  </house>
  <house id = "2">
.......................................
  <seller mood = "motivated"/>
  </house>
</RealEstate>
```

attribute() method

```
attribute(attributeName:*):XMLList
```

Returns the XML value of the attribute that has the name matching the attributeName parameter. The attributeName parameter can be any data type; however, String is the most common data type to use. When passing any object other than a QName object, the attributeName parameter uses the

toString() method to convert the parameter to a string. If you need a qualified name reference, you can pass in a QName object. A QName object defines a namespace and the local name, which you can use to define the qualified name of an attribute. Therefore calling attribute(qname) is not the same as calling attribute(qname.toString()) (attribute identifier (@) operator).

Example (file 1)

```
var xmlData:XML = XML(event.target.data);
trace(xmlData.house[1].attribute("id"));
trace(xmlData.house[1].built);
trace(xmlData.house.(@id = = 2).built);
trace(xmlData.house.(built = = 1982).image);
```

Trace is

```
2
1982
1982
images/noimage.jpg
```

attributes() method

```
attributes():XMLList
```

Returns a list of attribute values for the given XML object. Use the name() method with the attributes() method to return the name of an attribute. Use @* to return the names of all attributes.

Example (file 2)

```
var xmlData:XML = XML(event.target.data);
trace(xmlData.house.attributes());
```

Trace is

```
1
```

child() method

```
child(propertyName:Object):XMLList
```

Lists the children of an XML object. An XML child is an XML element, text node, comment, or processing instruction. You can also use the child's index number, for example, name.child(0). All children can be output if we use an asterisk (*), for example, doc.child("*").

Example (file 2)

```
var xmlData:XML = XML(event.target.data);
trace("A: "+xmlData.house.child(0));
trace("B: "+xmlData.house.child("bedroom"));
trace("C: "+xmlData.house.child("bedroom")[0].toXMLString());
```

Trace is

```
A: <!-- This house is in a beautiful area. -->
B: 3
C: <bedroom description = "Bedroom:">3</bedroom>
```

childIndex() method
```
childIndex():int
```
Identifies the zero-indexed position of this XML object within the context of its parent.

Example (file 2)
```
var xmlData:XML = XML(event.target.data);
trace("A: " + xmlData.house.bath.childIndex ());
trace("B: " + xmlData.house.city.childIndex ());
```

Trace is

```
A: 3
B: 6
```

children() method
```
children():XMLList
```
Lists the children of the XML object in the sequence in which they appear. An XML child is an XML element, text node, comment, or processing instruction.

Example (file 2)
```
var xmlData:XML = XML(event.target.data);
trace("A: "+xmlData.house.children()[0].toXMLString());
trace("B: "+xmlData.house.bedroom.children()[0].
 toXMLString());
trace("C: "+xmlData.house.children()[1].toXMLString());
```

Trace is

```
A: <!-- This house is in a beautiful area. -->
B: 3
C: <?xml-stylesheet href = "foo.xsl" type = "text/xml"
 alternate = "yes"?>
```

comments() method
```
comments():XMLList
```
Lists the properties of the XML object that contain XML comments.

Example (file 2)

```
XML.ignoreComments = false;
var xmlData:XML = XML(event.target.data);
trace(xmlData.house.comments().length());
trace(xmlData.house.comments()[0].toXMLString());
```

Trace is

```
1
A: <!-- This house is in a beautiful area. -->
```

contains() method

```
contains(value:XML):Boolean
```

Compares the XML object against the given value parameter.

Example (file 2)

```
var xmlData:XML = XML(event.target.data);
trace("A: "+xmlData.house.built.contains(1982));
trace("B: "+xmlData.house.bedroom.contains(1982));
trace("C: "+xmlData.house.bath.contains(1982));
```

Trace is

```
A: true
B: false
C: false
```

copy() method

```
copy():XML
```

Returns a copy of the given XML object. The copy is a duplicate of the entire tree of nodes.

Example (file 2)

```
var xmlData:XML = XML(event.target.data);
var newData:XML = xmlData.copy();
trace(newData.house.bedroom);
```

Trace is

```
3
```

defaultSettings() method

```
AS3 static function: defaultSettings():Object
```

Returns an object with the following properties set to the default values: ignoreComments, ignoreProcessingInstructions, ignoreWhitespace, prettyIndent, and prettyPrinting. The default values are as follows:

```
* ignoreComments = true
* ignoreProcessingInstructions = true
* ignoreWhitespace = true
* prettyIndent = 2
* prettyPrinting = true
```

Example (file 2)
```
XML.ignoreComments = false;
XML.ignoreProcessingInstructions = false;
var xmlData:XML = XML(event.target.data);
var copyData:XML = xmlData.copy();
trace("A: "+copyData.toXMLString());
XML.setSettings(XML.defaultSettings());
var newData:XML = xmlData.copy();
trace("B: "+newData.toXMLString());
```

Trace "A" will give the original file with comments and instructions. In trace "B" all comments and instructions are stripped off.

descendants() method
```
descendants(name:Object = *):XMLList
```

Returns all descendants (children, grandchildren, great-grandchildren, and so on) of the XML object that has the given name parameter. To return all descendants, use the "*" parameter. If no parameter is passed, the string "*" is passed and returns all descendants of the XML object.

Example (file 2)
```
var xmlData:XML = XML(event.target.data);
trace(xmlData.descendants("*").length());
trace(xmlData.descendants("*")[1].toXMLString());
trace(xmlData.descendants("*")[3].toXMLString());
```

Trace is

```
17
<!-- This house is in a beautiful area. -->
<bedroom description="Bedroom:">3</bedroom>
```

elements() method
```
elements(name:Object = *):XMLList
```

Lists the elements of an XML object. An element consists of a start and an end tag.

Example (file 2)
```
var xmlData:XML = XML(event.target.data);
trace(xmlData.house.elements("*").length());
trace(xmlData.house.elements("*")[1].toXMLString());
trace(xmlData.house.elements("*")[3].toXMLString());
```

Trace is

```
7
<bath description="Bath:">2</bath>
 <built description="Built in">1982</built>
```

hasComplexContent() method
```
hasComplexContent():Boolean
```

Used to determine whether the XML object contains complex content. An XML object contains complex content if it has child elements. XML objects with attributes, comments, processing instructions, and text nodes do not have complex content.

Example (file 2)
```
var xmlData:XML = XML(event.target.data);
trace(xmlData.house.hasComplexContent());
trace(xmlData.house.bedroom.hasComplexContent());
trace(xmlData.house.built.hasComplexContent());
```

Trace is

```
true
false
false
```

hasOwnProperty() method
```
hasOwnProperty(p:String):Boolean
```

Checks to see whether the object has the property specified by the p parameter.

Example (file 2)
```
var xmlData:XML = XML(event.target.data);
trace(xmlData.house.hasOwnProperty("built"));
trace(xmlData.house.hasOwnProperty("bedroom"));
```

Trace is

```
true
false
```

hasSimpleContent() method

```
hasSimpleContent():Boolean
```

Used to determine whether the XML object contains simple content. An XML object with text nodes and/or attribute nodes or an XML element that has no child elements has simple content. XML objects that represent comments and processing instructions do not contain simple content.

Example (file 2)

```
var xmlData:XML = XML(event.target.data);
trace(xmlData.house.hasSimpleContent());
trace(xmlData.house.bedroom.hasSimpleContent());
trace(xmlData.house.built.hasSimpleContent());
```

Trace is

```
false
true
true
```

inScopeNamespaces() method

```
inScopeNamespaces():Array
```

Lists the namespaces for the XML object, based on the object's parent.

Example (file 3)

```
var xmlData:XML = XML(event.target.data);
trace(xmlData.inScopeNamespaces());
```

Trace is

```
http://www.getyourownhouse.com
```

insertChildAfter() method

```
insertChildAfter(child1:Object, child2:Object):*
```

Inserts the given child2 parameter after the child1 parameter in this XML object and returns the resulting object. In the example the child2 object is inserted after the second <house> node.

Example (file 1)

```
var xmlData:XML = XML(event.target.data);
xmlData.insertChildAfter(xmlData.house.(@id==2), '<seller
 mood="motivated" />');
trace(xmlData);
```

Trace is

```
<RealEstate>
  <house id="1">
    <bedroom description="Bedroom:">3</bedroom>
    <bath description="Bath:">2</bath>
    <price description="Price:">239,999</price>
    <built description="Built in">1990</built>
    <city description="City:">North Sacramento</city>
    <image description="Image:">images/house1.jpg</image>
    <details description="Details:">null</details>
  </house>
  <house id="2">
    <bedroom description="Bedroom:">2</bedroom>
    <bath description="Bath:">1</bath>
    <price description="Price:">139,999</price>
    <built description="Built in">1982</built>
    <city description="City:">South Sacramento</city>
    <image description="Image:">images/noimage.jpg</image>
    <details description="Details:">null</details>
  </house>
  <seller mood="motivated"/>
</RealEstate>
```

insertChildBefore() method

```
insertChildBefore(child1:Object, child2:Object):*
```

Inserts the given child2 parameter before the child1 parameter in this XML object and returns the resulting object. In the example the child2 object is inserted between the first and the second <house> nodes.

Example (file 1)

```
var xmlData:XML = XML(event.target.data);
xmlData.insertChildBefore(xmlData.house[1], '<seller
 mood="motivated" />');
trace(xmlData);
```

Trace is

```
<RealEstate>
  <house id="1">
    <bedroom description="Bedroom:">3</bedroom>
    <bath description="Bath:">2</bath>
    <price description="Price:">239,999</price>
    <built description="Built in">1990</built>
```

```
      <city description="City:">North Sacramento</city>
      <image description="Image:">images/house1.jpg</image>
      <details description="Details:">null</details>
    </house>
    <seller mood="motivated"/>
    <house id="2">
      <bedroom description="Bedroom:">2</bedroom>
      <bath description="Bath:">1</bath>
      <price description="Price:">139,999</price>
      <built description="Built in">1982</built>
      <city description="City:">South Sacramento</city>
      <image description="Image:">images/noimage.jpg</image>
      <details description="Details:">null</details>
    </house>
  </RealEstate>
```

length() method

```
      length():int
```

For XML objects, this method always returns the integer 1. The length() method of the XMLList class returns a value of 1 for an XMLList object that contains only one value.

Example (file 1)

```
      var xmlData:XML = XML(event.target.data);
      trace(xmlData.house.length ());
```

Trace is

```
      2
```

localName() method

```
      localName():Object
```

Gives the local name portion of the qualified name of the XML object.

Example (file 3)

```
      var xmlData:XML = XML(event.target.data);
      trace(xmlData.localName());
```

Trace is

```
      Agency
```

name() method

```
      name():Object
```

Gives the qualified name for the XML object.

Example (file 1)

```
var xmlData:XML = XML(event.target.data);
trace("A: "+xmlData.house[1].attribute("id").name());
trace("B: "+xmlData.house[1].built.name());
trace("C: "+xmlData.children()[0].name());
trace("D: "+xmlData.house.(built==1982).name());
```

Trace is

```
A: id
B: built
C: house
D: house
```

namespace() method

```
namespace(prefix:String = null):*
```

If no parameter is provided, namespace associated with the name of this XML object is returned. If there is no such namespace, the method returns undefined.

Example (file 3)

```
var xmlData:XML = XML(event.target.data);
trace(xmlData.namespace());
trace(xmlData.namespace("ag"));
```

Trace is

```
http://www.getyourownhouse.com
undefined
```

namespaceDeclarations() method

```
namespaceDeclarations():Array
```

Lists namespace declarations associated with the XML object in the context of its parent.

Example (file 3)

```
var xmlData:XML = XML(event.target.data);
trace(xmlData.namespaceDeclarations().length);
for (var i = 0;i < xmlData.namespaceDeclarations().
 length;i++)
{
   trace(xmlData.namespaceDeclarations()[i]);
}
```

Trace is

```
1
http://www.getyourownhouse.com
```

nodeKind() method
```
nodeKind():String
```

Specifies the type of node: text, comment, processing-instruction, attribute, or element.

Example (file 2)
```
var xmlData:XML = XML(event.target.data);
trace("A: "+xmlData.house.children()[0].nodeKind());
trace("B: "+xmlData.house.children()[1].nodeKind());
trace("C: "+xmlData.house.children()[2].nodeKind());
```

Trace is

```
A: comment
B: processing-instruction
C: element
```

normalize() method
```
normalize():XML
```

For the XML object and all descendant XML objects, merges adjacent text nodes and eliminates empty text nodes.

Example
```
var myXml:XML = <body></body>;
myXml.appendChild("This is a");
myXml.appendChild("normalize Example.");
//
trace(myXml.children().length()); // 2
trace(myXml.child(0));
myXml.normalize();
trace(myXml.children().length()); // 1
trace(myXml.child(0));
```

Trace is

```
2
This is a
1
This is anormalize Example.
```

parent() method
```
parent():*
```

Returns the parent of the XML object. If the XML object has no parent, the method returns undefined.

Example (file 2)

```
var xmlData:XML = XML(event.target.data);
trace("A: "+xmlData.text.parent());
trace("B: "+xmlData.house.parent());
trace("C: "+xmlData.house.(built.contains("1982")).parent());
```

Trace is

```
A: undefined
B: <RealEstate>
   <house id="1">
     <!-- This house is in a beautiful area. -->
     <?xml-stylesheet href="foo.xsl" type="text/xml"
      alternate="yes"?>
     <bedroom description="Bedroom:">3</bedroom>
     <bath description="Bath:">2</bath>
     <price description="Price:">239,999</price>
     <built description="Built in">1982</built>
     <city description="City:">North Sacramento</city>
     <image description="Image:">images/house1.jpg</image>
     <details description="Details:">null</details>
   </house>
   </RealEstate>
C: <RealEstate>
   <house id="1">
     <!-- This house is in a beautiful area. -->
     <?xml-stylesheet href="foo.xsl" type="text/xml"
      alternate="yes"?>
     <bedroom description="Bedroom:">3</bedroom>
     <bath description="Bath:">2</bath>
     <price description="Price:">239,999</price>
     <built description="Built in">1982</built>
     <city description="City:">North Sacramento</city>
     <image description="Image:">images/house1.jpg</image>
     <details description="Details:">null</details>
   </house>
   </RealEstate >
```

prependChild() method

```
prependChild(value:Object):XML
```

Inserts a copy of the provided child object into the XML element before any existing XML properties for that element.

Example

```
var myXml:XML = <body></body>;
myXml.appendChild("This is a prependChild Example.");
//
trace("A: "+myXml.children().length()); // 1
trace("B: "+myXml.child(0));
myXml.prependChild("This is a new child.");
trace("C: "+myXml.children().length()); // 2
trace("D: "+myXml.child(0));
trace("E: "+myXml.child(1));
myXml.normalize();
trace("F: "+myXml.children().length()); // 1
trace("G: "+myXml.child(0));
```

Trace is

```
A: 1
B: This is a prependChild Example.
C: 2
D: This is a new child.
E: This is a prependChild Example.
F: 1
G: This is a new child.This is a prependChild Example.
```

processingInstructions() method

```
processingInstructions(name:String = "*"):XMLList
```

If a name parameter is provided, lists all the children of the XML object that contain processing instructions with that name. With no parameters, the method lists all the children of the XML object that contain any processing instructions.

Example (file 2)

```
XML.ignoreProcessingInstructions = false;
var xmlData:XML = XML(event.target.data);
trace("A: "+xmlData.processingInstructions().length());
trace("B: "+xmlData.house.processingInstructions().length());
trace("C: "+xmlData.house.processingInstructions());
```

Trace is

```
A: 0
B: 1
C: <?xml-stylesheet href="foo.xsl" type="text/xml"
 alternate="yes"?>
```

propertyIsEnumerable() method

```
propertyIsEnumerable(p:String):Boolean
```

Checks whether the property p belongs to the properties that can be iterated in a "for...in" statement applied to the XML object.

Example (file 2)

```
var xmlData:XML = XML(event.target.data);
trace("A: "+xmlData.propertyIsEnumerable(0));
trace("B: "+xmlData.house.propertyIsEnumerable(0));
trace("C: "+xmlData.house.propertyIsEnumerable(2));
trace("A-child: "+xmlData.child(0));
trace("B-child: "+xmlData.house.child(0));
trace("C-child: "+xmlData.house.child(2));
```

Trace is

```
A: true
B: true
C: false
A-child: <house id="1">
  <!-- This house is in a beautiful area. -->
  <?xml-stylesheet href="foo.xsl" type="text/xml"
   alternate="yes"?>
  <bedroom description="Bedroom:">3</bedroom>
  <bath description="Bath:">2</bath>
  <price description="Price:">239,999</price>
  <built description="Built in">1982</built>
  <city description="City:">North Sacramento</city>
  <image description="Image:">images/house1.jpg</image>
  <details description="Details:">null</details>
</house>
B-child: <!-- This house is in a beautiful area. -->
C-child: 3
```

removeNamespace() method

```
removeNamespace(ns:Namespace):XML
```

Removes the given namespace for this object and all descendants.

Example (file 3)
```
var xmlData:XML = XML(event.target.data);
trace(xmlData.namespaceDeclarations().length);
var hs:Namespace = xmlData.namespace("hs");
xmlData.removeNamespace(hs);
trace(xmlData.namespaceDeclarations().length);
```

Trace is

```
1
1
```

replace() method
```
replace(propertyName:Object, value:XML):XML
```

Replaces the properties specified by the propertyName parameter with the given value parameter. If no properties match propertyName, the XML object is left unmodified.

Example (file 2)
```
var xmlData:XML = XML(event.target.data);
trace(xmlData.house[0]);
xmlData.house.replace(3, '<replaced message="bath is
  replaced" />');
trace(xmlData.house[0]);
```

Trace is

```
<house id="1">
......
  <bath description="Bath:">2</bath>
......
</house>
<house id="1">
  ......
  <replaced message="bath is replaced"/>
......
</house>
```

setChildren() method
```
setChildren(value:Object):XML
```

Replaces the child properties of the XML object with the specified set of XML properties, provided in the value parameter.

Example (file 2)
```
var xmlData:XML = XML(event.target.data);
trace(xmlData);
var list:XMLList = xmlData.house.child(3);
xmlData.house.setChildren(<setChildren message="Children
 are set." />);
trace(xmlData);
xmlData.house.setChildren(list);
trace(xmlData);
```

Trace is

```
<RealEstate>
  <house id="1">
    <bedroom description="Bedroom:">3</bedroom>
    <bath description="Bath:">2</bath>
    <price description="Price:">239,999</price>
    <built description="Built in">1982</built>
    <city description="City:">North Sacramento</city>
    <image description="Image:">images/house1.jpg</image>
    <details description="Details:">null<details>
  </house>
</RealEstate>
<RealEstate>
  <house id="1">
    <setChildren message="Children are set."/>
  </house>
</RealEstate>
<RealEstate>
  <house id="1">
    <built description="Built in">1982</built>
  </house>
</RealEstate>
```

setLocalName() method
```
setLocalName(name:String):void
```

Changes the local name of the XML object to the given name parameter.

Example (file 3)

```
var xmlData:XML = XML(event.target.data);
xmlData.setLocalName("newName");
trace(xmlData);
```

Trace is

```
<hs:newName:xmlns:hs="http://www.getyourownhouse.com">
  <hs:Body>
    <hs:Built text="Built in ">1990</hs:Built>
    <hs:Location text="Located in ">Sacramento</hs:Location>
    <hs:Price text="Price: ">$239,000</hs:Price>
  </hs:Body>
</hs:newName>
```

setName() method

```
setName(name:String):void
```

Sets the name of the XML object to the given qualified name or attribute name.

Example (file 2)

```
var xmlData:XML = XML(event.target.data);
trace(xmlData);
xmlData.house.setName("NewHouse");
trace(xmlData);
```

Trace is

```
<RealEstate>
  <house id="1">
    <!-- This house is in a beautiful area. -->
    <?xml-stylesheet href="foo.xsl" type="text/xml"
     alternate="yes"?>
    <bedroom description="Bedroom:">3</bedroom>
    <bath description="Bath:">2</bath>
    <price description="Price:">239,999</price>
    <built description="Built in">1982</built>
    <city description="City:">North Sacramento</city>
    <image description="Image:">images/house1.jpg</image>
    <details description="Details:">null</details>
  </house>
</RealEstate>
```

```
<RealEstate>
  <NewHouse id="1">
    <!-- This house is in a beautiful area. -->
    <?xml-stylesheet href="foo.xsl" type="text/xml"
     alternate="yes"?>
    <bedroom description="Bedroom:">3</bedroom>
    <bath description="Bath:">2</bath>
    <price description="Price:">239,999</price>
    <built description="Built in">1982</built>
    <city description="City:">North Sacramento</city>
    <image description="Image:">images/house1.jpg</image>
    <details description="Details:">null</details>
  </NewHouse>
</RealEstate>
```

setNamespace() method

```
setNamespace(ns:Namespace):void
```

Sets the namespace associated with the XML object.

Example (file 3)

```
var xmlData:XML = XML(event.target.data);
var ns:Namespace = xmlData.namespace("hs");
trace("NS: "+ns);
var newXML:XML = new XML(<Agency><Body/></Agency>);
newXML.setNamespace(ns);
trace("New: "+newXML);
```

Trace is

```
NS: http://www.getyourownhouse.com
New: <hs:Agency xmlns:hs="http://www.getyourownhouse.com">
 <Body/></hs:Agency>
```

setSettings() method

```
setSettings(... rest):void
```

Sets values for the following XML properties: ignoreComments, ignoreProcessingInstructions, ignoreWhitespace, prettyIndent, and prettyPrinting. The following are the default settings, which are applied if no parameter is provided:

```
* XML.ignoreComments = true
* XML.ignoreProcessingInstructions = true
```

```
* XML.ignoreWhitespace = true
* XML.prettyIndent = 2
* XML.prettyPrinting = true
```

Example (file 1)

```
XML.ignoreComments = false;
XML.ignoreProcessingInstructions = false;
var customSettings:Object = XML.settings();
/******** will override the previous settings
  *********************/
XML.setSettings(XML.ignoreComments = true);
XML.setSettings(XML.ignoreProcessingInstructions = true);
var xmlData:XML = XML(event.target.data);
trace(xmlData);
```

Trace is

```
<RealEstate>
<house id="1">
  <bedroom description="Bedroom:">3</bedroom>
  <bath description="Bath:">2</bath>
  <price description="Price:">239,999</price>
  <built description="Built in">1982</built>
  <city description="City:">North Sacramento</city>
  <image description="Image:">images/house1.jpg</image>
  <details description="Details:">null</details>
</house>
</RealEstate>
```

settings() method

```
settings():Object
```

Retrieves the following properties: ignoreComments, ignoreProcessingInstructions, ignoreWhitespace, prettyIndent, and prettyPrinting.

Example (file 2)

```
Script in InitiateXml_ss.as:
XML.ignoreComments = false;
XML.ignoreProcessingInstructions = false;
var customSettings:Object = XML.settings();
/******** will override the previous settings
  *********************/
XML.setSettings(XML.ignoreComments = true);
```

```
XML.setSettings(XML.ignoreProcessingInstructions = true);
//or for all settings:
//XML.setSettings(XML.defaultSettings());
/******************************************************
 ***************/
```

Script in SetSettings.as:

```
var data:XML = InitiateXml_ss.xData;
trace(data);
```

Trace is

```
<RealEstate>
  <house id="1">
    <bedroom description="Bedroom:">3</bedroom>
    <bath description="Bath:">2</bath>
    <price description="Price:">239,999</price>
    <built description="Built in">1982</built>
    <city description="City:">North Sacramento</city>
    <image description="Image:">images/house1.jpg</image>
    <details description="Details:">null</details>
  </house>
</RealEstate>
```

text() method

```
text():XMLList
```

Returns an XMLList object of all XML properties of the XML object that represent XML text nodes.

Example (file 2)

```
var xmlData:XML = XML(event.target.data);
trace("A: "+xmlData.house.image.text());
trace("B: "+xmlData.house.bedroom.text());
trace("C: "+xmlData.house.text());
```

Trace is

```
A: images/house1.jpg
B: 3
C:
```

toString() method

```
toString():String
```

Returns the XML object as a string. The rules for this conversion depend on whether the XML object has simple content or complex content. If the XML object has simple content, the start tag, attributes, namespace declarations, and end tag are eliminated. If the XML object has complex content, the whole XML object with all tags is returned. To return the entire XML object every time, the toXMLString() method is used.

Example (file 3)
```
var xmlData:XML = XML(event.target.data);
trace(xmlData.toString());
var simpleXML:XML = new XML('<house location=
  "Sacramento" />');
trace("Simple: "+simpleXML.toString());
```

Trace is

```
<hs:Agency xmlns:hs="http://www.getyourownhouse.com">
  <hs:Body>
    <hs:Built text="Built in ">1990</hs:Built>
    <hs:Location text="Located in ">Sacramento</hs:Location>
    <hs:Price text="Price: ">$239,000</hs:Price>
  </hs:Body>
</hs:Agency>
Simple:
```

toXMLString() method
```
toXMLString():String
```

Returns the XML object as a string. The toXMLString() method always returns the start tag, attributes, and end tag of the XML object, regardless of whether the XML object has simple content or complex content.

Example (file 3)
```
var xmlData:XML = XML(event.target.data);
trace(xmlData.toXMLString());
var simpleXML:XML = new XML('<house location=
  "Sacramento" />');
trace("Simple: "+simpleXML.toXMLString());
```

Trace is

```
<hs:Agency xmlns:hs="http://www.getyourownhouse.com">
  <hs:Body>
    <hs:Built text="Built in ">1990</hs:Built>
```

```
    <hs:Location text="Located in ">Sacramento</hs:Location>
    <hs:Price text="Price: ">$239,000</hs:Price>
  </hs:Body>
</hs:Agency>
Simple: <house location="Sacramento"/>
```

valueOf() method

```
valueOf():XML
```

Returns the XML object.

Example (file 2)

```
var xmlData:XML = XML(event.target.data);
trace(xmlData.valueOf() === xmlData);
trace(xmlData.valueOf());
```

Trace is

```
true
<RealEstate>
. . . . . . . . . . . . . . . . .
</RealEstate>
```

The XMLList Class

An XMLList object is an ordered collection of properties. An XMLList object represents an XML document, an XML fragment, or an arbitrary collection of XML objects. An XMLList object with one XML element is treated the same as an XML object. When there is one XML element, all methods that are available for the XML object are also available for the XMLList object.

XMLList(value:Object)

Creates a new XMLList object.

The following methods are similar to those from the XML class. Check the XMLList folder for examples and definitions.

An example for the attribute method is given here.

```
attribute(attributeName:*):XMLList
```

Example (file 2)

We create a fragment of the XML file, which will get the data type XMLList. Then we can apply methods of the XMLList class similar to the XML class. If we use the whole XML file and declare

it an XMLList object we would get the following error message, because the length of the object is more than 1:

```
Implicit coercion of a value of type XML to an unrelated
 type XMLList.
var data:XML = InitiateXml.xData;
var xmlFragment:XMLList = data.house;
trace(xmlFragment.attribute("id"));
```

Trace is

```
1
1
```

Methods of the XMLList class

```
attributes():XMLList
child(propertyName:Object):XMLList
children():XMLList
comments():XMLList
contains(value:XML):Boolean
copy():XMLList
descendants(name:Object = *):XMLList
elements(name:Object = *):XMLList
hasComplexContent():Boolean
hasOwnProperty(p:String):Boolean
hasSimpleContent():Boolean
isPrototypeOf(theClass:Object):Boolean
length():int
normalize():XMLList
parent():Object
processingInstructions(name:String = "*"):XMLList
propertyIsEnumerable(p:String):Boolean
setPropertyIsEnumerable(name:String, isEnum:Boolean =
 true):void
text():XMLList
toString():String
toXMLString():String
valueOf():XMLList
```

The LoaderClass Class

As the exercise of this chapter, we will create the LoaderClass class, which we have used so far for all the examples. This class not only is the AS2 homologous class that we have created for loading

XML files for Flash 8, but also includes the capabilities to load images and movies. We will design this class to be able

- to load images and movies,
- to load XML files from a foreign server using the proxy method,
- show XML data that will be available in XMLDocument and XML class format, and
- to show XML files that will not stay in cache and to be renewed every time the file is loaded.

If you do not want the last option, you can easily alter the file. We have used this class for this chapter and will use it in the following chapters. In this exercise we discuss only the XML loading capabilities. At a later stage, when we need the class to load images, we will discuss the function that loads images.

We start the script by importing several classes. We place the script in a folder named "Helper", which means that we need to define the path as package scripts.helper.

```
package scripts.helper
{
```

We could import classes using a wildcard (*), but in this base class we try to avoid that, to have only the classes that we need available.

```
import flash.display.Sprite;
import flash.display.MovieClip;
import flash.display.Loader;
//
import flash.events.IEventDispatcher;
import flash.events.Event;
import flash.events.IOErrorEvent;
import flash.events.HTTPStatusEvent;
//
import flash.system.Capabilities;
//
import flash.net.URLLoader;
import flash.net.URLRequest;
import flash.net.URLRequestMethod;
```

We extend the Sprite class, which is similar to the MovieClip class and is a basic display list building block:

```
public class LoaderClass extends Sprite
{
```

We declare several variables, but only "xmlLoader" is important for loading XML files.

```
private var urlLoader:Loader;
private var holder:MovieClip;
private var im_url:String;
```

```
private var xmlLoader:URLLoader;
public function LoaderClass ()
{
}
```

We skip the "initLoader" function and turn to the "initXML" function, which has two parameters, for the path of the XML file and for a function that will be dispatched when loading is completed:

```
public function initXML (xmlFile:String, loadParse:
  Function):void
{
```

To prevent caching of an XML file we add a random number to the URL to make it unique. The Capabilities class, which we are using here, provides properties related to the system and the player. For some purposes, if the XML file is large and not altered by a script, you may not want this option.

```
var URL:String = xmlFile;
if (Capabilities.playerType != "External" &&
  Capabilities.playerType != "Standalone")
{
   URL += "?" + new Date ().getTime () + Math.floor
     (Math.random () * 10000);
}
```

We now use two classes to load the XML file; the first is the URLRequest class, which captures information of an http request and passes it on to the load method, in this case of the URLLoader class. The second class is the URLLoader class, which downloads data from a URL. This class is suitable for text. We create a new instance of the URLLoader class and let it invoke several event listeners. This is similar to the former load/onLoad event handling, as we know it from AS2.

```
var request:URLRequest = new URLRequest(URL);
xmlLoader = new URLLoader();
xmlLoader.addEventListener(Event.COMPLETE, loadParse);
xmlLoader.addEventListener(IOErrorEvent.IO_ERROR,
  ifFailed);
xmlLoader.addEventListener(HTTPStatusEvent.HTTP_STATUS,
  httpStatusHandler);
```

We then use the URLRequest Method class, which specifies whether a URL should use the "POST" or the "GET" method. Although this is not required for loading XML files directly from

the local server, it is required if we want to load XML files via the PHP-proxy method. We then use the URLLoader load method, which will result in a response from the server.

```
request.method = URLRequestMethod.POST;
urlLoader.load(urlRequest);
}
```

If loading has a problem, the user will be notified:

```
private function ifFailed (event:IOErrorEvent):void
{
  trace("ERROR");
}
```

We also add the loading status, which will come as a trace action every time an XML file is loaded using this class:

```
private function httpStatusHandler (event:
 HTTPStatusEvent):void
{
  trace("Status is " + event.status);
}
  }
}
```

Both of the above classes are shared by the two main public functions. We will use this class from now on, whenever we load an XML file or an image or movie. For demonstration purposes we test this class calling an XML file from a foreign domain using the proxy method.

Testing the LoaderClass Class

We already extensively tested the LoaderClass class when we went through the methods and properties of the different XML-related classes. As the final test we check if the class also works when we call an XML file from a foreign domain. To execute this we create the Proxytest class, which is similar to the XML-related classes except that we replace the trace actions by a TextField. We place this script in the .fla file, which will create a new instance of the Proxytest class, and call it myProxy.php. In the Document class text field we add the path to the Root class to create a timeline:

```
var URL:String = "myProxy.php";
var a:Proxytest = new Proxytest ();
a.parseData (URL);
```

The Proxytest class has the following executing script. We start with the variable declarations. We create a "LoaderClass" variable and a "Root" variable, which will be the timeline in the movie.

```
private var pXml:LoaderClass;
private var _root:MovieClip = Root._root;
```

Then we load the XML file by creating a new LoaderClass instance and executing the "initXML" function.

```
public function parseData (xmlFile:String):void
{
  pXml = new LoaderClass ();
  pXml.initXML (xmlFile, loadParse);
}
```

Once the XML file is loaded the "loadParse" function is executed and we retrieve the XML data, as we are used to doing. Then we create a TextField instance, which we add to the _root timeline:

```
private function loadParse (event:Event):void
{
  var xmlData:XML = XML(event.target.data);
  var showXML:TextField = new TextField ();
  showXML.width = 250;
  showXML.x = 100;
  showXML.y = 10;
  showXML.autoSize = TextFieldAutoSize.LEFT;
  showXML.text = xmlData;
  _root.addChild(showXML);
}
```

We can now test the movie and upload all the files to the server and test them. We should see an XML file displayed.

18 Menu Bar and ComboBox

Overview

In this chapter we will create the first application using ActionScript 3. We will develop a menu bar that is similar to the one we created before (Chapter 12). However, instead of using the former AS2 script we will script this menu bar from the beginning. There will be particular focus on changes from AS2 to AS3 and these will be explained in detail. The second object we will develop is a ComboBox-type menu. I did not have access to any components when this book was written.

The Menu Bar: .fla

Before we start writing any scripts we need to design the parts that we need for the menu bar. Actually, we can take all the MovieClips from the former menu bar, which was called "custom_menubar". We can take the .fla file and use it again for the new menu bar. However, we need to make some changes. First of all we change the Publish-Settings to Flash 9—ActionScript 3. This will cause a dramatic change in the movie that is very different from a change from Flash 7 to Flash 8. Open the .fla file custom_menubar_AS2.fla in the Chapter 18—Menubar— Menubar_Starter folder and make those Publish-Settings changes. Now open the library and click on one of the MovieClips and check the properties. All the linkage information is gone and instead in the class slot there is the former class path written, and in the Flash 9 preview it says "Auto-generated", while in Flash CS3 it will show only the class name. Therefore, the first task will be to write a simple base class for all MovieClips except for the frame MovieClip (see the MenuBar class as an example). We then go back to the MovieClips in the library and enter the class path for each MovieClip. We also delete all former AS2 ActionScript from the movie.

In this movie we are using frames and, as I mentioned earlier, it might be a better strategy to define a timeline with a name to which we can always refer, despite the fact that Flash will automatically create one. Therefore, we write a root class for the timeline, which is our Document class.

```
package scripts.menubar
{
  import flash.display.MovieClip;
  public class Root extends MovieClip
```

```
    {
      public static var _root:MovieClip;
      public function Root ()
      {
        _root = this;
      }
    }
  }
```

We can now place any object on this timeline and if we need to refer to an object from a different class we use the name of the timeline (_root) and the name of the object.

The Menu Bar: XML

Before we write any code we need to design the XML file. Since we use AS3 we will make use of the new XML class, which facilitates parsing XML. However, we also have to be careful now in naming each node if we do not want to miss any. When we used the XMLDocument class (former XML class) we were searching for child nodes and all node names could be different. We can still do that with methods from the new XML class, but there is also an even easier way, by just calling the node name. To make use of this option we give common nodes the same node names. If you look at the XML file that we use for the menu bar you will see:

```
<?xml version="1.0"?>
<menu>
  <item>
    <Name>Home</Name>
    <Data>home</Data>
  </item>
  <item>
    <Name>Search</Name>
    <Data>search</Data>
    <Links>
      <Name>Just sold</Name>
      <Data>sold</Data>
    </Links>
  </item>
  <item>
    <Name>New on Market</Name>
    <Data>news</Data>
  </item>
  <item>
    <Name>Just sold</Name>
    <Data>sold</Data>
  </item>
```

```
<item>
  <Name>Contact us</Name>
  <Data>contact</Data>
</item>
<item>
  <Name>Links</Name>
  <Links>
      <subitem label="Flashscript.biz"
       data="http://flashscript.biz" />
      <subitem label="Flashkit.com"
       data="http://flashkit.com" />
      <subitem label="Actionscript.org"
       data="http://actionscript.org" />
  </Links>
</item>
</menu>
```

We give all nodes the name <item>. Then later we can loop through the XML file by using "XML.item(count).Data" in case we want to catch all the <Data> nodes. We then do not have to worry that any of the child nodes might not be wanted, which could happen if we ask for all child nodes. As you can see here we no longer use as many attributes as we often used in XML files that were parsed using AS2. Attributes were easier to use then. We are now ready to write code.

The Menu Bar: Myparser.as

In the following scripts the classes to import and the class variables will no longer be mentioned. They are listed in the Starter scripts. The imported classes are always divided into Flash classes and custom classes, which we create. When you see a wildcard (.*), it means that more than one class of that path will be imported. We extend the Sprite class for this class, since there are no frames and we do not add any non-class-declared properties.

We have to decide, at this point, how we will proceed. There are different ways to place an object. One possibility is to create a MovieClip as a container and place all objects that belong to the application into the MovieClip. We will do that for the ComboBox (see below). For the menu bar we use a different strategy. We use the MenuBar object, which is the background bar for the menu, as the orientation for all other objects. In the class script, which has code to place the MenuBar on the timeline, we add the *x* and *y* coordinates. The name of this class is Myparser. We place the code for the coordinates in the constructor for that class and use new static variables for the values. We also define the timeline variable "_root" here.

```
public function Myparser (xpos:uint, ypos:uint)
{
  xposition = xpos;
  yposition = ypos;
  _root = Root._root;
}
```

The next task will be to call the XML file, and using a public function, which will be initiated in the .fla file, does this. From now on we use a new class, the LoaderClass, which contains the main function from the InitiateXml class, in a modified form, and, additionally, a function to load images and movies.

```
public function parseData (xmlFile:String):void
{
  pXml = new LoaderClass ();
  pXml.initXML (xmlFile, loadParse);
}
```

We first create a variable to hold the XML data in the listener function "loadParse". We need to add the parameter event to this function, which was sent from the urlLoader URLLoader object. Now we can easily get the XML data by adding .data to the event.target, which is the URLLoader object. We need to cast this object to an XML data type, since it is string data.

```
private function loadParse (event:Event):void
{
  var xmlData:XML = XML(event.target.data);
```

We first add the MenuBar object and position it with the *x* and *y* coordinates, which we got from the movie. We place it on "_root". Unlike in AS2, *x* and *y* and other variables do not have any underscore.

```
var menuBack:MenuBar = new MenuBar();
var bLength:MenuButton = new MenuButton();
menuBack.width = xmlData.children().length() *
 bLength.width;
menuBack.x = xposition;
menuBack.y = yposition;
_root.addChild(menuBack);
```

Now we loop through the XML data to get all children. As you can see we access the node values by directly calling the nodes with the node name <item>. Please note also that length() is a method and not a property, unlike in arrays.

```
for (var count01:uint = 0; count01 <
 xmlData.children().length(); count01++)
{
  var linkData:String = xmlData.item[count01].Links;
  var mName:String = xmlData.item[count01].Name;
  var mData:String = xmlData.item[count01].Data;
```

We create Button instances for each item node:

```
var button:MenuButton = new MenuButton();
```

We use a setter to associate the strings encoded in the variables to the buttons. Later, when we write the code for the MenuButton, we will need to add a setter() method.

```
button.linkSet = linkData;
button.dataSet = mData;
```

We trigger the mouse event when the cursor moves over the buttons by setting buttonMode to true. Then we add the buttons to the main timeline _root:

```
button.buttonMode = true;
_root.addChild(button);
```

We then create a text field. Please note not to use the underline with properties, unlike in AS2.

```
var tf:TextField = new TextField();
tf.width = button.width;
tf.height = button.height;
tf.border = true;
var tfo:TextFormat = new TextFormat();
tfo.align = "center";
tfo.bold = true;
tfo.font = "Verdana";
tfo.size = 10;
tf.defaultTextFormat = tfo;
```

We do not want the text field to respond to a mouse-over. We set the width of the TextField instance to the button width and add the TextField as a child to the button:

```
tf.mouseEnabled = false;
tf.text = mName;
tf.width = button.width;
button.addChild(tf);
```

We arrange the buttons using the original *x* and *y* coordinates and the width of each button:

```
button.x = xposition + button.width*count01;
button.y = yposition;
```

This is the end of the first class. We need to add a script to the .fla file in frame 1, where we create an instance of this class.

```
import scripts.menubar.Myparser;
var parser:Myparser = new Myparser (10, 5);
parser.parseData ("xml_files/menu.xml");
```

If you now test the movie you should get error messages pointing to the "button.linkSet = linkData;" and "button.dataSet = mData;" lines. We have not yet created the setter methods. To test the class, just comment these two lines out. If you have problems and get error messages, either try to repair it by yourself or use the Myparser_ready.as file, but convert the name to Myparser.as.

The Menu Bar: MenuButton Class

Now that we have the menu bar and menu buttons we need to give function to the buttons. There are two types of buttons, one for moving the timeline from one frame to another and one to open a menu with links. But before we get into the details of that, we need to add some general methods to all of the buttons. Instead of using onPress or onRelease for button functions, as we were used to from AS2, we add event listeners. This should also be familiar to you from the Flash 8 components, but it may be unfamiliar for you to use them for simple MovieClips or buttons. We add the event listeners to the constructor. We create three listeners for different mouse events. We also define the timeline variable "_root" in this class and at a later point we'll need an array. We create the Array instance here. We add several mouse events, such as MOUSE_OVER, MOUSE_OUT, and MOUSE_DOWN, which add button behavior.

```
public function MenuButton ()
{
  _root = Root._root;
  indexArray = new Array ();
  addEventListener (MouseEvent.MOUSE_OUT,
   mouseOutHandler);
  addEventListener (MouseEvent.MOUSE_OVER,
   mouseOverHandler);
  addEventListener (MouseEvent.MOUSE_DOWN,
   mouseDownHandler);
```

As you may remember, in the Myparser class we added a setter to the menu buttons. We now add the setter method. mData is the frame name, while lData is the nodes with the node name <Links>.

```
public function set dataSet(myData:String):void
{
  mData = myData;
}
public function set linkSet(liData:String):void
{
  lData = liData;
}
```

We add the actual button functions. The mouse-out and mouse-over functions lead the timeline in the button MovieClip to the corresponding frames.

```
private function mouseOutHandler (event:MouseEvent):void
{
  event.target.gotoAndPlay ("frame11");
}
```

```
private function mouseOverHandler
  (event:MouseEvent):void
{
  event.target.gotoAndPlay("frame2");
}
```

The mouse-down function is the main function for the buttons. We prepare to close the links drop-down menu when it is open. This is triggered when any of the other buttons is pressed. The sign that a drop-down menu is open is when the indexArray length is larger than 0.

```
private function mouseDownHandler
  (event:MouseEvent):void
{
  if(indexArray.length > 0)
  {
```

By using a "for" loop and the number of links as limit we remove all the previous dropped down links.

```
for (var count02 = 0; count02 <
  linkData.children().length(); count02++)
  {
    myClip.removeChild(indexArray[count02]);
  }
```

We then set the XML data to null and declare a new Array instance.

```
linkData = null;
indexArray = new Array();
}
```

We now need an "if" statement to differentiate between the two button types. When we want to add links instead of frame names we ask for the number of children of the <Links> node, which is given by the expression "linkData.children().length()". All <item> nodes that lack a <Links> node will have 0 children, while those with a <Links> node will have more than 0 children. Therefore, nodes with a linkLength of 0 have a <Data> node with a frame name as the node value. In this way we can easily add as many links as we like and wherever we want and the menu is completely autonomous and will be determined by the XML alone.

```
linkData = XMLList(lData);
var linkLength:int = linkData.children().length();
if(linkLength == 0)
{
  _root.gotoAndStop(mData);
}
else
{
```

When there are links we create a reference to the particular menu button. This is achieved with currentTarget, which points to the button object that was pressed and not to the MovieClip, which is common to all buttons. We give the counter variable "count01" the value 0 and add a function call to open the drop-down menu.

```
        myClip = event.currentTarget;
        count01 = 0;
        fallMenu ();
    }
}
```

In the function "fallMenu" the drop-down menu is created. We achieve this effect by creating instances of the LinkButton class, which we let slide down. The link buttons are children of the menu button that triggers their instantiation. We first create new LinkButton class instances.

```
    private function fallMenu ():void
    {
        var lButton:LinkButton = new LinkButton ();
```

We also create a new TextField instance for each button, since we want to label them.

```
        var lTextField:TextField = new TextField ();
```

The text for each button is derived from the XML attribute label, which we access here using the linkData variable and moving down in the XML document object model to the <subitem> node and its attribute label.

```
        var lText =
         linkData.subitem[count01].attribute("label");
        lTextField.text = lText;
```

The URLs for the links are the data attributes, which we access in the same way:

```
        var liUrl =
         linkData.subitem[count01].attribute("data");
```

We associate the corresponding URLs with each button.

```
        lButton.linkUrl = liUrl;
```

Then we give properties to the text fields as discussed earlier.

```
        lTextField.width = lButton.width;
        lTextField.height = lButton.height;
        lTextField.mouseEnabled = false;
        lTextField.border = true;
```

Finally we add the text fields to each button ...

```
        lButton.addChild(lTextField);
```

… and then link buttons to the menu buttons, which we access here using the "this" word.

```
this.addChild(lButton);
```

We add each LinkButton instance to the array indexArray. We do not need to do that using a special name. As you know, the indexArray array is needed when the next button is pressed. When it has a length of more than 0, it is a sign that the drop-down menu is open and it can then be used to close it. The Button instance information is also stored in the array.

```
indexArray.push(lButton);
```

We have to set the initial y coordinate for each link button:

```
var butMoved:uint = (count01+1)*(lButton.height+4)+4;
```

We are now ready to create a new Timer instance with a 1-millisecond interval and length determined by the y value for the final link button. The Timer class is similar to the former setInterval method. We can set the number of intervals in addition to the interval time. The first argument is the delay argument. We set the delay (interval) time to 1 millisecond. The second argument is the repeatCount, which is the frequency of the interval and which we set to the y coordinate of the button. Depending on the number, which will increase with more buttons, the number of intervals will occur.

```
var myTimer:Timer = new Timer(1, butMoved);
```

The myTimer instance will trigger an event listener. Here a different way of writing the event type is shown. Instead of the class, which in this case is TimerEvent, followed by the event type, we write the event type in quotations. The method start() will start the timer.

```
myTimer.addEventListener("timer", timerHandler);
myTimer.start();
function timerHandler(event:TimerEvent):void
{
```

We set a time delay between two timer events. The delay will increase and cause an easing effect.

```
event.target.delay = event.target.currentCount/4;
```

The y value for each button is equal to the number of times myTimer was fired, which in this case is determined by the value of but Moved.

```
lButton.y = event.target.currentCount;
```

If the currentCount number has reached the total number of repeats (repeatCount) we increment the "count01" variable.

```
if(lButton.y >= event.target.repeatCount)
{
  count01++;
```

If count01 exceeds the number of links, we stop the timer and set count01 back to 0.

```
if(count01 >= linkData.children().length())
{
  event.target.stop();
  count01 = 0;
}
else
{
```

Otherwise we repeat the function for the next link button.

```
      fallMenu ();
    }
  }
}
}
```

You can test the movie now but you need to comment out the line "lButton.linkUrl = liUrl;", since we did not write the whole LinkButton class yet. If you have not added the code by yourself you can still test the current movie. Just change the name MenuButton_ready.as to MenuButton.as in the Menubar_StarterB folder.

The Menu Bar: LinkButton Class

Our menu is functional so far, except that we need to add function to the link buttons. Their task is to call a URL to open a new Web site, which should be quite simple. Since the buttons have frames we extend this class to the MovieClip class. We need only one class variable, "lkUrl", for a setter method. This is the data from the MenuButton class (lButton.link Url = liUrl;).

```
private var lkUrl:String;
```

Since these are buttons we add mouse event handlers to the link buttons:

```
public function LinkButton ()
{
  this.addEventListener(MouseEvent.MOUSE_DOWN,
   mouseDownHandler);
  this.addEventListener(MouseEvent.MOUSE_OUT,
   mouseOutHandler);
  this.addEventListener(MouseEvent.MOUSE_OVER,
   mouseOverHandler);
}
```

We use a setter method to get the data from the MenuButton class:

```
public function set linkUrl(mUrl:String):void
{
    lkUrl = mUrl;
}
```

We add mouse-over and mouse-out animations:

```
private function mouseOutHandler
  (event:MouseEvent):void
{
    event.target.gotoAndPlay("frame11");
}
private function mouseOverHandler (event:MouseEvent):void
{
    event.target.gotoAndPlay("frame2");
}
```

The button-down event will trigger the call to open a new Web site. Note that the former getURL method is now replaced with the navigateToURL method. It is important that we first create a URLRequest object, which has as a parameter the URL. The URLRequest class creates a single http request. The class is also used in combination with other URL loading functions.

```
private function mouseDownHandler (event:MouseEvent):void
{
    var urlRequest:URLRequest = new URLRequest(lkUrl);
     navigateToURL(urlRequest, "_blank");
}
```

And this brings us to the end of this tutorial. However, to maintain the menu bar as one unit we add an interface to it. We do that from now on with every unit we create. Adding an interface works in the same way we learned in the AS2 section, when we created the search engine (Chapter 13).

The ComboBox: Overview

In the Flash 9 preview we do not have any components available, including the ComboBox component. However, in the search engine application we need to use a ComboBox. The solution is easy: we make our own. At this stage it is not that difficult to do so, because we have already developed a menu bar, which in its functionality shares features with the ComboBox. One important feature is the drop-down menu. In the ComboBox every menu button triggers a drop-down menu. An important difference from the menu bar is that when we click on one of the buttons from the drop-down menu a text field will stay, with a label that is associated with data, if we have coded this in the XML file. In this tutorial we will not cover the whole script if it is repetition from the previous tutorial. However, you will learn another important aspect of AS3, which is event bubbling.

The ComboBox: XML

The XML is also similar to the menu bar XML, especially the part for the drop-down menu. One main child node of the XML file is shown below.

```
<item>
  <Name>Select Region</Name>
  <Data>myURL</Data>
  <Links>
    <subitem label="North" data="xml_files/North.xml" />
    <subitem label="South" data="xml_files/South.xml" />
    <subitem label="East" data="xml_files/East.xml" />
    <subitem label="West" data="xml_files/West.xml" />
  </Links>
</item>
```

As we know from the menu bar this XML structure will trigger a drop-down menu.

The ComboBox: .fla

As I mentioned earlier we use a different strategy to place the ComboBox on stage. While we placed the menu bar directly in the "_root" timeline, which we created, we will place the ComboBox into a MovieClip, which we then manipulate. So first we create a MovieClip. We could have created a Sprite object, but since we use frames in some of the objects, we stick to MovieClip in our whole application. Otherwise we need to add more classes, which, in my opinion, is not necessary. We position the MovieClip, cb, on the timeline, which is again defined by the Root class (see Document class).

```
import scripts.CombBox.ComboMenu;
var cb:MovieClip = new MovieClip ();
cb.x = 10;
cb.y = 10;
this.addChild (cb);
```

Then we create an instance of the ComboMenu class and call the public function "parseData" with the function arguments for an XML file and the MovieClip cb.

```
var myCombo:ComboMenu = new ComboMenu ();
myCombo.parseData ("xml_files/combo.xml", cb);
```

The ComboBox: ComboMenu Class

We now turn to the ComboMenu class. Since this script is very similar to the Myparser script for the menu bar we will discuss only the different parts. We are positioning the ComboBox in a MovieClip, cb, which is a function argument of the "parseData" function. Therefore, we pass the

reference for the MovieClip on to the ComboMenu class and have it ready as the variable "myClip" for the class.

```
public function parseData (xmlFile:String,
 mClip:MovieClip):void
{
  myClip = mClip;
  pXml = new LoaderClass ();
  pXml.initXML (xmlFile, loadParse);
}
private function loadParse (event:Event):void
{
```

When we create the background bar for the ComboBox we now place it into the myClip MovieClip:

.

```
myClip.addChild(menuBack);
```

We then loop through the children and catch all child nodes of the <item> child nodes and associate them with variables:

```
for (var count01:uint = 0; count01 <
 xmlData.children().length(); count01++)
{
  var mName:String = xmlData.item[count01].Name;
  var mData:String = xmlData.item[count01].Data;
  var linkData:String = xmlData.item[count01].Links;
```

We create the main menu buttons and transfer them using setters to the MenuButton class. We also give the menu buttons names as identifiers. We need the names later to identify each data value with a particular menu button. We then add each button to the myChild MovieClip.

```
var button:MenuButton = new MenuButton ();
button.name = "mb_"+count01;
button.dataSet = mData;
button.linkSet = linkData;
button.buttonMode = true;
myClip.addChild(button);
```

The ComboBox: LinkButton Class

The MenuButton class is basically identical to the same class for the menu bar and we do not discuss it any further, except that we need to give names to each link button when it is placed on the timeline. See the MenuButton class for that.

```
lButton.name = "lb"+count02;
```

We now turn to the LinkButton class. The way the ComboBox functions is to open a drop-down menu consisting of link buttons. When we press one of the link buttons we want this button to be visible while all other buttons disappear. We do that with the aid of event bubbling. We add mouse event handlers to each button. As an example the function when the mouse is pressed is shown.

```
private function mouseOverHandler
  (event:MouseEvent):void
{
    event.stopPropagation ();
    this.gotoAndPlay("frame2");
}
```

We know this type of function from the menu bar. However, the important line here is "event.stopPropagation ();". What this does is prevent the parents of the link button from reacting to the button event. If we omitted this line and pressed one of the link buttons the corresponding menu button would react as well and we could see the green border glowing.

On the other hand, we make use of that when the mouse is in the "up" state after pressing. As you may recall, when the menu button is pressed the link buttons form a drop-down menu. If we now release the mouse after pressing a link button, the menu button will be activated as well and then all the link buttons will be removed. In the function below we first add a line to remove any child that is a prior link button text field. Since the text field was placed at level 0, we can now easily remove the text field from level 0 using the removeChildAt () method. We then create a new TextField and disable any button properties using the mouseEnabled Boolean.

```
private function mouseUpHandler (event:MouseEvent):void
{
  this.parent.removeChildAt (0);
  var tf:TextField = new TextField ();
  tf.name ="tf";
  tf.mouseEnabled = false;
  .................
```

Here we place the text field at level 0. If we had prevented event bubbling it would be a mess and all buttons would still be present. You can test that by adding the "event.stopPropagation ();" line to this function.

```
this.parent.addChildAt (tf, 0);
```

Further, we need to create memo variables depending on which menu button was pressed. The line "this.parent.name" refers to the name of the menu button, since each link button is a child of a menu button. Using a switch function we associate private static variables with the

data from the XML that was transferred from the MenuButton class to a setter in the LinkButton class.

```
switch (this.parent.name)
{
  case "mb_0":
      mb_0_cont = lkUrl;
      mb_0_dat = daUrl;
      break;
  case "mb_1":
      mb_1_cont = lkUrl;
      break;
  case "mb_2":
      mb_2_cont = lkUrl;
      break;
  case "mb_3":
      mb_3_cont = lkUrl;
      break;
  default:
    trace("Not 0, 1, or 2");
  }
}
```

We create getters for the data depending on which menu and link buttons were pressed. This enables us to retrieve the data from another class. It will become important when we develop the search engine, since we need this data to display the correct house listings.

```
public function get mb_0 ():String
{
  return mb_0_cont;
}
public function get mb_0_D ():String
{
  return mb_0_dat;
}
public function get mb_1 ():String
{
  return mb_1_cont;
}
public function get mb_2 ():String
{
  return mb_2_cont;
}
```

```
public function get mb_3 ():String
{
  return mb_3_cont;
}
```

The final part of this project is to add an interface to all classes to confine the application as a unit. This brings us to the end of the tutorial. We are now ready to develop the search engine using this ComboBox application.

19 The Search Engine (Part 1)

Overview

We are now ready to approach the search engine, which will be covered in the next two chapters. As before we need to plan which objects will be in the movie and where we place them. Figure 19.1 shows the final movie, which we want to produce.

We will first create the base search engine, which is covered in this chapter. We then add a Next–Previous module and a Save Search option, as we did for the Flash 8 application. Although

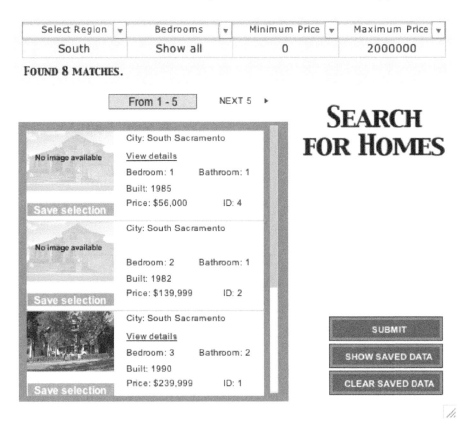

Figure 19.1 *Outline of the database movie*

we try to write the code as efficiently as possible and try to omit unnecessary code, our application will be ready only when it has passed a test. We will test our final application with a large XML file, which contains over 125 house nodes. We will measure the time from the beginning of the search to the end, when all house descriptions are displayed. We then will work to reduce compilation time to make our application faster. We will test which scripts cause a slowdown of the player and then we will correct them.

What do we need for this movie? We need the ComboBox, which we developed earlier. We place the ComboBox folder into the library of the new Database .fla file. However, beforehand we place the ComboBox folder containing all the class scripts into a folder named Scripts. We test, by checking the properties of all MovieClips, whether the class file paths are correctly recognized. If there was a problem it will show the "Auto-generated" notice and we need to correct that. Then we need three buttons for submitting, showing saved data, and clearance. Since the buttons have the same appearance but different text, we need only one button type, which, however, should be enabled to have customized text. We further need a scrollbar, which I have provided. As before, we will need a MovieClip, which will have text fields for the house descriptions and which displays the images for the houses. As is obvious from Figure 19.1, we will also have a gray frame and a mask. To show next and previous images, we need a module with buttons. The figure also indicates a text field, which shows the number of matches.

The strategy we apply is similar to other applications. We first design the MovieClips and have them available in the library. We don't add any text fields, since we will add them by scripts. We write simple class files, which have only the class declaration and the constructor without any further variables or methods. Those will be added later. Since in the beginning we want only to get the search engine working without saving any data or using Next–Previous buttons, we do not yet add them. Basically, we add the following MovieClips: EventButton, Frame, HouseDisplay, a Mask, and a MortgageAd for when the movie opens. Except for MovieClips that have frames, all other MovieClips will extend the Sprite class.

We also need an Alert window in case the user did not set all the values necessary for a search (Figure 19.2). Since we do not have any access to components, we need to create our own AlertBox, which consists of the box and a button. Both the button and the box have fills, which are MovieClips. We do not add any classes for the fills, but we add filters like a shadow or a glow. The MovieClips are all stored in a folder named AlertWindow. The Alert box will also open if the user has selected a higher minimum compared to maximum price. For the AlertWindow we create two classes, one for the actual window (AlertBox) and one for the button (AlertButton), which will close the window. We place all the MovieClip class files in a folder named mc. Finally we add a shape and a headline to the movie, which are our sole hard-copy-added objects in the movie.

To start the movie we again create a Root class, as we have done in previous exercises (for example, Chapter 18). We write the path and name of the class, scripts.helper.Root, in the box of the .fla that says "Document class". This defines the main timeline of the movie. We have only a small script in the .fla file to call the initial class, ArrangeStage, to arrange the movie.

Figure 19.2 *The database movie with Alert box: the user has not selected number of bedrooms, which opens the Alert box when the Submit button is pressed*

```
import scripts.ArrangeStage;
var ars:ArrangeStage = new ArrangeStage ();
ars.initStage();
```

That is all that the movie itself contains.

The Search Engine Interface

Before we start writing the script, we will make a rough outline of the interface and look at the major classes and how they are connected. Figure 19.3 shows the outline.

The two core classes are the ArrangeStage and the DataBase classes. The DataBase class is triggered by the Submit button, and the ArrangeStage class places all the objects required to initiate a search on the stage. Those are the three main buttons and the initial MovieClips for displaying a search result. The DataBase class then communicates with other classes like those for the scrollbar, the Next and Previous buttons (NextModul), and the Save buttons, which are located in the display for

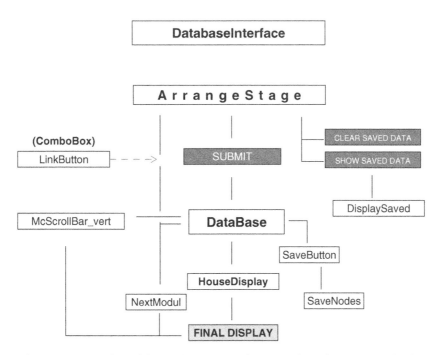

Figure 19.3 *Outline of the search engine interface. "Final Display" is not a class but the result of a search displaying houses and their descriptions. Not all classes are shown, for reasons of clarity.*

each house. As we will learn, several classes that require text fields interact with a superclass ButText to position the text fields and format the text. The first class, which, logically, we will cover in the next section, is the ArrangeStage class.

Arranging Objects on the Stage: The Arrange Stage Class

We start in a fashion similar to that for the Flash 8 movie. We place a number of objects that we need right away on stage. The main difference compared to the Flash 8 movie is the syntax and the fact that we use a specific timeline. The classes that we import and the variables declarations are not shown. You can look those up in the class files. We start with the timeline variable "_root", which is defined as a static variable and called over the Root class:

```
public function ArrangeStage ()
{
  _root = Root._root;
}
```

Then we have the main public function "initStage", which is called from the movie and initiates the whole movie:

```
public function initStage ():void
{
```

To have some orientation in the movie and to have a reference MovieClip, which contains all the objects of the display of the houses, we create a Sprite object, infoDisplay, and place it on the main "timeline" _root. Again be aware that the main timeline itself is a Class object and can be handled as such. The levels into which the MovieClips are placed are determined by the order in which we add them. For example, the main timeline has the lowest level, followed by infoDisplay. When we place this line into the main movie trace (stage.getChildIndex(Root._root)), the trace will be 0, since the first object of the Stage object is the _root object, which we call our "main timeline".

```
infoDisplay = new Sprite ();
infoDisplay.name = "infoDisplay";
_root.addChild (infoDisplay);
```

We add some objects to infoDisplay, like a frame …

```
myFrame = new Frame ();
myFrame.name = "myFrame";
infoDisplay.addChild (myFrame);
```

… and a mask, which will position the frame also. The mask is not yet used as an actual mask. However, we want to have it ready. Although we will cover the mask with a mortgage ad, we will make it invisible in case we do not use any additional MovieClips. It should be noted here that visible requires less memory than alpha. Therefore, whenever visibility is concerned we try to avoid alpha.

```
myMask = new Mask ();
myMask.name = "mask";
infoDisplay.addChild (myMask);
myMask.x = 10;
myMask.y = 120;
myMask.visible = false;
myFrame.x = myMask.x-4;
myFrame.y = myMask.y-4;
myFrame.width = myMask.width+25;
myFrame.height = myMask.height+10;
```

We add an animation to _root to lighten up the current movie and position and size it similar to the mask:

```
mo_ad = new MortgageAd (myMask.x, myMask.y,
 myMask.width, myMask.height);
mo_ad.name = "mo_ad";
_root.addChild (mo_ad);
```

Now we add the ComboBox using a holder MovieClip. The reason we add the ComboBox at this stage is that when it opens it will open above all other objects, since its level is higher.

```
cb = new MovieClip ();
cb.name = "cb";
cb.x = 10;
cb.y = 5;
_root.addChild (cb);
var myCombo:ComboMenu = new ComboMenu ();
myCombo.parseData("xml_files/combo.xml", cb);
```

Finally, we add an EventButton object, submitBut, to start the search and label it "SUBMIT". We will get to the EventButton class in a moment.

```
submitBut = new EventButton ("SUBMIT");
submitBut.name = "submitBut";
submitBut.x =  myFrame.x + myFrame.width + 50;
submitBut.y =  myFrame.y + 220;
_root.addChild (submitBut);
```

We add behavior to the button, when the mouse is pressed:

```
submitBut.addEventListener(MouseEvent.MOUSE_DOWN,
 submitDownHandler);
function submitDownHandler (event:MouseEvent)
{
```

This is to trigger an animation, as we have done with other buttons in previous exercises.

```
event.currentTarget.gotoAndStop("frame11");
```

We now create a new object of the ComboBox LinkButton class, because we want to access the data from the Combo menu. If there are none, or the maximum house price is equal to or smaller than the minimum house price, we open an Alert box. We add the text as a parameter to the Alert box, which will set the text that is displayed. We set a Boolean to true, signaling at this point to proceed. However, if there is a problem, proceed will be false and the process will be terminated.

```
proceed = true;
var link:LinkButton = new LinkButton ();
var ab:AlertBox = new AlertBox ("One or more
 parameters are null. Please, select all
 parameters.");
```

We test if any of the ComboBox values expressed as "link["mb_"+count01]" are null. In the ComboBox LinkButton class we have several getters with the name "mb_" plus a number (0–3). These getters will have values when the ComboBox link buttons have been selected.

```
for (var count01:uint = 0; count01 <= 3; count01++)
{
```

```
if (link["mb_"+count01] == null)
{
```

If a value is missing, an Alert box will pop up and further script execution will be terminated. We will look at the scripts for the Alert box shortly.

```
ab.x = _root.stage.stageWidth/4;
ab.y = _root.stage.stageHeight/4;
_root.stage.addChild (ab);
proceed = false;
return proceed;
}
}
```

A second possibility is that the user has selected a value for the minimum price that is higher than or equal to the maximum price. Then we also want to alert the user and we add a different text:

```
if (uint(link.mb_2) >= uint(link.mb_3))
{
  var ab:AlertBox = new AlertBox ("The maximum
   price is equal to or lower than the minimum
   price. Please correct.");
  ab.x = _root.stage.stageWidth/4;
  ab.y = _root.stage.stageHeight/4;
  _root.stage.addChild (ab);
  proceed = false;
  return proceed;
}
else if (proceed)
{
```

If there are no problems we create a new instance of the DataBase class and initiate the main function, and the search can proceed.

```
var ib:DataBase = new DataBase ();
ib.initDbase ();
mo_ad.visible = false;
}
}
}
}
}
```

The ButText Superclass

We have touched on a number of classes in the ArrangeStage class. Some of them, like the Frame class, have no content except for the class declaration and the constructor. Others have additional content, which gives them further functionality. Some classes we have seen so far have one parameter in common: they all have text fields. We will see more classes like this in the next chapter. One possibility is that in every class we repeat the same scripts to create a text field and format it. However, that would be a lot of additional scripts, which we would like to avoid. Instead, we create one class, which has all the properties and methods to create and format a text field. This class, ButText, will be the superclass for other classes. This class itself is a subclass of the MovieClip class. In this way, subclasses of ButText that represent MovieClip objects will still maintain all the methods and properties of MovieClips. Figure 19.4 shows all the MovieClips that use the ButText class. As you may notice there are more MovieClips in the ComboBox, for example, that have text fields. Those are, however, separate applications. Also, the display units for houses have text fields, but, as you will learn, those text fields are separately created and formatted for a particular reason.

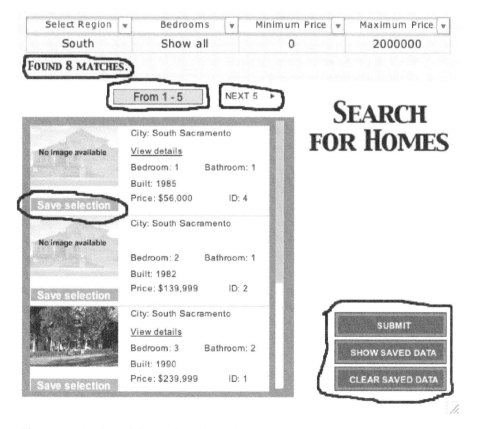

Figure 19.4 *The circled areas show objects that use the ButText class to manipulate text fields*

It is time to see what the ButText class looks like. Basically, it is a script that creates a text field with formatting. Then there are a number of getters and setters, which are needed to change the text format of the text field once it has been created. We import the MovieClip class and for the text classes we currently use a wildcard. We declare only one variable, "tf", of data type TextField.

```
import flash.display.MovieClip;
import flash.text.*;
public class ButText extends MovieClip
{
    private var tf:TextField;
    public function ButText ()
    {
```

In the constructor we place a script to create a new text field with various properties like *x* and *y* coordinates, width, and so on. We disable any mouse reaction of the text field:

```
tf = new TextField ();
tf.name = "tf";
tf.mouseEnabled = false;
tf.x = this.x;
tf.y = this.y;
tf.width = this.width;
tf.height = this.height;
tf.wordWrap = false;
tf.multiline = false;
tf.textColor = 0x000000;
tf.htmlText = "TextField";
```

We also add the line "this.addChild (tf);". The "this" word would refer to the object that is calling the ButText class, for example, the EventButton class, which extends the ButText class. The text field would then be placed on the EventButton instance:

```
this.addChild (tf);
```

We further create a default text format, which determines basic properties of the text field:

```
var format:TextFormat = new TextFormat ();
format.align = "center";
format.font = "Arial";
format.size = 12;
tf.defaultTextFormat = format;
}
```

To make this class more versatile and be able to change properties at runtime, when the text field is already created, we add getter and setter methods for changing the text field content, *x, y,* width, height, wordwrap, multiline, color, and some other properties of the text field and associated text.

This allows adding button behavior to text in a text field, such as italic, bold, and/or color change, to mention a few examples. I have listed only two examples here for getters and setters, for the label …

```
public function set tf_label (t_label:String):void
{
  tf.htmlText = t_label;
}
public function get tf_label ():String
{
  return tf.htmlText;
}
```

… and for the multiline property, which can be set by using a Boolean (true or false). When the getter is set it is important to add the return type to the function. Otherwise there will be an error.

```
public function set tf_multiline
  (t_multiline:Boolean):void
{
  tf.multiline = t_multiline;
}
public function get tf_multiline ():Boolean
{
  return tf.multiline;
}
```

For some of the changes we need to create a new text format, which will override the current format. This allows only subclasses to call these functions. Again, the whole function with all individual statements is not shown here, only the first two statements, which demonstrates how this function works. We also add "else" statements, which will set some of the original default values of the text format back if there is no change. If we omitted them, the value of, for example, "format.align = "center";", which centers the text, would change to the Flash default parameter, which, in the case of text alignment, is "left".

```
public function setFormat (tf_align:String,
  tf_font:String, tf_size:Object, tf_bold:Boolean,
  tf_italic:Boolean):void
{
  var format:TextFormat = new TextFormat ();
  if (tf_align != null)
  {
    format.align = tf_align;
  }
  else
  {
```

```
            format.align = "center";
        }
        if (tf_font != null)
        {
            format.font = tf_font;
        }
        else
        {
            format.font = "Arial";
        }
        . . . . . . . . .
```

The final statement would be to set a text format:

```
        tf.setTextFormat (format);
    }
  }
}
```

Extending the ButText Class:
Example EventButton Class

To see how we make use of the ButText class we will look at some examples now. The first exam-
ple is the EventButton class. We are using this class for several buttons, which all have different labels.
We import the MouseEvent and the ButText classes, which are the only classes we need. We extend
the ButText class. This allows us to access all the functions directly using the "this" word, although
in AS3 we can also omit "this". You can test it by deleting the "this" word. The constructor has one
parameter, which is the label for the text field. It is indicated here that this class is a subclass by the
super () method and, of course, by the word "extend". We can omit the super () method; however,
for clarity I have added it to the script. Also if the constructor of the ButText class has parameters,
we have to add super with the correct number of parameters. Unlike in AS2, however, super () does
not have to be added in line 1 of the constructor any more, but can occur later.

```
        import flash.events.MouseEvent;
        import scripts.ButText;
        public class EventButton extends ButText
        {
            public function EventButton (label:String)
            {
                super ();
```

Now we set some properties for the text field. We do that by using some variables. You may have
noticed that we have never declared these variables in this class. We don't have to, because this class
is using methods and properties from the ButText class and that means all the variables are already
defined by just calling the superclass.

```
tf_label = label;
tf_y = 3;
tf_col = 0xFFFFFF;
setFormat(null, null, 10, true, false);
```

The rest of the script is very familiar to us from other MovieClip button scripts:

```
this.buttonMode = true;
this.addEventListener(MouseEvent.MOUSE_OUT,
 mouseOutHandler);
this.addEventListener(MouseEvent.MOUSE_OVER,
 mouseOverHandler);
}
private function mouseOutHandler
  (event:MouseEvent):void
{
event.currentTarget.gotoAndPlay("frame11");
}
private function mouseOverHandler
  (event:MouseEvent):void
{
this.gotoAndPlay("frame2");
}
```

All other classes that require text fields function exactly the same way. Next we will look at the AlertBox class.

AlertBox and AlertButton Classes

Creating an Alert box is, as you will see, not very difficult. The main function of the Alert box is to pop up and show some text. The user then needs to click on a button to delete the Alert box. All we need to have is a variable, which will hold the string that will be shown when the Alert box pops up. The AlertBox class also extends the ButText class, which makes formatting text easy.

```
public class AlertBox extends ButText
{
  public function AlertBox (my_label:String)
  {
    super ();
    this.name = "al_box";
```

It is of course important to add a button that will remove the Alert box:

```
var ab:AlertButton = new AlertButton ();
this.addChild (ab);
```

The rest of the script is only positioning the text field and formatting text:

```
this.tf_label = my_label;
this.tf_x = 25;
this.tf_y = 90;
this.tf_width = 200;
this.tf_height = 100;
this.tf_wordwrap = true;
this.tf_multiline = true;
this.setFormat (null, null, 15, false, false);
    }
  }
```

The crucial part of the AlertButton class script is "this". Since the Alert button is a child of the AlertBox we can access the AlertBox by using "this.parent". However, we need to access the stage, which is the parent of the AlertBox, to remove the Alert box. Remember that originally we placed the Alert box on the stage. Then we can access the AlertBox only by using the "getChildBy-Name(name);" syntax. That is the reason we need to give MovieClips names, so we can access them by their name. We cannot access them by the variable that originally was used to add the object to the display list.

```
public function AlertButton ()
{
  this.buttonMode = true;
  addEventListener(MouseEvent.MOUSE_DOWN,
    mouseDownHandler);
}
  private function mouseDownHandler
    (event:MouseEvent):void
{
  this.parent.parent.removeChild
    (this.parent.parent.getChildByName ("al_box"));
}
```

We will use the ButText class for more objects in the next chapter. We now turn to the DataBase class to perform a search.

Search Engine: DataBase Class

If you have read the book from the beginning and know the DataBase class, which we created for the Flash 8 search engine, you know how cumbersome it was. For example, we had to incorporate an EventDispatcher. You will be surprised how simple the script becomes using AS3. We don't need an EventDispatcher, because the EventDispatcher methods are now included in event handling, similar to event handling for components in Flash 7 and 8.

In the following script we have omitted the classes that we import. We start with the class declaration. The DataBase class extends the Sprite class. We declare some variables, which we want to be present in the script and not be local. Some variables, which have only one value and which we want to belong to the class, are static like the holder for the displays, hd. We define the timeline and create a ComboBox LinkButton instance, because now we need to access the data the user has selected from the ComboBox. When the DataBase.as script is executed the user has made a selection (see Arranging Objects on the Stage: The ArrangeStage Class).

```
public function DataBase ()
{
  _root = Root._root;
  lbt = new LinkButton ();
}
```

Then we load and parse the XML data. We use the LoaderClass class, which we have discussed earlier (Chapter 16). The URL for the XML file lbt.mb_0_D is derived from the LinkButton class and we can get it by calling the getter (see Chapter 18, The ComboBox: LinkButton Class).

```
public function initDbase ():void
{
  pXml = new LoaderClass ();
  var xmlFile:String = lbt.mb_0_D;
  pXml.initXML (xmlFile, loadParse);
}
```

Once the XML file is loaded we make arrangements regarding former displays, infoDisplay, and hd, which need to be removed. We need to ask whether the MovieClip or, better, Sprite is not null. Omitting this line would give an error if the Sprite were null, since null objects cannot be removed.

```
private function loadParse (event:Event):void
{
  ifd = Sprite(_root.getChildByName("infoDisplay"));
  if (Sprite(ifd.getChildByName("hd")) != null)
  {
    var ch1:Sprite = Sprite(ifd.getChildByName ("hd"));
    var ch2:Sprite = Sprite(ifd.getChildByName
    ("myScroller"));
    ifd.removeChild (ch1);
    ifd.removeChild (ch2);
  }
```

We create a new holder for the displays and position it with the mask. The masking of the holder will be done at a later point. We position the holder, hd, accordingly and add it to the infoDisplay Sprite. We are now ready with all preparations to take care of the XML.

```
var myMask:Sprite =
 Sprite(ifd.getChildByName("mask"));
hd = new Sprite ();
hd.name = "hd";
hd.x = myMask.x
hd.y = myMask.y
ifd.addChild (hd);
```

First we catch the XML data, which is the data from the event.target, xmlLoader, a URLLoader object (see LoaderClass.as). We create an XMLList object, xdh, which holds all the <house> nodes. Then we create a new array, which we will need to sort the data and process it.

```
var xmlData:XML = XML(event.target.data);
var xdh:XMLList = xmlData.house;
var houseArray:Array = new Array();
```

We now loop through the child nodes and catch each <house> node individually.

```
for (var count01 = 0; count01 <
 xmlData.children().length(); count01++)
{
  var my_id:XML = xdh[count01];
```

As we did in the AS2 version we also convert the price from a string to a number. "xdh.child("price")" will hold each <price> in all <house> nodes. The syntax is the same as in AS2. Using the "count01" variable we get each node individually.

```
var price_string:String =
 xdh.child("price")[count01];
var splitted:Array = price_string.split (",");
var num_price:uint = uint (splitted.join (""));
```

Again, as before, we differentiate according to the house price and number of bedrooms for the search engine parameters. We sort the price, pt, in the array starting lowest first. We start with the option "Show all", which is not a number and has to be treated separately from the number of bedrooms, which follows in the second "if" statement. Except for the numeric price, we add all data for each <house> node collectively by adding the complete node hnd.

```
if (lbt.mb_1 == "Show all" && num_price >=
 uint(lbt.mb_2) && num_price <= uint(lbt.mb_3))
{
  houseArray.push({hnd:my_id, pt:num_price});
}
else if (lbt.mb_1 == xdh.child("bedroom")[count01]
 && num_price >= uint(lbt.mb_2) && num_price <=
 uint(lbt.mb_3))
```

```
        {
            houseArray.push({hnd:my_id, pt:num_price});
        }
        houseArray.sortOn("pt", Array.NUMERIC);
```

When looping is finished, we cover the displays with the mask and loop through the sorted array. The former setMask () method has been replaced by the set mask () method.

```
        if (count01 == (xmlData.children().length()-1))
        {
            hd.mask = myMask;
            for (var count02:uint = 0; count02 <
             houseArray.length; count02++)
            {
```

We create new HouseDisplay instances for each <house> node and set the *y* coordinates according to the height of each display unit. We add each display unit to the holder MovieClip.

```
            var myHd:MovieClip = new HouseDisplay ();
            myHd.name = "myHd_"+count02;
            myHd.y = count02*myHd.height+5;
            hd.addChild (myHd);
```

We process all the data for each of the <house> nodes, which is one image and otherwise text, which is all encoded in the array element hnd. We create separate variables for each text element and add text as it should appear in the displays.

```
            var hnd:XML = houseArray[count02].hnd;
            var ct:String = "City: "+hnd.child("city");
            var dt:String = hnd.child("details");
            var bd:String = "Bedroom: "+
             hnd.child("bedroom");
            var ba:String = "Bathroom: "+
             hnd.child("bath");
            var yb:String = "Built: "+ hnd.child("built");
            var pr:String = "Price: $"+ hnd.child("price");
            var hid:String = "ID: "+ hnd.attribute("id");
            var im:String = hnd.child("image");
            myHd.createFields (ct, dt, bd, ba, yb, pr,
             hid, im);
```

When we have looped through the houseArray array we place the scroller and set its visibility to false. Inside the scroller script there is an option so that it will become visible once the size of the MovieClip to be scrolled is determined. The problem is that the scrollbar extends over its limits. We fix that by adding a mask, which limits the visibility of the scroller.

```
        if(count02 >= houseArray.length-1)
        {
          var myScroller: McScrollBar_vert = new
           McScrollBar_vert ();
          myScroller.name = "myScroller";
          myScroller.arrangeStage (hd, myMask);
          myScroller.visible = false;
          ifd.addChild (myScroller);
        }
      }
    }
  }
 }
 }
}
```

Search Engine: The HouseDisplay Class

The next important class, and also the final class for the basic search engine to function, is the class that will display text and the image in each of the display units. We declare all the variables we need and make them available in the class.

```
private var wCity:TextField;
private var detailsLink:TextField;
private var bRoom:TextField;
private var bathRoom:TextField;
private var yBuilt:TextField;
private var prText:TextField;
private var idNum:TextField;
private var saveField:MovieClip;
public function HouseDisplay ()
{
}
```

The main function is a public function that is called from the DataBase class and contains all the variables that hold the text and image values for the display.

```
public function createFields (wCitylabel:String,
 details:String, bed:String, bath:String,
 built:String, price:String, hid:String,
 myImage:String):void
 {
```

We now create individual text fields for each value as shown in one example by calling a new class, Createtextfields, which belongs to this source file. Only one example is shown here, since it is the same for all the text fields.

```
wCity = new TextField ();
wCity.name = "wCity";
var wc:Createtextfields = new Createtextfields (this,
    wCity, 117, 1, 150, 15, wCitylabel, false);
```

We have one image, which we need to add to each display. We create a new MovieClip, which will hold the Loader object. We then call the LoaderClass:

```
var mh:MovieClip = new MovieClip ();
mh.x = 5;
mh.y = 1;
this.addChild (mh);
var lc:LoaderClass = new LoaderClass ();
var mv_mh:MovieClip = MovieClip(mh);
lc.initLoader (myImage, loadFinished, mv_mh);
}
```

When the image is loaded we scale it to make it smaller:

```
private function loadFinished (event:Event):void
{
  var loadedName:MovieClip =
   event.target.content.parent.parent;
  loadedName.scaleX = 0.5;
  loadedName.scaleY = 0.5;
  }
 }
}
```

We add a second class to the source file to format the text. We need to import a number of classes related to text fields (classes are not shown). Here is a typical example, in which we use the Sprite class, since we do not use any frames nor associate new properties to instances of this class.

```
class Createtextfields extends Sprite
{
```

We need only one variable, which is of data type TextField:

```
private var htf:TextField;
```

Then we have the constructor with all parameters …

```
public function Createtextfields (_root:MovieClip, htf,
 xpos:uint, ypos:uint, wt:uint, ht:uint, label:String,
 myHtml:Boolean)
 {
```

... followed by formatting the text field instances:

```
htf.mouseEnabled = false;
htf.x = xpos;
htf.y = ypos;
htf.width = wt;
htf.height = ht;
htf.antiAliasType = AntiAliasType.ADVANCED;
var b:TextFormat = new TextFormat();
b.align = "left";
b.font = "Arial";
b.color = 0x000000;
b.bold = false;
b.size = 10;
htf.defaultTextFormat = b;
```

Occasionally we have a link in the display units that opens HTML pages. If a display unit has a link the Boolean variable "myHtml" will be true and the label will be "detailsLink".

```
if (myHtml)
{
   if(label != "null" && htf.name == "detailsLink")
{
```

We give the text field button properties and also include an HTML link:

```
htf.mouseEnabled = true;
htf.htmlText = "<a href=\""+label+"\"><u>View
  details</u></a>";
htf.addEventListener (MouseEvent.MOUSE_OVER,
  mouseOverHandler);
htf.addEventListener (MouseEvent.MOUSE_OUT,
  mouseOutHandler);
function mouseOverHandler (event:MouseEvent)
{
```

When the user moves the mouse over the text field we want the text to change. We use a local style sheet instead of HTML tags, although it requires a bit more scripting. However, I show it here as one possible option. The example shows two different ways the style sheet can be applied, as a new tag or by using the span class attribute.

```
var style:StyleSheet = new StyleSheet();
var link:Object = new Object();
link.fontWeight = "bold";
link.color = "#FF0000";
var body:Object = new Object();
```

```
            body.fontStyle = "italic";
            style.setStyle(".link", link);
            style.setStyle("body", body);
            event.target.styleSheet = style;
            event.target.htmlText = "<body><a
             href=\""+label+"\"target='_blank'><span class=
             'link'><u>View details!</u></span></a></body>";
        }
```

When the mouse moves out we reverse the text behavior:

```
        function mouseOutHandler (event:MouseEvent)
        {
            event.target.htmlText = "<a href=\
             ""+label+"\"><u>View details</u></a>";
        }
    }
```

If the display unit has no details link, we keep the text field empty:

```
        else
        {
          htf.text = "";
        }
    }
```

Or for other text fields we add the corresponding label:

```
        else
        {
          htf.text = label;
        }
        _root.addChild (htf);
      }
    }
```

This brings us to the end of the first part of the search engine. We can now test it.

Improving Performance

We should get used to improving the performance of applications by testing the compilation time and then rechecking all the scripts for unnecessary lines and/or classes that we have imported but actually no longer need, because we have made some changes. This is especially important for applications, like search engines, that handle a lot of data and/or objects. To measure the performance we

add these lines in the DataBase class after instantiating the houseArray before starting the first loop through the XML data:

```
var md:Date = new Date ();
trace("A: "+md.getMilliseconds());
trace("B: "+md.getSeconds());
```

We add similar lines to the end of the chain that is in the HouseDisplay class after the image has been loaded. So open the HouseDisplay class and add these lines after "loadedName.scale Y = 0.5;":

```
var md:Date = new Date ();
trace(md.getMilliseconds());
trace("C: "+md.getSeconds());
```

These lines will be executed several times until all the displays are loaded. We will get the seconds and the milliseconds. We then deduct C from A and B and get seconds:milliseconds. For our test we use a special XML file with 128 house nodes. Although they are not all different, the player needs considerably longer time to process such a large file compared to smaller files. The file that we change for testing is North.xml and is present in all folders. We set the ComboBox values to "North", "Show all", "0", and "2000000", which will cover all the nodes. If we do that for our present application we get a mean value of 2:265.

Where can we improve the speed? The two major classes are the DataBase and the HouseDisplay classes. There is currently nothing obvious in the DataBase class. However, we can make changes in the HouseDisplay class. For example, we are creating MovieClips for the images in the display units. We can eliminate those and just position the images themselves. Below are lines that are commented out or newly added:

```
//var mh:MovieClip = new MovieClip ();
//mh.x = 5;
//mh.y = 1;
//this.addChild (mh);
var lc:LoaderClass = new LoaderClass ();
//var mv_mh:MovieClip = MovieClip(mh);
lc.initLoader (myImage, loadFinished, null);
}
private function loadFinished (event:Event):void
{
  //var loadedName:MovieClip =
   event.target.content.parent.parent;
  var loadedName:Bitmap = event.target.content;
   // new
  loadedName.x = 5;// new
  loadedName.y = 1;// new
```

When we test the movie now we get an error, because in the LoaderClass class we have the following line:

```
holder.addChild(urlLoader);
```

However, the holder would be null and we cannot add a child to a null object. So we change the script and make an "if" statement:

```
if(holder != null)
{
   holder.addChild(urlLoader);
}
```

When we test the movie three times we get a very consistent value of 2:167 seconds, which is an improvement of about 0.1 second, which is enormous. The file size itself has not changed (about 41 kB).

Let's stay with the HouseDisplay class. Another change we can make is to eliminate all the individual text fields and replace them with one text field in which we arrange the text. That should not be so difficult, but saves us creating a large number of TextField instances. This is a dramatic change. Most of the script that deals with creating new text fields would disappear and be replaced by these few lines:

```
public function createFields (wCitylabel:String,
  details:String, myImage:String):void//new
     {
       var wc:Createtextfields = new Createtextfields (this,
         wCity, 117, 1, 150, 100, wCitylabel, false);
       detailsLink = new TextField ();
       detailsLink.name = "detailsLink";
       var dt:Createtextfields = new Createtextfields (this,
         detailsLink, 117, 75, 100, 15, details, true);
```

We need to create one large text field and one text field for the detailsLink, since that is special. However, now we arrange the text already in the DataBase class. It is pretty simple to do that using "\n" for a new line and " " for creating spaces. The function "createFields" has of course fewer parameters.

```
var completeDescription:String = ct +"\n" +
bd + "     " + ba + "\n" + yb + "\n" + pr +
"       " + hid;// new
//myHd.createFields (ct, dt, bd, ba, yb, pr,
  hid, im);
myHd.createFields (completeDescription, dt,
  im);//new
```

Furthermore, instead of creating a virtual text field we add a hard copy text field to the houseDisplay MovieClip and name it "wCity" so that we do not need to change any naming. We need to make "private var wCity:TextField;" public, because it is present already in the movie and has to be public. We eliminate the last line "_root.addChild (htf);" and add this within the "if" statement when the detailsLink is created. Now we test again. The results of three tests show a mean time of 1:890 seconds, which is approximately an additional 0.25 second savings. Our "cleaning" process was quite successful and saved us about 0.35 seconds. We are now ready to proceed with the search engine and add more functionality.

20 The Search Engine (Part 2)

What Is Next?

So far, we have completed the first part, the core search engine, and tried to optimize the execution of the movie. We are able to display about one hundred house displays, including images. As with the Flash 8 version we would also like to include an option to save individual displays in a list and later call them back. We want to have the option to display only a certain number of house displays at one time, so we need a Next–Previous module. If you go back to Figure 19.3 you will see how those options are connected to the search engine. We have additional classes, which are called from the DataBase class.

To have a Next–Previous module we need to add several objects to the movie library. Open the DataBase.fla and you will find a folder, Next–Prev, which contains the Next and Previous buttons, the Modul MovieClip, and an empty MovieClip, the NextModul. We create actual classes for all the objects that will be located in the Scripts—mc folder except for the Next Modul class.

The NextModul Class

Unlike some of the other scripts, we can use the AS2 script that we have already written and modified, which saves us some work. This class has to extend the MovieClip class, because we use frames. We first declare the "_root" variable to have a reference to the main timeline:

```
public class NextModul extends MovieClip
{
    private static var _root:MovieClip;
```

Now we declare all the display objects. nMod has to be of data type MovieClip, because later we dynamically add a new property to it, which is not allowed with Sprite objects.

```
private static var prevBut:Sprite;
private static var nMod:MovieClip;
private static var nextBut:Sprite;
private var ifd:Sprite;
```

We create a variable for an array that holds the display MovieClips and a counter variable, "count", to count the number of displays, which is similar to what we did in the AS2 script.

```
private static var displayArray:Array;
private static var count:uint;
```

Within the constructor we define the "_root" variable and create all the objects we need for the module to function. We add names. If you open the files for the classes PreviousBut, Modul, and NextBut in the Scripts—mc folder you will see that all these classes extend the ButText class. As we learned earlier this class will create a text field. The constructor in all these classes has one parameter for a string. We add this parameter here, which will be the label for the individual objects:

```
public function NextModul ()
{
  _root = Root._root;
  prevBut = new PreviousBut ("PREVIOUS 5");
  prevBut.name = "prevBut";
  prevBut.x = 0;
  this.addChild (prevBut);
  nMod = new Modul ("SELECT");
  nMod.name = "nMod";
  nMod.x = prevBut.width + 5;
  this.addChild (nMod);
  nextBut = new NextBut ("NEXT 5");
  nextBut.name = "nextBut";
  nextBut.x =  prevBut.width + nMod.width + 10;
  this.addChild (nextBut);
}
```

In the DataBase class we have a static function renewArray, which creates a new instance of the displayArray array replacing the former one. We place this static function here, which will be executed only once when called from the DataBase class:

```
public static function renewArray ():void
{
  displayArray = new Array ();
}
```

This is followed by the core function of this class, which has only one parameter for each of the house displays. From here on the script is similar to the AS2 script. We fill the array with all the displays.

```
public function showNextFive
(homeDisplay:MovieClip):void
{
  displayArray.push (homeDisplay);
```

If the number of displays is larger than 4 the module will be visible, but only the Next button.

```
this.visible = true;
```

```
if (displayArray.length > 4)
{
  prevBut.visible = false;
  nextBut.visible = true;
```

We indicate the first numbers of the displays. We are changing the content of the text field dynamically; this is the reason nMod cannot be a Sprite but has to be a MovieClip object.

```
  nMod.tf_label = "From 1 - 5";
}
else
{
```

Otherwise the buttons will be invisible, if the number of displays is 5 or less:

```
  prevBut.visible = false;
  nextBut.visible = false;
  nMod.tf_label = "From 1 - "+displayArray.length;
}
```

We set count to 0 and add the functions for the Next and Previous buttons:

```
count = 0;
nextBut.addEventListener(MouseEvent.MOUSE_DOWN,
  nextHandler);
prevBut.addEventListener(MouseEvent.MOUSE_DOWN,
  prevHandler);
}
```

In the Next button function we create a variable for the myFrame Sprite to avoid lengthy lines:

```
private function nextHandler (event:MouseEvent):void
{
  var myFrame:Sprite = Sprite(ifd.getChildByName
    ("myFrame"));
```

We pull back the scroller to its original position. See the last part of this script for the function "adjustScroller".

```
adjustScroller ();
```

We increment count, which counts the units of five displays.

```
count++;
```

We can now make the Previous button visible, since we have more than one unit of displays.

```
prevBut.visible = true;
```

We loop through the displayArray array, which holds all displays:

```
for (var counter = 0; counter < displayArray.length;
 counter++)
{
```

We create instances of each display:

```
var display:MovieClip =
 MovieClip(displayArray[counter]);
```

We determine the number of displays and show only those corresponding to count. If count is 2, then only those larger than or equal to 10 (2*5) and smaller than 15 (3*5) will be shown.

```
if (counter >= (count * 5) && counter <
 ((count + 1) * 5))
{
```

To show them, we place them on the left side within the mask area ($x = 0$). We make the Next button invisible:

```
display.x = 0;
nextBut.visible = false;
```

Since the number of displays in the last unit is not necessarily 5 but could be from 0 to 5, we need to calculate this number, since we want to show the numbers in the text field for the Modul. If the "count+1" number—in our example that is 3—is smaller than the length of the array, for example, 12, we would indicate from 11 (2*5+1) to 12.

```
if(((count * 5)+1) < displayArray.length)
{
  nMod.tf_label = "From "+((count * 5)+1)+"-
   "+displayArray.length;
}
else
{
  nMod.tf_label = " No: "+displayArray.length;
}
}
```

Coming back to the original "if" statement, all other displays are placed outside the mask and are invisible. Since this is not the end of the display array length we make the Next button visible.

```
else
{
  display.x = myFrame.x + myFrame.width;
  nextBut.visible = true;
```

```
      nMod.tf_label = "From "+((count * 5)+1)+" -
        "+((count + 1) * 5);
    }
  }
}
```

The Previous button function is very similar except that now we decrement the display numbers. Therefore, I am not commenting the lines further.

```
function prevHandler (event:MouseEvent):void
{
  var myFrame:Sprite = Sprite(ifd.getChildByName
   ("myFrame"));
  adjustScroller ();
  count--;
  for (var counter:uint = 0; counter <displayArray.
   length; counter++)
  {
    var display:Sprite = Sprite (displayArray[counter]);
    if (counter >= (count * 5))
    {
      nextBut.visible = true;
      nMod.tf_label = "From "+((count * 5)+1)+" -
        "+((count + 1) * 5);
    }
    else
    {
      nextBut.visible = false;
      nMod.tf_label = "From "+((count * 5)+1)+" -
        "+displayArray.length;
    }
    if (count < 1)
    {
      prevBut.visible = false;
      nMod.tf_label = "From 1 - 5";
    }
    if (counter >= (count * 5) && counter <
     (count + 1) *5)
    {
      display.x = 0;
    }
    else
    {
```

```
        display.x = myFrame.x + myFrame.width;
      }
    }
  }
```

The final function is to adjust the scroller, since we do not want the scroll handle to be in the position where we left it, so we put it back to its original position including the display holder hd.

```
    private function adjustScroller ()
    {
      var shortCut:Sprite = Sprite(ifd.getChildByName
        ("myScroller"));
      var myScrollBar:Sprite = Sprite(shortCut.
        getChildByName ("myScrollerBar"));
      var hd:Sprite = Sprite(ifd.getChildByName ("hd"));
      hd.y = 120;
      myScrollBar.y = 0;
    }
  }
}
```

In the DataBase class we need to make some changes as well. First of all we need to import the NextModul class. Then we need to add a line to call the main function of the NextModul class. It will be placed after the HouseDisplay class is called:

```
    MovieClip(_root.getChildByName("n_Module")).showNextFive
      (myHd);
```

You can now test the movie.

Saving Data: The SaveButton Class

The last implementation for the search engine is to save and display multiple searches. We will create three classes, the SaveButton, the SaveNodes, and the DisplaySaved classes. Unlike in the previous Flash 8 version, we can directly access the Save buttons, which have their own script. As you will see later, this is an important class when it comes to performance issues and we will make several changes. But for now we just write the class as we think we should.

The SaveButton class extends the ButText class, because we also create a TextField instance:

```
      public class SaveButton extends ButText
      {
```

We define some general variables, among them also a variable for the SharedObject object. We will come back to this in a later part of this chapter.

```
        private var myLabel:String;
        private var my_id:XML;
```

```
private static var newXML:XML;
private var my_so:SharedObject = SharedObject.getLocal
  ("kookie");
```

In the constructor we examine whether the SharedObject object has data. If there is data, we continue using this XML. Otherwise we need to create a new XML file:

```
public function SaveButton ()
{
  super ();
  if(my_so.data.xml == null)
  {
    newXML = new XML ("<text/>");
  }
  else
  {
    newXML = my_so.data.xml;
  }
```

The main public function gets data from the DataBase class, a label for the button, the XML information for the house display, and myHd, which is the display unit where we need to place the button.

```
public function createButton (label:String, hnd:XML,
  myHd:MovieClip):void
{
```

We write the *x* and *y* coordinates for the button and add it to the display:

```
this.x = 5;
this.y = 80;
myHd.addChild (this);
```

We use a variable, "my_id", and set it equal to the XML data:

```
my_id = hnd;
```

Then we associate the data with the button:

```
this.my_id = my_id;
```

Now we add text and format it:

```
myLabel = label;
this.buttonMode = true;
this.tf_label = "<u><b>"+myLabel+"</b></u>";
this.tf_col = 0xFFFFFF;
this.setFormat(null, null, 12, true, false);
```

We add mouse event handlers for button behavior:

```
if(my_id != null)
{
   addEventListener(MouseEvent.MOUSE_OUT,
     mouseOutHandler);
   addEventListener(MouseEvent.MOUSE_OVER,
     mouseOverHandler);
   addEventListener(MouseEvent.MOUSE_UP,
     mouseUpHandler);
   addEventListener(MouseEvent.MOUSE_DOWN,
     mouseDownHandler);
   }
}
```

Then we add individual text formats to the different button states:

```
private function mouseOutHandler
  (event:MouseEvent):void
{
  event.stopPropagation ();
  this.tf_label = "<u><b>"+myLabel+"</b></u>";
}
```

As the example shows we can create local style sheets to format the text. We could, of course, also just use simple HTML tags. But why make it simple if we can make it more complicated? Later when we revise the movie we will eliminate all this. However, for demonstration purposes, and because we had this idea, we leave it for now.

```
private function mouseOverHandler
  (event:MouseEvent):void
{
  event.stopPropagation ();
  var tf:TextField = TextField(event.target.
    getChildByName("tf"));
  var style:StyleSheet = new StyleSheet();
  var link:Object = new Object();
  link.fontWeight = "bold";
  link.color = "#522994";
  var body:Object = new Object();
  body.fontStyle = "italic";
  style.setStyle(".link", link);
  style.setStyle("body", body);
  tf.styleSheet = style;
```

```
    this.tf_label = "<body><spanclass='link'><u>
     "+myLabel+"</u></span></body>";
}
private function mouseUpHandler (event:MouseEvent):void
{
  event.stopPropagation ();
  this.tf_label = "<u><b>"+myLabel+"</b></u>";
}
```

The "mouseDownHandler" function is the essence of this class. Here we add a new child to the XML file, which is XML data from the "my_id" variable. We add data to the shared object over the static function "save_myxml" of the SaveNodes class:

```
private function mouseDownHandler(event:MouseEvent):
 void
{
  newXML.appendChild (event.target.my_id);
  SaveNodes.save_myxml (newXML);
}
}
}
```

We need to call the SaveButton class now from the DataBase class. We import the SaveButton class and add a few lines to call the class. We place the script before or after calling the NextModul class, which does not make any difference.

```
var saveField:SaveButton = new SaveButton ();
saveField.createButton ("Save selection", hnd,
 myHd);
```

Before testing the movie we need to write two more classes.

Saving Data: The SaveNodes Class

The SaveNodes class will record and store newly saved data. It is similar to Getter–Setter methods. However, because the final storage site for the data is a shared object, we do not need a Getter, since we can retrieve data from a shared object by calling it directly. We make the main function and also the variables static. This gives us the advantage of calling the function directly over the class and we avoid creating several instances of variables.

```
private static var my_so:SharedObject;
public function SaveNodes ()
{
}
```

```
public static function save_myxml(s_xml:XML)
  :SharedObject
{
```

We create a new SharedObject object whenever the function is called. The old data will always be replaced by the new data. We simply set the "my_so.data.xml" variable equal to the newly created XML file, s_xml.

```
my_so = SharedObject.getLocal ("kookie");
my_so.data.xml = s_xml;
my_so.flush();
return my_so;
}
}
}
```

Saving Data: The DisplaySaved Class

The final class we need to write is the DisplaySaved class to display the saved data. This class is identical to the DataBase class, except that we load the XML data from the shared object. We need only one public function with an argument of data type XML.

```
public function loadParse (saved_xml:XML):void
{
```

We call this class from the ArrangeStage class using a button. We create a new EventButton instance and give it a label to identify it as the button to display saved data:

```
saveBut = new EventButton ("SHOW SAVED DATA");
saveBut.name = "saveBut";
saveBut.x = myFrame.x + myFrame.width + 50;
saveBut.y = myFrame.y + 250;
_root.addChild (saveBut);
saveBut.addEventListener(MouseEvent.MOUSE_DOWN,
  saveDownHandler);
function saveDownHandler (event:MouseEvent):void
{
```

When the user presses this button a new SharedObject object is created, which has the same identity, "kookie", as an object we saved previously. We make any Next or Previous buttons invisible:

```
n_Module.visible = false;
var my_so:SharedObject = SharedObject.getLocal
  ("kookie");
```

If the data of the shared object is not null, we create a new instance of the DisplaySaved class and the saved data will be shown. Otherwise we indicate in the myMessage text field that no data was found:

```
if (my_so.data.xml != null)
```

```
    {
      for_save = true;
      saved_doc = new XML(my_so.data.xml);
      var sn:DisplaySaved = new DisplaySaved ();
      sn.loadParse (saved_doc);
      mo_ad.visible = false;
    }
    else
    {
      myMessage.tf_label = "No saved data found.";
      myMessage.setFormat ("left", "Capitals", 12,
        false, false);
    }
}
```

We also offer a button to clear all the data:

```
clearBut = new EventButton ("CLEAR SAVED DATA");
clearBut.name = "clearBut";
clearBut.x = saveBut.x;
clearBut.y = myFrame.y + 280;
_root.addChild (clearBut);
clearBut.addEventListener(MouseEvent.MOUSE_DOWN,
 clearDownHandler);
function clearDownHandler (event:MouseEvent):void
{
  n_Module.visible = false;
  var my_so:SharedObject = SharedObject.getLocal
    ("kookie");
  if (my_so.data.xml != null)
  {
```

We clear the shared object:

```
      my_so.clear ();
```

We delete any MovieClips from previous searches and reset the stage:

```
      var ifd:Sprite = Sprite(_root.getChildByName
        ("infoDisplay"));
      if (Sprite(ifd.getChildByName("hd")) != null)
      {
      var ch1:Sprite = Sprite(ifd.getChildByName
        ("hd"));
```

```
        var ch2:Sprite = Sprite(ifd.getChildByName
          ("myScroller"));
        ifd.removeChild (ch1);
        ifd.removeChild (ch2);
      }
      mo_ad.visible = true;
      myMessage.tf_label = "Saved data are cleared.";
      myMessage.setFormat ("left", "Capitals", 12,
        false, false);
    }
    else
    {
```

If there wasn't any saved data, we indicate that as well:

```
      myMessage.tf_label = "No saved data found.";
      myMessage.setFormat ("left", "Capitals", 12,
        false, false);
      }
    }
```

As we did in all other applications we also create an interface for this movie. We create a file, DatabaseInterface, which contains some of the methods we have been using:

```
function initStage ():void; // from ArrangeStage class
function initDbase ():void; // from DataBase class
function loadParse (saved_xml:XML):void; // from
  DisplaySaved class
function showNextFive (homeDisplay:MovieClip):void; //
  from NextModul class
```

We add these methods to all the classes that implement the DatabaseInterface class. Those are the top classes within the Scripts folder.

Now the time has come to test the application. Open the FINAL_1 folder and open the DataBase.fla. We still have the lines in the scripts, which help us measure the execution time of the search.

Movie Optimization: First Revision

If you select the North file, which contains 128 nodes, you will notice that the application runs much slower than the original application without the Next, Previous, and Save buttons. The compilation time then was 1:900 seconds and now it is about 7:500 seconds. We do not yet know the reason for this dramatic slowdown. So we comment out some of the new function calls in the DataBase class. First we comment out the call for the Next and Previous button functions:

```
//MovieClip(_root.getChildByName("n_Module")).showNextFive
  (myHd);
```

When we now measure the time it is about 7:200 seconds, which is not much faster. Therefore, the Next and Previous button functions do not seem to cause any problems.

The second new feature of the movie was to save data. There are two lines. We first comment out only the function call:

```
//saveField.createButton ("Save selection", hnd, myHd);
```

The compilation time is now reduced to 6:800, which is close to 1 second faster. Now we also comment out the line to create a new instance of the SaveButton class.

```
// var saveField:SaveButton = new SaveButton ();
```

Do not forget to comment out the import for the SaveButton class or there will be an error. When we test the movie it causes a dramatic increase in speed and the time to compile the script is now about 2 seconds. Therefore, only creating the instance of the SaveButton class without calling the main function caused the reduction in speed. This shows that creating the variables and initiating the constructor are causing the slow compilation. This makes it easy for us to debug. This example gives you another reason it is important to leave the constructor empty and call a separate function, since we can easily detect problems occurring when we import classes, declare variables, and execute the constructor.

What might cause the slow speed? The following lines show the part of the script that contains the part that causes the slow compilation:

```
package scripts.mc
{
  import flash.display.MovieClip;
  import flash.text.TextField;
  import flash.text.StyleSheet;
  import flash.events.MouseEvent;
  import flash.net.SharedObject;
  import scripts.SaveNodes;
  import scripts.ButText;
  public class SaveButton extends ButText
  {
    private var myLabel:String;
    private var my_id:XML;
    private static var newXML:XML;
    private var my_so:SharedObject = SharedObject.getLocal
      ("kookie");
    public function SaveButton ()
    {
      super ();
      if(my_so.data.xml == null)
      {
```

```
    newXML = new XML ("<text/>");
  }
  else
  {
    newXML = my_so.data.xml;
  }
```

Importing any of the classes can be excluded as a reason. However, creating variables may cause the problem. We were creating a label for each button (private var myLabel:String;). Since the label is the same for all the buttons, we can make the variable static, which will reduce the number of instances to 1 and the label would be a class object. When we test the movie it does not have much of an effect on the speed. So the reason for the slow compilation must be different.

We cannot make "my_id" static, because every button needs its separate XML node. Then there is the shared object. For every display we create a new SharedObject object. We actually need only one shared object. So we make this variable static as well and see what happens. We change this line to

```
private static var my_so:SharedObject = SharedObject.getLocal
  ("kookie");
```

The effect is dramatic and now the compilation time is down to about 2:700 seconds. This shows that creating a new SharedObject object for each display uses large chunks of memory. We have now made the biggest improvement and we go further from here. We call the folder with the revised version of the class REVISION_1.

Movie Optimization: Second Revision

We are not yet finished revising the movie. First of all you may have noticed that we have a lengthy, complex script for the Save buttons. But do we need that or can we simplify? Since the text for the Save buttons is always the same and we just want to animate the text or button a little bit, we can change the button to a SimpleButton object. I have already done that if you check the SaveButton class in the FINAL folder. We now have a regular button. However, we also need to change the script. Instead of extending the ButText class we extend the SimpleButton class:

```
public class SaveButton extends SimpleButton
```

The main function will of course also change. First of all we can omit one function argument for the label:

```
public function createButton (hnd:XML, myHd:MovieClip):
 void
 {
```

The positioning still stays but we have deleted all the lines for formatting the label text:

```
this.x = 5;
this.y = 80;
```

```
myHd.addChild (this);
my_id = hnd;
this.my_id = my_id;
```

We have also deleted several of the event listeners and leave one listener specific for a SimpleButton object mouse event. The animation is now automatically done, since this is a button object:

```
this.addEventListener(MouseEvent.CLICK, butHandler);
}
```

We leave the essential function to save the XML data:

```
private function butHandler (event:MouseEvent):void
{
  newXML.appendChild (event.target.my_id);
  SaveNodes.save_myxml (newXML);
}
```

Testing the movie now shows a time of about 2:400 seconds, which is a further improvement.

Final: Completing the Real Estate Web Site

Our final task is to integrate the database movie in the real estate application. As a template we use the custom_menubar.fla, which we created in Chapter 18, and convert it to make it look similar to our former real estate movie. Frame 1 of our movie contains this script, which places a menu bar on the main timeline:

```
import scripts.menubar.Myparser;
var parser:Myparser = new Myparser (10, 5);
parser.parseData ("xml_files/menu.xml");
```

We now need to add scripts to load all the other movies. We use a simple approach. First we import the classes we need:

```
import flash.display.Loader;
import flash.net.URLRequest;
```

Then we create a Loader instance for every movie. As an example I show the Loader, which will load the new database movie:

```
var db:Loader = new Loader ();
db.name = "dataBase";
db.x = 150;
db.y = 150;
this.addChild(db);
```

We also create a general script to load the movies when we need to:

```
function simpleLoader (URL:String, urlLoader:Loader)
```

```
{
  var urlRequest:URLRequest = new URLRequest(URL);
  urlLoader.load(urlRequest);
}
```

And now we are ready to fill all the other frames. The frame script to load the database movie is below. We first unload all other movies and then we use the simpleLoader function:

```
stop();
cf.unload();
js.unload();
fi.unload();
tm.unload();
simpleLoader ("database.swf", db);
```

We do something similar in all other frames and then we can test the movie. Unfortunately, at the time this book was written, there was a problem loading Flash 8 or lower Flash version movies containing V2 components into a Flash 9 movie that uses AS3. There is no problem if there is only one movie with components loaded into a one-frame Flash 9 movie. However, our movie contains several frames and loads different movies with V2 components. We have three choices at this point. Either we continue using the original Flash 8 movie or we convert all the Flash 8 movies with components to Flash 9/Flex movies. Alternatively, we can eliminate the components in the Flash 8 movies and replace them with different methods that will perform the same tasks. We will not do this for the application described in this book. Instead we will just pretend as if everything was fine and just load the new database movie.

When we test the movie now and go to the frame where the database movie is loaded, we get this error message in the trace output window:

```
ReferenceError: Error #1074: Illegal write to read-only
  property scripts.helper::LoaderClass on global.
    at global$init()
```

What does this mean and how can we solve this problem? This error occurs when a parent movie and the child movie or any object in it use overlapping timelines due to the same Document class. This might have happened at one point when we created the ComboBox or the final database movie, since the names for folders and some classes are similar, Scripts, Helper, Root, etc. The solution is not so difficult. All we do is change the name of the folder for the menu bar, which contains the Document class for the Real-Estate.fla. We need to change the paths for all the classes as well and not to forget the class paths for the menu bar objects in the library. Having done that we can now test the movie and there is no longer an error. And that brings us to the end of this book.

Index

Printed and bound by CPI Group (UK) Ltd, Croydon, CR0 4YY

21/10/2024

01777093-0004